D0849952

The Art of Welded Sculpture

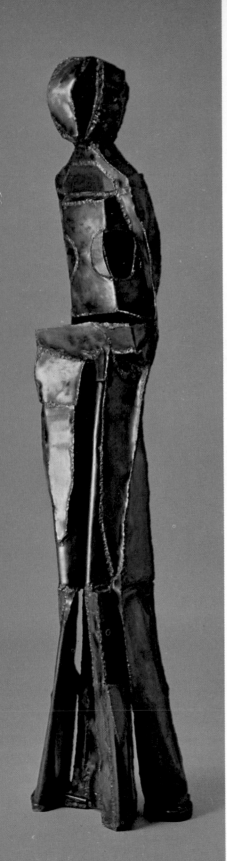

1

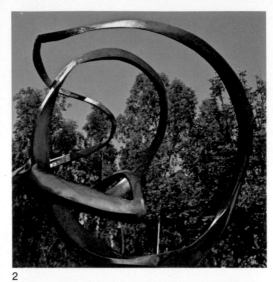

2

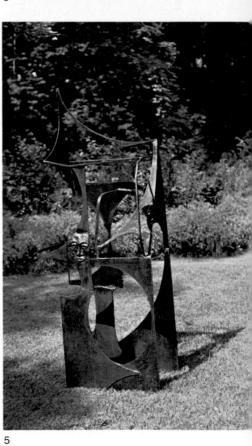

3

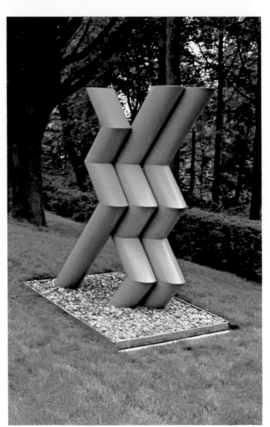

4

5

The Art of
WELDED SCULPTURE

Suzanne Benton

with sculptural pieces, drawings, and photographs by the author

VNR **VAN NOSTRAND REINHOLD COMPANY**
New York Cincinnati Toronto London Melbourne

Acknowledgments

To Hobart Brothers Company, for their technical photographs, general information, and the enthusiastic help of Mr. Howard Cary, Russell Simmons, and Harry Petranski; to Airco Welding Products, for generously providing studio, supply, and how-to photographs taken in my studio—special thanks to Bud Peterson, for his exceptional interest, and to Rich Fruchey, the photographer; and to the sculptors, galleries, and museums, who happily supplied photographs and information.

I also wish to acknowledge Judith Hannah Weiss, Dee Crabtree, and Linda McGuire, for their collaboration with the Mask Ritual Tales; Dorothy Dehner, for warmth, information, and support; Carol Lindberg and Mary Brennan, two artists whose hours of typing and help provided very real assistance; Ted Gotthelf, for sharing his knowledge of practical matters; and the Connecticut Commission on the Arts, whose grant support has helped me grow as an artist and write this book.

Van Nostrand Reinhold Company Regional Offices:
New York Cincinnati Chicago Millbrae Dallas
Van Nostrand Reinhold Company International Offices:
London Toronto Melbourne

Copyright © 1975 by Litton Educational Publishing, Inc.
Library of Congress Catalog Card Number 74-22513
ISBN 0-442-20692-5

Jacket photo by Gajda.

Designed by Loudan Enterprises
All sculptural pieces, drawings, and photos are by the author unless otherwise credited.

Published by Van Nostrand Reinhold Company
A Division of Litton Educational Publishing, Inc.
450 West 33rd Street, New York, N.Y. 10001

16 15 14 13 12 11 10 9 8 7 6 5 4 3 2 1
Library of Congress Cataloging in Publication Data

Benton, Suzanne.
 The art of welded sculpture.

 Bibliography: p.
 1. Welded sculpture. 2. Benton, Suzanne.
I. Title.
NB1220.B46 731.4 74-22513
ISBN 0-442-20692-5

66865

Page 2
C-1. Suzanne Benton. *Androgynous Figure.* Copper-coated steel, 75½" high.
C-2. Carmen Wenzel. *Giros.* Laminated copper, forged and welded, 1972.
C-3. Suzanne Benton. *Pelvic Woman* (from the *I Am a Woman* road-touring set). Copper-coated steel, 20" x 20½" x 17".
C-4. Josefa Filkosky. *Pipe Theme in Blue I.* Aluminum pipe, 10" in diameter, 90" high.
C-5. Suzanne Benton. *Variations on the Crescent II.* Arc-welded steel, 81" high.

Space Walker. Copper-coated steel, 88" high. (Collection of Caroline Whitbeck.)

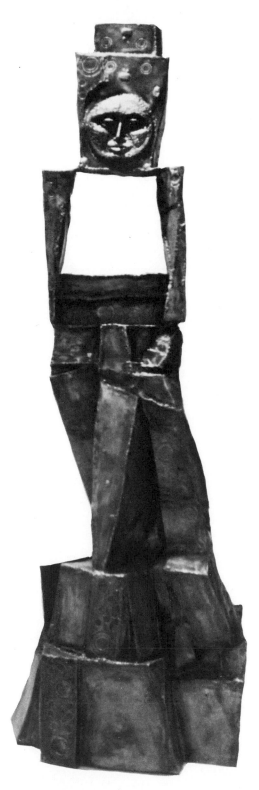

Contents

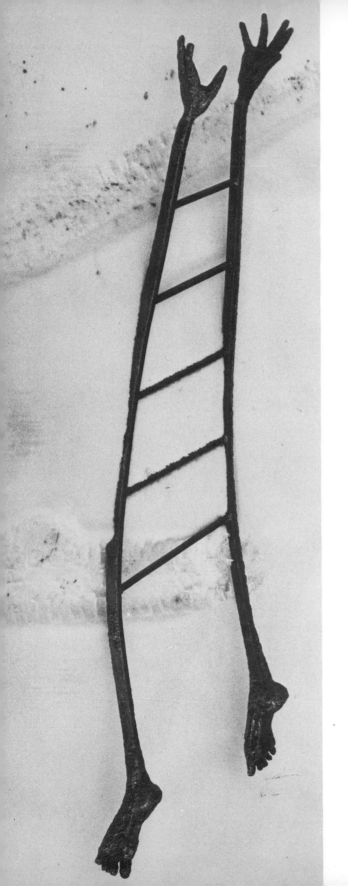

Introduction

As you may gather from the title, this book is about every facet of welded sculpture—art, techniques, meaning. I will tell you what it is for me to be an artist. Sometimes it is the wild longing to release the passions, the tensions into that miraculous thing called a body of work. At other times, it is a river—elegiac, lyrical, dependable. If you think that art is something far removed from you, you may ask yourself why you are drawn to this book. Is it to understand the creative process as a magic secret inside yourself, to see if perhaps a hidden spark will catch and come alive? If you are uncertain about your ability, your approach may tend to be imitative. There is nothing wrong with that, but this book is intended as a catalyst to your own search for self—your unique art. We are all involved in the creative process of our own lives. The function of art is to communicate, and your ability to understand yourself is the first step in communication, a challenge to embrace.

This book encompasses my knowledge and understanding of the art of welded sculpture. My own approach to art, the philosophy that impels me, the internal drive—these create the personality of authorship. The reader will know me as a person and as an artist. I will encourage you to become deeply involved in the same way in your own work, to find your own solutions. It is very important to have a continuous work pattern, the creation of an ever-growing body of work.

I-1. *The Railing.* Steel, 64" high. (Collection of Enid and Howard Cutler; photo by Arnold Benton.)

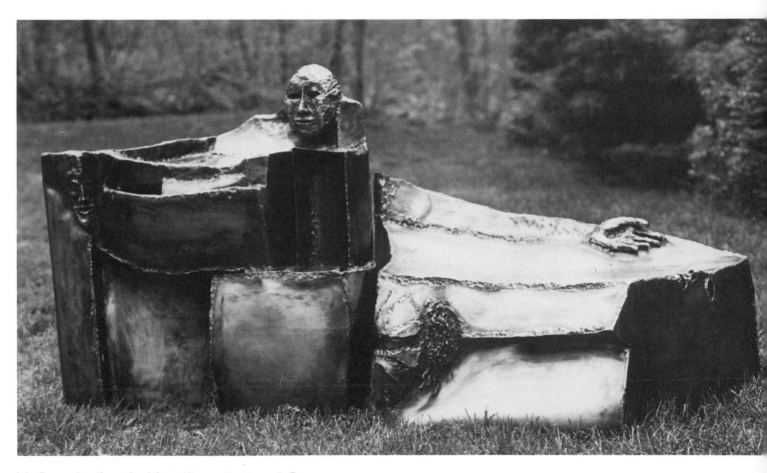

I-2. *Expansion* (from the *I Am a Woman* theater set). Bronze-coated steel in two sections, 58″ x 30″. (Photo by Claudia Stephens.)

I-3. *Chain Mask.* Steel, partly brazed, 10″ high. (Collection of Dee Crabtree.)

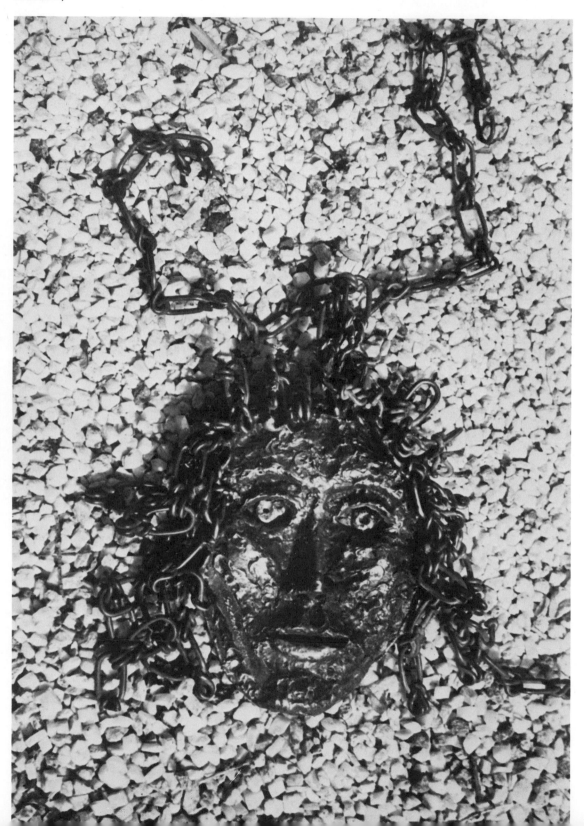

Specific problems of the woman/artist/sculptor are given thorough coverage, and the book is directed throughout to a female audience. Since women have had to adjust for so long to masculine references, it should be refreshing for the male reader to experience the reverse adjustment. Since the male term is always included within the female term, man can find himself in (he)rself.

I-4. *Social Pressure.* Steel, 21 1/2" high. (Collection of Shirley McConahay; photo by Arnold Benton.)

I-5. *Phallic Cross.* Brazed steel, 30" high. (Collection of Heidi and Burt Tydeman; photo by Arnold Benton.)

I-6. *Behindeverygreatwomanthereisaman.* Steel, 63 1/2" high. (Collection of Heidi and Burt Tydeman; photo by Arnold Benton.)

9

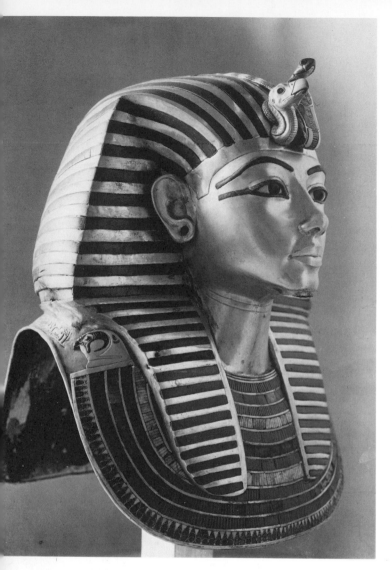

I-7. (Collection of The Metropolitan Museum of Art; photo by Harry Burton.)

I-8.

Welded-metal sculpture is both old and new. The earliest welded metal was of meteoric origin. The earliest known example of welded metal put to an artistic use is the miniature headrest found in the gold coffin of Tutankhamen (1350 B.C.). While the beaten-gold mask (figure I-7) is highly artistic, the headrest itself (figure I-8) is crude but elegant in form.

The Incas in Peru pounded gold into thin sheets and chain links to make large-scale masks for ceremonial occasions. They used the technique of repoussé, in which metal is hammered from behind to form the shape. The process of working with thin sheets of metal, however, often lacks strength and can be easily damaged, especially in today's world.

In the past metal sculpture was often cast. In the casting process the original piece is created in another medium, such as clay, plaster, wax, or sand, and a mold is made from the original. Molten metal (bronze, silver, gold, pewter, lead, or iron) is poured into the mold, thus creating the work of art. Casting is a long and tedious process. The final cast is far removed from the original form, and it is also costly.

Welded sculpture is also a new medium. Oxyacetylene welding as a technique was invented at the turn of the century and brought with it some of the promise of the contemporary era. Still, in many ways it speaks of the nineteenth century as well. It is not a push-button medium: the welder is in direct control of the torch and thus an integral part of the process. The tool still has the sense of immediacy that our more recent technology has chosen to dispense with.

Contemporary art, in general, differs from the art of the past in one important respect. Communication has made it possible for us to receive an overwhelming amount of content and cross-cultural input. This has affected our art most directly through the almost universal acceptance of collage. The techniques of adding, covering, multitextures, seemingly illogical joinings all blend into what can be described as a stream of consciousness. In addition we have the option to revamp—to destroy part and begin anew while still joined to the original work. This psychological second chance along with an indiscriminate use of input characterizes contemporary life and art.

This construction technique has markedly affected contemporary sculpture. Whereas in the past sculpture was generally cast or carved with a concept of the single unity, it now seems to liberally employ disparate objects, forms, and media. These unusual joinings create a new juxtaposition and are significant to the modern statement.

Welding has liberated sculpture and made it prolific. Steel in particular makes it possible for sculptors to work with a portable, readily available medium and source of

I-9.

I-10. Eila Hiltunen at work on *Flame of Life*.

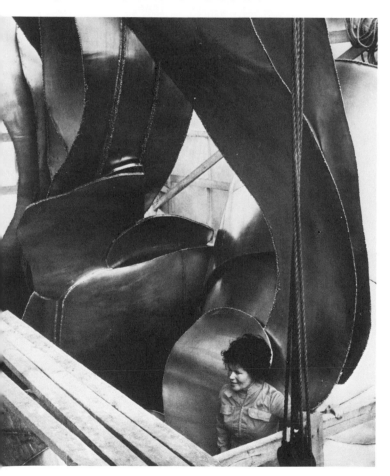

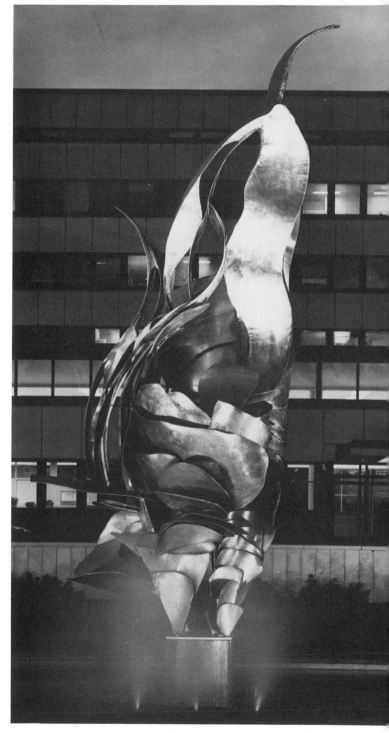

I-11. Eila Hiltunen. *Flame of Life*. Welded aluminum and bronze, 1972.

I-12. Louise Nevelson. *Tropical Tree X*. Welded aluminum, painted black, 78″ high, 1972. (Collection of Pace Gallery; photo by Al Mozell.)

I-13. Josefa Filkosky. Painted aluminum.

supply. The work is direct: beginning, intermediate, and final stages are all worked on the single, original piece. Welding is fast: large pieces of metal can be joined easily, and the sense of the completed work can be blocked out significantly sooner than with carving.

Welding makes it possible to span space with vast openings difficult to achieve through casting. Extraordinary surface variation can be accomplished with the torch and a variety of industrial scrap. Industrial forms lend a strange believability to the work in this culture in which we experience machines more than we experience art. Welding certainly possesses the criteria for creative work with metal: flexibility, aesthetic drama, responsiveness to individual statements, and a possibility of endless variety and depth.

The process was actually invented for industrial purposes. Several sophisticated and efficient welding techniques have been developed—oxyacetylene welding and various forms of arc (electrical) welding. These methods are discussed in this book.

This book is divided into three parts. The first part explains the technical data of welding, each stage of which is clearly illustrated. The second part describes the practical steps involved in exhibiting, publicity, and selling. The last part is historical in both a personal and a social sense. It includes my feelings about my own work, women artists, and the artist's role in society. This provides the reader with a framework that encourages exploration and understanding of uncharted possibilities.

Because it is so easy to learn the fundamental technique, the field appeals to the broad population, and many people have taken to the torch as an avocation. You will be guided through the beginning and more complex phases of welding, thus giving you an idea of the range within welded-metal sculpture.

A regard for safety is emphasized along with a respect for the nature of the material. Fire has both a primitive aspect and a role in the process of civilization. The primal element will find its way into the final sculpture. Control of the welding torch, with its unique combination of the primitive and the industrialized, is an ideal coming together of ancient force and the genius of civilization.

Fire can be a frightening thing. Mastering the fear, the danger will give you strength in all areas of your life. You will have to confront yourself on a deep level while you are learning the art of welded sculpture. You must examine work patterns and problems as indications of where you are as a creator. You must face limitations with patience through learning phases, which go on continuously; find time to work; establish a studio; deal with personal stumbling blocks; discover a sense of worth. You must learn how to bring your work into the culture, in content and responsibility as well as showing and selling.

I-14. *The Perfect Mask.* Steel and white metal with copper coating, 16″ high. (Photo by Claudia Stephens.)

The art of welded sculpture mirrors the dilemma of our times—how to live in harmony with both the primitive within us and the contemporary discoveries that have created new possibilities for human life. How each of us deals with the crudeness of this symbolic medium, what we choose to say, how we execute our ideas—this is the challenge. Welded sculpture is a valid art vehicle with which we can explain and understand ourselves and our culture.

In revealing my logic and motivation as an example for the learning metal sculptor, my aim is not to be emulated but to serve as a model.

Art is magic. A piece of metal can convey emotion and experience, it can recreate the reaction between viewer and art again and again. The content that is frozen in the work is ready to come to life in the mind of the viewer. My own work surprises me, even though I am sure of my ability as a sculptor. The process of creation has a life of its own. We never know what its scope and range will be until it begins to emerge.

Since welded sculpture is a relatively new art form, the first works have great power, emanating the vigor of new discovery. As we become more familiar with the process and its possibilities, discrimination comes into play, and we are able to distinguish between the merely facile and the truly excellent. This is in response to both our own creation and the work of others.

Each phase of my work has been filled with drama, excitement, and challenge. These powerful reinforcers enable me to keep moving onward. Which direction shall your work take? The terror of this choice is yours. I will open the door to this unique art form. If it fires and flames within you, you will come into this world and learn what there is within you to know. Welcome.

I-15. *Blue and White Double Mask*. Painted steel, 13″ high. (Photo by Claudia Stephens.)

PART 1

Chapter 1.

Equipment

Now that you have decided to learn how to weld, begin to familiarize yourself with the oxyacetylene fuel-gas equipment. Hunt out places where people weld, such as welding and auto-repair shops. These people will be willing to answer your questions once you express your sincere interest in the technique. They can also help you to find local sources of supply.

Your welding supplier is also an excellent source of information. (You can locate suppliers in the Yellow Pages under Welding.) Make sure that you find a supplier who is willing to give you information on an ongoing basis and not one who will make you feel helpless and ignorant. Most suppliers have sculptors as customers and very much enjoy this part of their business.

It is not always necessary to immediately purchase all of the equipment that you will be using: sometimes it can be rented from your supplier. Another alternative is to take a course at a vocational high school or an art school that has welding facilities.

TOOLS
The Welding Torch

There are many excellent welding torches on the market. A good one for beginners (and useful to me to this day) is commonly called a light-duty or aircraft welding outfit (figure 1-1). I have a Purox outfit (W-201 welding torch with CW-202 cutting attachment). The torch has stood me in good service for nine years with occasional replacement of tips. The outfit comes with:

Welding torch and three tips.

Cutting attachment and one nozzle.

Oxygen regulator.

Acetylene regulator.

Friction lighter.

12 1/2-foot hose with fittings (I bought an extra length of hose so that I can also work outside).

T-wrench.

Goggles (figure 1-2). (You can ask for a mask instead, which I prefer, as it keeps your face cleaner and also keeps you from inhaling a lot of the fumes.)

Tip cleaners (figure 1-3).

If you are purchasing a torch, it is important to get one with removable tip heads for easy cleaning.

After I had been welding for four years, I purchased a heavy-duty torch. The expense is worth it as you become more committed and expert in your art, because this torch is essential for heavier work. My two torches are attached via Y-connectors to one set of regulators and tanks. The welding-supply manufacturers offer a medium-duty torch, but I have found that its weight and balance are awkward and uncomfortable.

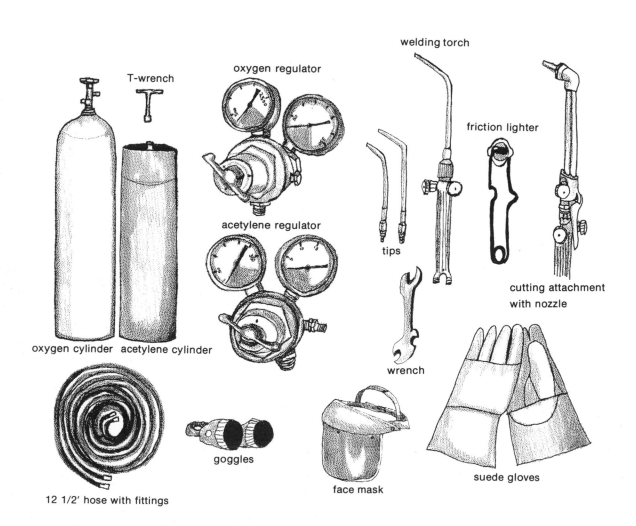

T-wrench

oxygen regulator

welding torch

friction lighter

acetylene regulator

tips

wrench

cutting attachment
with nozzle

oxygen cylinder acetylene cylinder

goggles

face mask

suede gloves

12 1/2' hose with fittings

1-1.

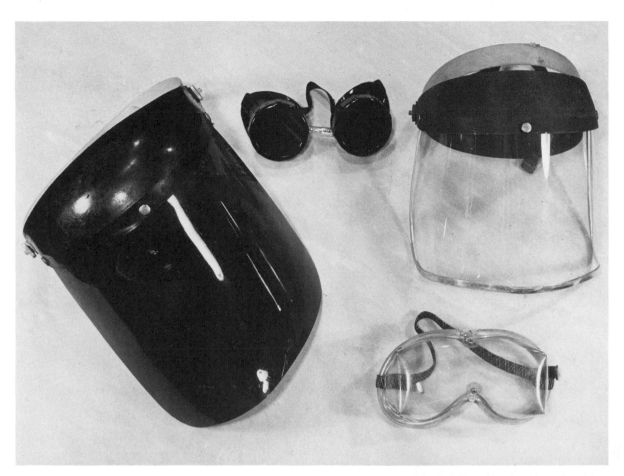

1-2. Mask and goggles—dark for welding, clear for finishing. (Studio photos in this and the following two chapters courtesy Airco Welding Products, unless noted otherwise.)

1-3.

The Tanks

You need both oxygen and acetylene tanks to fuel your torch. Rent them from a welding supplier. Your supplier picks up empties, delivers new fuel-gas tanks, and is responsible for repair and maintenance. (The cost of the oxygen and the acetylene is always additional. It is difficult to determine the burnup rate, because different amounts of fuel gas are consumed for different jobs.) I began with a one-year rental and then decided on five years. The long-term rental is the cheapest. If you think you may be moving, you can ask whether you will receive a refund.

The oxygen tank or cylinder is drawn from a single plate of high-grade steel. The cylinder itself is the shipping container for the compressed gas. It is trucked to your studio, and you purchase it by the cubic foot. Oxygen cylinders commonly come in three sizes:

80 cubic feet (35 inches high, about 6 inches in diameter, 67 pounds full, 60 pounds empty).

122 cubic feet (48 inches high, 7 inches in diameter, 89 pounds full, 79 pounds empty).

244 cubic feet (56 inches high, 9 inches in diameter, 152 pounds full, 133 pounds empty).

Begin with the 122-cubic-foot tank. It is relatively easy to handle and does not run out of gas so quickly. Remember, when you do a lot of cutting with the cutting torch, you use more oxygen in proportion to acetylene.

Each oxygen cylinder has a safety valve, which is designed to operate at high pressures. The double-seat valve prevents leakage around the valve stem when the valve is fully opened. The tank is painted green and comes with an iron cap that screws on the top over the valve for protection during shipping and handling. This cap is removed to attach the oxygen regulator.

The oxygen cylinders are gassed under pressure charged at 2,200 pounds per square inch at 70 degrees Fahrenheit. All gasses expand when hot and contract when cool, therefore, at lower temperatures the pressure will register less; at higher temperatures, more. The cylinder has a safety nut that bursts and releases the oxygen if the pressure gets too high. If this occurs, the oxygen will disperse in the air. If the condition of the space is flammable or if there are sparks or open flames, a forceful fire will result. Do not store or use in an area where the cylinder may become overheated.

Acetylene is also distributed in cylinders and rented along with the oxygen cylinder, but its construction is quite different. It is a strong, black, steel container full of a porous substance saturated with acetone. Acetone dissolves and absorbs many times its own volume of acetylene. Look for the acetylene tag. Acetylene is a volatile substance; adhere to safety precautions. The acetylene regulator must never be set at pressures above 15 pounds per square inch to prevent a possible explosion. The T-valve should not be turned open more than one and a half turns. A half turn is usually enough to draw the acetylene into your torch. It is important that the key handle (T-valve), which operates the valve, be kept in place in case you need to turn off the acetylene quickly in case of backfire or fire. Each acetylene cylinder has a safety fuse plug to meet an emergency. Acetylene cylinders also come in three sizes:

60 cubic feet (55 pounds full, 51 pounds empty).

100 cubic feet (97 pounds full, 90 pounds empty).

300 cubic feet (240 pounds full, 223 pounds empty).

Begin with the 100-cubic-foot tank if you are seriously going to learn welded sculpture.

Opposite page

C-6. Suzanne Benton. *Bronze Circle Mask.* Bronze, 7½" high.

C-7. Suzanne Benton. *The Warrior.* Steel, painted red, 11¼" high.

C-8. Suzanne Benton. *Sarah's Mask.* Steel, 14" high.

C-9. Suzanne Benton. *Bronze Warrior.* Copper-coated steel, 13¾" high.

C-10. Suzanne Benton, *Lilith.* Copper-coated steel and brazed bronze, 37" high.

C-11. Suzanne Benton. *Queen Elizabeth.* Welded steel, brazed with bronze, 24" high.

C-12. Suzanne Benton. *Golden Child Mask.* Brazed bronze on steel, 17" high.

C-13. Suzanne Benton. *Mystery Mask.* Steel, 10" high.

C-14. Suzanne Benton. *The Golden Queen.* Bronze on steel, 12" high. (All photos on this page by Gajda.)

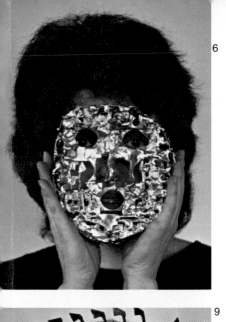

6

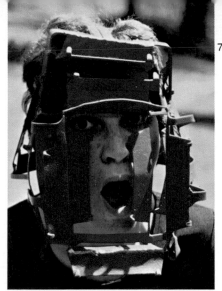

7

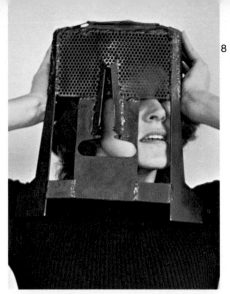

8

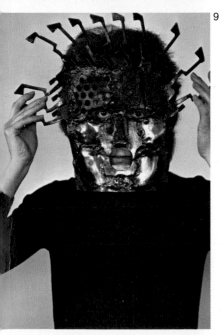

9

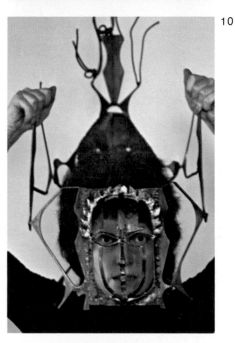

10

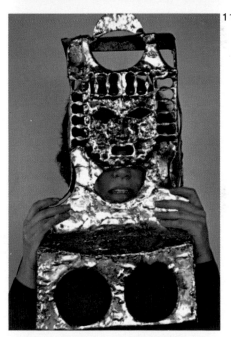

11

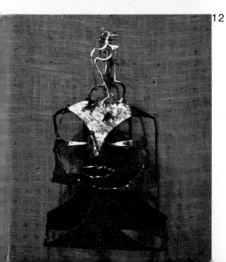

12

13

14

Other Supplies

To set up a welding studio, you will also need these supplies (figures 1-4 and 1-5):

Small pair of angle-jawed pliers.

Wire brush for removing scale from metal and spatter from your spray of spark.

Ball-peen and/or sledge hammer for molding and forming heated steel (remember that the handle is made of wood and can catch fire if kept in the range of the torch).

Chalk for marking work for cutting and revision.

Center punch for chiseling off bits of metal that have superficially adhered to your piece.

Vise-grip, spring, and C-clamps are invaluable for holding an addition to a larger work and for visually aiding you in your creative decisions.

Vise for holding metal when you are heating, bending, or polishing.

Grinding and polishing wheel for finishing and for preparing the work for brazing.

1/4-inch electric drill with pointed Carborundum or wire brush heads affords portability in polishing.

Small anvil for forming details.

Dollies for moving large pieces around (make them yourself by cutting squares of wood and putting casters on them—you might want to make them of steel so they will not be flammable).

I also own a high-speed (5,000 revolutions per minute), hand-held grinder and a flexible shaft polisher with a 6-foot shaft, which holds a 4- or 6-inch wire brush. At this point in my work these are indispensible, but I did not purchase either until I had been working for six years.

Your studio equipment is almost as important as your basic torch apparatus. It is discussed in detail in Chapter 2.

1-4.

ball-peen hammer

wire brush

anvil

grinder/polisher

sledge hammer

vise

angle-jawed pliers

file

center punch

1-5.

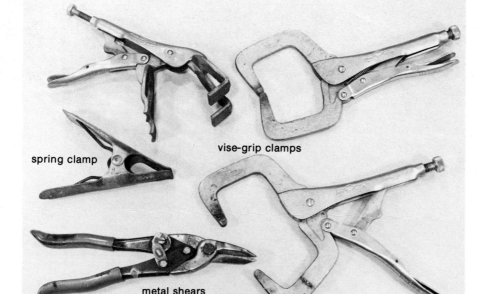

spring clamp

vise-grip clamps

metal shears

METAL SUPPLIES
Welding Rods

Order your welding rods (figures 1-6 and 1-7) from your oxyacetylene supplier. To begin, get an assortment of mild-steel welding rods. (They come with a light copper coat to prevent rust.) Rods come in diameter sizes ranging from 1/32 inch to 1/16, 3/32, 1/8, 3/16, 1/4, 3/8, and 1/2 inch; they are usually 36 inches long. The 1/8-inch size is the all-purpose rod. Start with a 10-pound assortment of various sizes and ten more 1/8-inch rods. I buy rods in 50-pound quantities and store them in an upright rack. Also buy a can of bronze welding flux and some bronze 3/32-inch rods for braze welding from the welding supplier.

1-7.

rod diameter	actual size	number of rods per pound	
		steel	bronze
3/8"	●	1	1
5/16"	●	1 1/3	—
1/4"	●	2	2
3/16"	●	3 1/2	3
5/32"	●	5	—
1/8"	●	8	7
3/32"	●	14	13
1/16"	●	31	29

1-6.

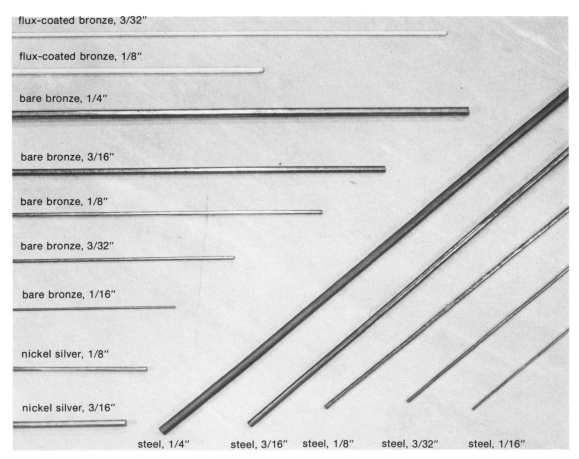

flux-coated bronze, 3/32"

flux-coated bronze, 1/8"

bare bronze, 1/4"

bare bronze, 3/16"

bare bronze, 1/8"

bare bronze, 3/32"

bare bronze, 1/16"

nickel silver, 1/8"

nickel silver, 3/16"

steel, 1/4" steel, 3/16" steel, 1/8" steel, 3/32" steel, 1/16"

Metal Stock

In order to begin, you will need some steel stock. Your local metal junkyard may be cooperative. Go down for a visit and tell them that you are learning to weld and need some steel. Some junkyards do not let individuals into the yard; you may have to hunt around a bit for a good one. Auto shops sometimes will give you steel. Metal fabricators also have skeleton steel (the steel that is left after they cut their stampings). They are a good source; this steel is often very clean. Prices vary according to the location and the generosity of the people you encounter. You can ask a local welding shop to purchase steel for you; you can also buy their scrap. Steel is the most inexpensive metal, although with inflation prices are going up. Get some strips, sheets (1/8 inch thick or less), steel plate (approx. 1/4 inch thick), stampings, angle iron, rods, and pipes (figure 1-8). Think in terms of enough steel for a few projects requiring a variety of shapes and sizes.

To find sources of supply, your most useful guides are the Yellow Pages of your telephone book and word of mouth. If you live in a remote area, use the Yellow Pages of a large city near you.

The categories to look for are Steel, Steel Fabricators, Steel Products, Metal, and Metal Stamping. Under Steel there will be a listing of special types of steel and other metals (aluminum, brass, bronze, stainless steel, and copper) that you can purchase. Some of the large companies are more cooperative than others. Many of them have done business with artists and are willing to sell small lots. They will often be very helpful in finding the specific metal and gauge you seek. When you order sheet metal, cash is usually required in advance. Sometimes deliveries can be made C.O.D.

Steel fabricators can provide helpful information. When you are ready to work on a project, they can be approached directly. Under Metal Stamping you come upon fabricators who work with sheet metal. They stamp out parts that are used for industrial and consumer products. Often these people will give you the metal or charge you a nominal fee.

The metal-service companies buy in large logs from steel mills and keep inventories for metalworkers who purchase odd lots. They are in touch with all the sources of supply and are a great help. They are accustomed to working with

1-8.

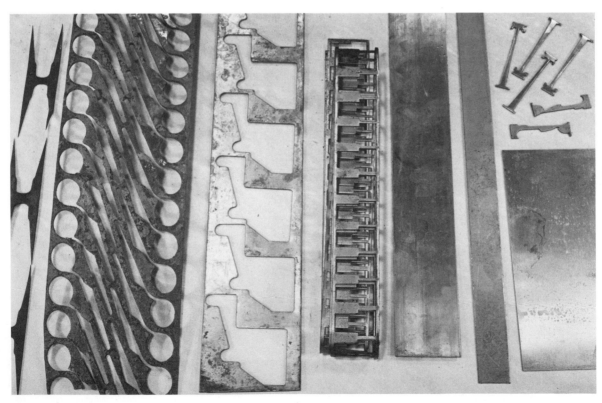

clear metal specifications. It is important to understand the metal properties and gauges of the different metals that you will work with. Give the type, size, and gauge of metal you want.

I work most often with sheet and stamped steel, which can be abundantly provided by the metal-processing yards, frequently known as scrap yards. They will be found under Scrap Metal in the Yellow Pages. It is generally best to visit these yards and speak to the people in charge about your needs and the procedure for obtaining metal. Although the price of metal is growing, the scrap yards remain a relatively reasonable source. It is also possible on occasion to obtain stainless steel, copper, brass, and bronze from the scrap yards.

A trip to a metal-processing yard can be an exciting adventure for those who are stimulated by the sight of enormous mountains of steel. Despite the fact that the metal is dumped as so much trash, it is a precious resource that we sculptors reclaim to the highest level of human expression, art.

If you are making a trip to a yard, the following equipment is advisable: hard hat, gloves, boots, a jacket to keep the dirt off your body, a handkerchief, and a magnet to test the metal to make sure it is steel (figure 1-10).

1-9. (Photo by Claudia Stephens.)

1-10. (Photo by Claudia Stephens.)

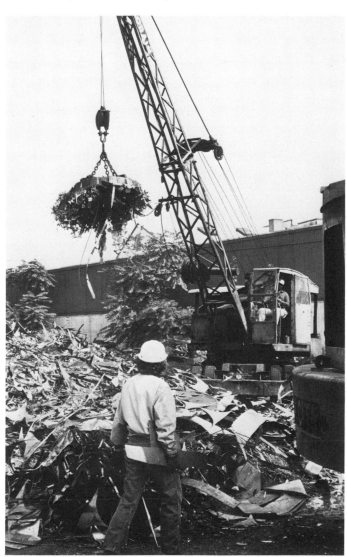

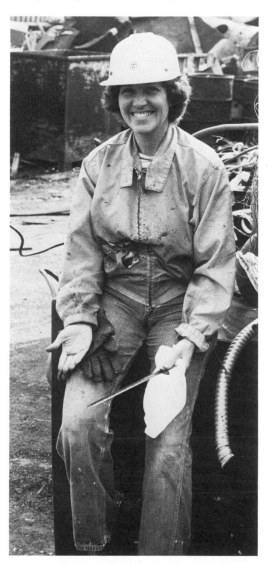

At Jacobs Brothers, the metal-processing yard I use, the procedure is as follows: go through the scrap piles, pulling out pieces of metal and placing them in piles throughout the yard. (You must always keep in mind the constant traffic and overhead cranes.) After the metal has been selected, weigh your empty car at the scale, then drive around once more into the yard and fill your vehicle (figure 1-11). If you do not wish to mess up your car by dumping steel in it, I suggest that you rent a truck for the day and obtain enough steel to last at least six months. Bear in mind the weather, because summer and winter are difficult times—the heat during the summer is unbearable, and the snow and ice in the winter freezes the metal and makes it impossible to free from the pile. When you are finished loading, weigh your car and pay for your metal. The cost is somewhat negotiable. Remember to be friendly—cooperation from the yard is your most valuable asset to maintain a continued supply. Some yards do not allow individuals in the yard, so you should inquire before treading on their space.

When you are returning home with a load of metal, you must drive slowly. Be certain that the metal is packed well so that it will not be thrown forward to damage auto upholstery, windows, or yourself during the return trip. If you have a roof rack, it is a good idea to take some rope to tie up excess metal. Bring blankets and newspapers to protect your car.

The metal-stamping companies are usually small businesses. They stamp out metal parts for machines and manufacturers. Call ahead and find out if they have scrap supplies (sometimes called skeleton metal) on hand. Trips to metal fabricators are simple, because they usually have their metal in barrels in the back. If you take some cartons along, you can simply help yourself from their stocks. Wear gloves and an old coat.

Every community has welding shops. These people make a living welding and repairing metal products. They often have scrap supplies and will give and/or sell metal at a modest price. If you wish, they can build you a good welding table. It is also possible to buy some second-hand equipment from them, such as vises or metal rolling and cutting machines.

Establish a relationship with people in the metalwork field. You can often obtain their excess supplies and equipment at a reasonable price. They are also a useful source of technical information and advice.

The metal suppliers are a source for sheet steel, bars, strip, tubes, etc. They also supply aluminum, brass, bronze, copper, stainless steel, and galvanized steel.

For my own purposes I use .064 (16-gauge) steel, which enables me to create large works that are not heavy and yet remain sturdy. Sheets come in a variety of sizes, generally 4 by 8 or 10 feet in steel and 2 by 8 feet in bronze. Cost is per pound. The distributor arranges for shipping, which you pay for, and prices vary with the economy. Among the bronzes there is Munz metal (60 percent copper and 40 percent zinc), commercial bronze (90 percent copper and 10 percent zinc), and brass (70 percent copper and 30 percent zinc). Commercial bronze is the best to use with the fuel-gas torch. It has the least zinc and causes fewer dangerous fumes.

CONNECTING THE EQUIPMENT

Before you set up any of your welding apparatus, it is absolutely necesary to be thoroughly familiar with safety precautions. These are listed in detail in the section on safety in Chapter 2.

1-11. (Photo by Claudia Stephens.)

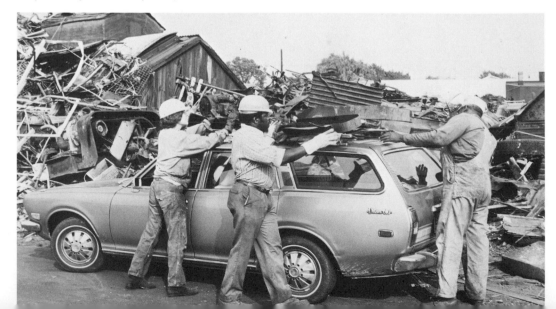

The Cylinders

Your oxygen and acetylene cylinders must be secured in an upright position so that they will not fall. You can chain them to a wall or buy a cart from your supplier. The first step in setting them up is to *crack* each cylinder valve. This means that you open each valve one quarter of a turn and then close it quickly. This frees your valve opening of any dirt or dust that could clog your torch. To open the cylinders, you turn the valve fitting counterclockwise on the oxygen tank. The T-wrench opens the acetylene valve. Both turn clockwise to close. In cracking the cylinders, keep your face and body out of the line of escaping gas. Acetylene cylinders spray liquid when cracked.

The Regulators

The oxygen and acetylene cylinders have attaching regulators, which reduce the cylinder pressure to the necessary working pressure (figure 1-12). This pressure must be varied with the pressure-regulating valve depending on thickness of metal and size of torch tip. Generally, the average working pressure for both oxygen and acetylene is 6 pounds per square inch. The regulators keep the working pressure constant. The pressure is adjusted by the regulating handle on the front of the regulator.

All acetylene connections, including the acetylene regulator, have left-hand threads. The pressure is

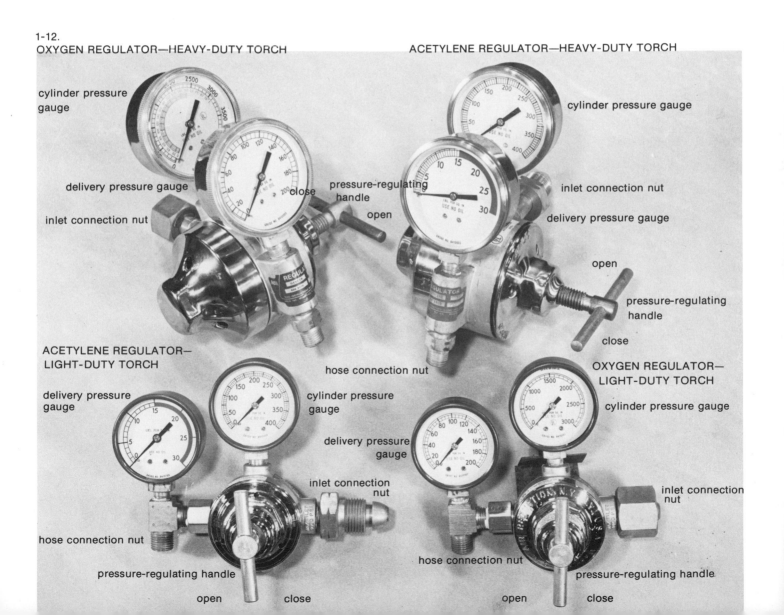

1-12.

OXYGEN REGULATOR—HEAVY-DUTY TORCH

cylinder pressure gauge

delivery pressure gauge

inlet connection nut

close

pressure-regulating handle

open

ACETYLENE REGULATOR—HEAVY-DUTY TORCH

cylinder pressure gauge

inlet connection nut

delivery pressure gauge

open

pressure-regulating handle

close

ACETYLENE REGULATOR—LIGHT-DUTY TORCH

delivery pressure gauge

cylinder pressure gauge

hose connection nut

delivery pressure gauge

inlet connection nut

hose connection nut

pressure-regulating handle

open close

OXYGEN REGULATOR—LIGHT-DUTY TORCH

cylinder pressure gauge

inlet connection nut

hose connection nut

pressure-regulating handle

open close

increased on both oxygen and acetylene regulators by turning to the right. Pressure is decreased by turning to the left, but it will not register unless the proper valve on the torch is opened to allow the excess pressure to bleed off. At no time should the acetylene regulator be adjusted beyond 15 pounds per square inch. This would create a dangerous pressure. When you are using the cutting torch, the oxygen regulator is increased to 20 to 40 pounds, depending on the thickness of the metal: the thicker the metal, the higher the pressure.

To adjust the welding pressure, open the oxygen and the acetylene valves, respectively, on the torch while you are setting the cylinder-pressure level, then close them. This will ensure accurate pressure; the dial will often raise slightly if your torch-head valves are closed.

To turn off the oxygen, then the acetylene, turn off the main cylinder, bleed your hose by opening the respective torch valves until the gas bleeds through (acetylene, then oxygen to assure a clean, nonflammable hose). Then loosen (counterclockwise) each pressure-adjusting handle in turn until it turns freely. If you continue to turn a pressure-adjusting handle, it will come off, but it easily returns to its

groove, and the regulator remains closed if this happens.

Always treat your regulators gently: never drop or throw them. Be sure to open the valves slowly. Use a wrench to tighten the regulators onto the proper cylinders. Do not work with a defective regulator: return it to the authorized service supplier. On occasion, the valve will creep beyond the point at which you have originally set it, and when you open the torch valve, it will drop over 5 pounds. This is an indication to have your regulator repaired.

To connect the oxygen regulator, make sure your pressure-regulator handle is turned to the left (counterclockwise) and turns loosely (figure 1-13a). Then attach the opening nut to the threaded opening of the cylinder valve and tighten it with the wrench provided with your equipment (figure 1-13b). This loose condition of the handle indicates that there is no pressure flowing through. At this point, when you turn the valve on top of the cylinder on (figure 1-13c), oxygen will register flow only into the cylinder-pressure gauge that indicates the amount of gas in the tank. When you adjust the pressure-regulating valve, the fuel gas will flow into your hose, which you will connect to your oxygen regulator (figure 1-13d).

1-13.

a.

b.

c.

d.

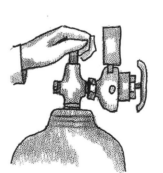
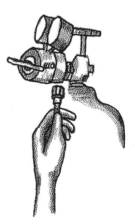

As this is the first time you are connecting your equipment, I am assuming that it is new. Therefore, it is important to blow out your hose, which may have talc or dust inside it. Attach the green hose, which indicates oxygen, to your oxygen regulator, which most manufacturers also color-code green. The hose-connection nut fits on the threaded regulator connection, which juts out of the cylinder. Your pressure handle at this point is turned to the left and is loose. Open your oxygen cylinder valve until it is on (one quarter of a turn), allowing your cylinder-pressure-gauge indicator (the left gauge) to move up and come to a stop. This gauge indicates the amount of gas you have in your tank. Turn your pressure handle to the right until a pressure of 5 to 10 pounds is reached. Then turn your oxygen off by turning the regulator pressure-adjusting handle to the left (counterclockwise). You have now blown out your hose and it is clean.

Now you are ready to connect your acetylene cylinder. When you turn on any of your oxyacetylene equipment, always be sure that there are no open flames or live sparks nearby. Every fitting for acetylene equipment has left-hand threads and must be turned to the left to tighten. Fasten your regulator to the tank tightly with the T-wrench. Turn the pressure-adjusting handle on the regulator to the left until it is loose. Open your cylinder valve with the T-wrench, slighly at first, then one to one and one-half turns to the left (figure 1-14a).

Remember, you turn on both the oxygen and the acetylene cylinders and pressure-regulator handles to the right. All of the connecting adjustments on the acetylene cylinder are counterclockwise to open, clockwise to close (figure 1-14b). Keep your T-wrench in place so that you can shut off your acetylene instantly if necessary.

If your acetylene hose is new, it must also be blown out. It is *not* blown out with acetylene, however, but with oxygen. Since these fittings don't screw in place, hold the end of your hose against the oxygen-tank opening, turn the oxygen pressure to 5 pounds per square inch, and after a few seconds close the regulator. You *must* blow vigorously with your mouth into the end of the hose afterwards to remove the oxygen from the hose, because you cannot have oxygen mixing with acetylene in a single hose.

Now you are ready to connect your acetylene hose to the acetylene regulator. Once more, your fitting is left-handed and is turned counterclockwise to tighten.

1-14.

a.

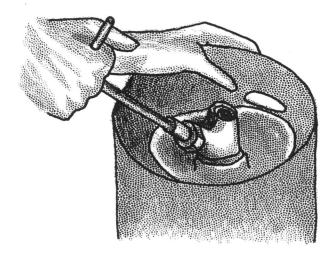

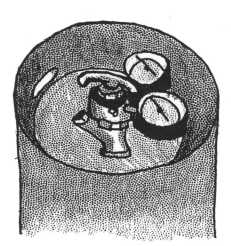

b.

The Torch

The two end connections on your torch (figure 1-15), which are stamped *oxygen* and *acetylene*, are for attaching the hoses (figure 1-16a). The green hose fits the oxygen fitting (right-hand thread); the red hose, the acetylene fitting (left-hand thread). A small, open-end wrench will make your fittings airtight.

Now you are ready to attach the welding tip (figure 1-16b). Welding tips vary in size and have different numbers depending on the kind of equipment that you buy. Begin with a medium to small tip. The torch end has a nut, which you remove. Push the tip in with a twisting motion until you feel it sitting in the connection. Then fit the nut over the top and screw it in place. (Do not use the wrench to tighten this nut.) The best position for your tip is facing downward with your oxygen and acetylene torch valves facing upwards, the oxygen hose on the right and the acetylene hose on the left. Some people prefer to work with the torch valve facing in the same downward direction as the tip, but I think having the valves up provides greater control.

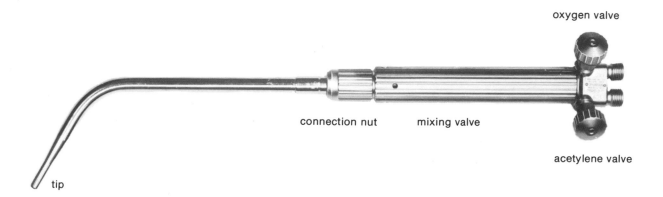

oxygen valve

connection nut mixing valve

acetylene valve

tip

1-15. (Photo courtesy Union Carbide, Linde Division.)

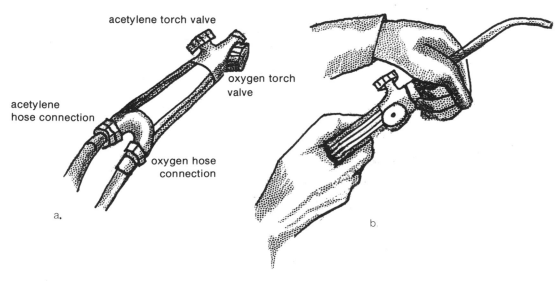

acetylene torch valve

oxygen torch valve

acetylene hose connection

oxygen hose connection

a.

b.

1-16.

28

Testing the Connections

Now you are ready to test all your connections for possible leaks (figures 1-17a, b, and c). With the torch valves closed, set your oxygen pressure gauge at 50 pounds per square inch and your acetylene pressure gauge to 10 pounds per square inch. Brush all your connections with a thick solution of Ivory soap and water. If bubbles appear at any connection, you have a leak. Tighten that connection. If this doesn't stop the leak, close the leaking cylinder valve; open the torch valve, which will remove all pressure from the line; and release your regulator pressure-adjust handle by turning it counterclockwise. Open the leaking connection and wipe the metal seating surfaces with a dry,

clean cloth. Check for nicks and scratches. Then reconnect, tighten, and turn on your cylinder valve; turn your pressure-regulating handle to the proper pressure; and test again.

Make sure that all your connections are leak-free before you light your torch. Your hoses should be tested periodically with the pressure on by immersing them in a bucket of water (figure 1-17d). Pass the entire hose through the water to check for air bubbles. Leaks can be repaired by cutting out the damaged sections and rejoining them with a hose splice. Send the hose to your supplier for repair.

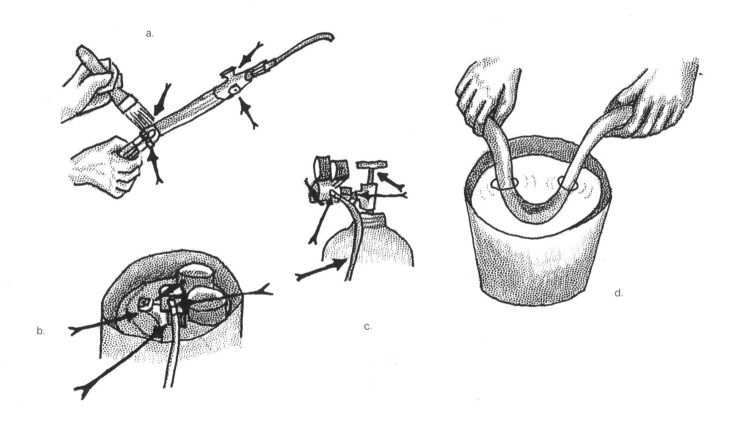

a.

b.

c.

d.

1-17.

The Cutting Torch

The difference between setting up for cutting and setting up for welding is that you use a special cutting head. The cutting attachment fits into the torch handle and is tightened with the connection nut that goes with this attachment (figure 1-18).

To remove your welding tip, loosen the connection nut and twist the tip out of the connection. Keep the connection nut and the tip in a specific place. Connect your cutting attachment by sitting and twisting it into the handle of the torch. The instruction brochure that comes with your torch will indicate the pressure per square inch that your regulator gauges must be adjusted to for cutting. Generally, the acetylene gauge is set at 5 to 8 pounds per square inch; the oxygen gauge, at 20 pounds per square inch for thin metal and 30 to 45 pounds per square inch for thicker metal. Read all instruction books that come with your equipment carefully for efficient and safe use.

You now know the basic construction of your welding equipment and how to set it up. Every time you weld, you will repeat all of these procedures, except for connecting the hoses to the tanks and blowing the talc out of the new hoses.

1-18.

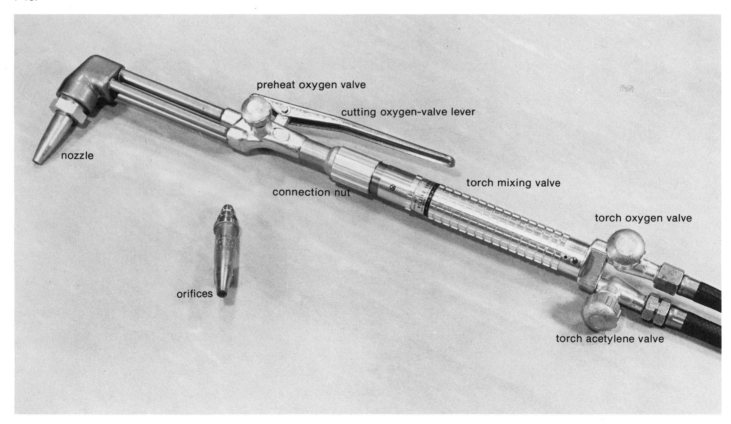

Chapter 2.
The Studio

The studio is a place where the artist rests, replenishes, and thrives. It is an exercise room—exercise of the spirit and, for the sculptor, the body as well. It is precisely your interest in and your unique approach to space that brings you to sculpture. Your sense of space will determine the look, character, and individuality of your studio. In addition to being an artist, you are an artisan. The studio is the place where your tools and working space are easily accessible. It can be simple or elaborate, depending on your means and needs. My first welding studio was the outdoors, with a small lean-to for storing tools. Some people work in a carport or basement. As welding sculpture becomes more and more a part of your life, you will establish a truly professional studio. This chapter discusses the elements of such a studio.

SPATIAL REQUIREMENTS
Location

Choosing a location for your studio is, of course, a major decision. Decide whether your studio will be part of your home or a separate space. Even if you can afford a separate studio, distance from your home and your geographical location will limit the possibilities further. If you live in a city, you will have greater access to galleries and other artists, but you may be able to afford more space in a rural area. Naturally, space in a business district will vary in cost according to the section of the city or town. Collectors are often very interested in visiting the artist's studio, and if you can arrange a separate area for sales, you will be at a definite advantage. However, you can also use your home as a showcase for your work. If you are interested in selling your work directly from your studio, you might want a location in the vicinity of stores, theaters, and antique shops, which would attract an art-buying public. If this is the case, consider exactly how much traffic you are willing to deal with. Many sculptors prefer to have a studio that is accessible by invitation only. This is a personal decision: do you work best in isolation or among people?

Studios are not prohibited in most areas. In commercial areas, however, it is often illegal to live in a studio. An artist's studio is generally an allowable adjunct to a home in residential areas.

If you are leasing a studio and plan to make improvements in the space, be sure to protect yourself with a relatively long lease, say five years, with the option to renew it. Whether you are renting or buying, be sure that the building itself is in good repair, meaning that there are no major leaks, ventilation is good, and windows, doors, and ceilings are sturdy and function properly. Remember that you should not overload your plumbing facilities by dumping metal residue down the sewage line, especially if you have a septic system. Make sure that your water supply is dependable and that your sewage disposal will not cause a problem.

Working Space

It is just as important to have adequate and comfortable working space. Your studio should be situated on a ground floor for easy access. Your floor should be fireproof (dirt, concrete block, quarry tile). Concrete is inexpensive and the most level. If you choose a city site, you may have to settle for a basement studio, unless you can fireproof the floor. If you must settle for a basement space, you will have to arrange for a sloping entry so that your materials can be moved in and out easily.

While welding is a somewhat noisy occupation, the sounds, such as the hissing of the flame and the rushing of the fan, tend to be steady. Grinding and polishing are the noisiest aspects of welding metal sculpture. You must be certain that the noise will not annoy your neighbors, and you should consider whether noises in your environment might interfere with your own comfort.

Recognize that whatever space you choose, there will be an additional cost for your electricity, heat, and lighting. Make sure there is adequate electricity for your finishing equipment. If you have an arc welder, you need a 220-volt line just for that.

It is desirable to have a high ceiling—10 to 12 feet would be adequate. My major studio space is only 7 1/2 feet high, but when I wish to create a larger piece, I have access to a slated outdoor area and a blacktop carport, which are both in direct proximity to my studio.

Excessive space can be almost as great a handicap as cramped quarters. A large space can dwarf your pieces and overwhelm you. Choose a size in which you are physically most comfortable. Spend some time observing your body movements and your life/work patterns. If you have a superlarge studio, partition it off to give yourself a more intimate and workable space. My studio is on sloping land and lies below ground level. Although I miss the sunset, it is a sheltering environment in which I feel very comfortable.

If you select a preexisting space, you are at an advantage, because you can clearly imagine and preplan working in this environment. If you want to add a studio onto your house, as I did, you can construct a space that will be a compromise between the possibilities of adding to your home and the basic requirements for a good studio. It is convenient to have some plumbing facility: there will be times when you need to wash a piece and cool your metal. If you don't have access to water, you can use a drum or large pail.

It is a good idea to make a scale drawing of the layout of your space with cardboard templates reflecting the relative size of your equipment. Graph paper is suitable for this. Let each square represent a foot, mark off your window and door areas, and move the templates around the space to determine the best arrangement of supplies, large studio fixtures (table, torches, grinder), welding areas, finishing space, storage space, and viewing distance. You will need good ventilation for painting your sculpture, and your welding area requires an exhaust fan to remove noxious fumes from the air. Some artists are much more fastidious and orderly than others. Decide what kind of environment you are most comfortable with.

Be sure that your heating system is adequate. It is especially important to allow for a source of fresh air to enter your studio. You need a good exhaust fan to pull in fresh air and draw out fumed air (figure 2-1). The burning torch also consumes oxygen in the air. Your supplier has exhaust equipment especially designed for welding, which is more efficient but also more expensive.

If you can afford it, you might consider air conditioning. I personally dislike the noise of air conditioning, even though welding makes its own noises. A ground-floor studio tends to be cooler than most other places, since hot air rises.

It is very pleasant to have good natural lighting. It is helpful for viewing your piece in progress. If you have a courtyard or outdoor area, you can observe the piece at different times of the day and watch the lighting effect upon the sculpture.

If your overall indoor lighting is not adequate, consider installing 4-foot or 8-foot fluorescent bulbs. They are the cheapest and give the greatest illumination. I find *warm white* to be the most pleasant color over a long period of time. For individual areas, you can install clip-on floodlights. Make sure that they are for indoor use; outdoor floodlights do not give off as much light, and they are hot to work under. Portable floodlights are also good for experimenting with lighting your piece in different ways in preparation for exhibition and for photographing your work.

Another essential requirement for your studio is accessibility for delivery of your supplies (figure 2-2). Are the doors wide enough for large pieces of sculpture to be moved in and out? Is it easy for you to unload supplies from an automobile or truck? Can your supplier deliver without any problems? My own driveway is not accessible during some of the heavy winter storms. I allow for this by ordering extra gas to tide me over bad weather. Another important consideration is whether the welding supplier will deliver to your studio. You might have to pick up your own gas if you are not on one of their delivery routes.

You should also take into account your proximity to potential buyers or collectors and to other artists. If you work in an urban area, you will have readier access to them, but many people love to leave the city and will make a visit to view an artist's work. The special trip often means a sale.

Think about whether you want a telephone in your studio. It can be very distracting to your work. If you will answer it while you are working, put it in.

2-2. (Photo by Claudia Stephens.)

2-1.

STUDIO EQUIPMENT
Storage Facilities

Your oxyacetylene tanks must be fastened firmly to prevent any danger of falling. Chain them against the wall or on a hand truck, which you can purchase from your supplier. I have an outdoor closet in which the tanks are kept (figure 2-3). The hoses come into the studio through a small door. This Is very handy for my supplier and keeps the tanks out of the way of the welding area. However, I must go outside to change the tanks, which is cold in the winter.

It is important to keep the hose off the floor and away from the welding vicinity, since flying sparks and hot metal can burn through it (figure 2-4). A simple arrangement for coiling your hose when not in use can be devised by welding a heavy piece of rod to a nail head and hammering it into the wall or, if you brace the hose against a door, by putting a bolt through the door. Use a large hook so that you can store the torch hose. A lawn-hose roller is another storing possibility. Check your hose periodically for holes and general wear. If flames shoot from your hose, turn off your equipment immediately. Your supplier can cut out the damaged portion and splice the hose together again with couplings. Do not store your torch end on the tank itself. Leaking gas and a spark in the vicinity could light your torch and endanger the safety of your cylinder.

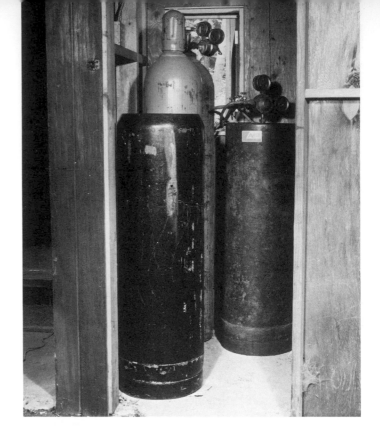

2-3.

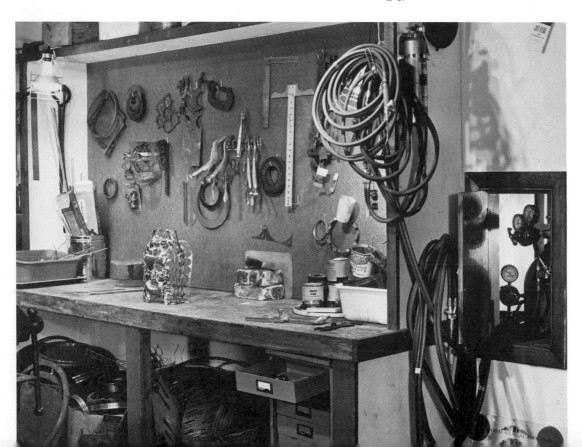

2-4.

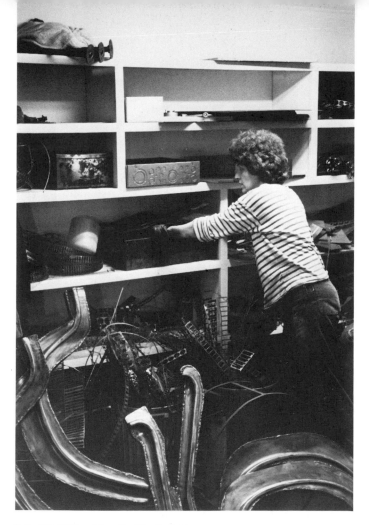

It is a good idea to keep your tank-changing wrench and adjusting wrenches in the vicinity of your tank. The simplest place to keep them is on a shelf or in a small bag hung nearby (figure 2-5).

Sturdy shelves are good for storing relatively small pieces of metal. Bins and cans set on casters can accommodate other sizes (figure 2-6). Wall hooks allow you to hang odd shapes. Metal strips can also be arranged against the wall by hammering in long nails or brackets at a slight angle to prevent the metal from falling. A pegboard is useful for keeping small tools in ready view. I save a variety of containers for particular forms, shapes, and kinds of metal. It is wise to label the different containers as to metal content.

Since it is advisable to reserve much of your studio space for completed works, you may want to have a metal storage area outside your house. To keep the metal from rusting, put under protective cover such as a tarpaulin, or better, in a closed shed. You should also consider where you will be storing your completed works. If you are prolific—and why not be prolific—you will require storage space for your pieces that you do not wish to display in your home and that are temporarily not on exhibition. I have a crawl space about 5 feet high where I can store work. Much to my surprise, collectors enjoy ferreting out pieces from this undesirable enviornment. They consider it a privilege to be allowed into this inner sanctum. The contrast of this dank environment to a more sophisticated showcase environment seems to appeal to many people. Do not avoid a likely space due to its lack of aesthetic appeal.

2-5. (Photo by Claudia Stephens.)

2-6.

2-10.

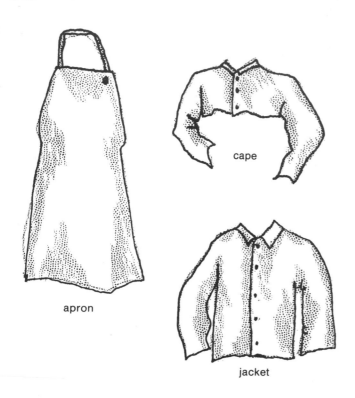

apron

cape

jacket

Clothing

It is essential to wear protective, flameproof clothing. To flameproof a welding jacket and/or overalls, dip it first into a solution of 12 ounces of sodium stannate to 1 gallon of water, wring it out, then dip it into a solution of 4 ounces of ammonium sulfate to 1 gallon of water, wring out, and dry. A treated garment should not be washed in water, but it will last through five dry cleanings.

Wear clothing that covers your body completely and make sure that it is free from oil or grease. Do not wear pants with cuffs or rolled-up sleeves—sparks may catch in them. Remove all pockets as well. High boots are recommended.

If you get close to your work, leather clothing (figure 2-10) is suggested. Wear fire-resistant gauntlet gloves to protect your hands and wrists (figure 2-11, left): suede ones are best. Avoid asbestos. Gloves with cotton gauntlets will catch fire. A railroad cap (figure 2-11, right) worn with the peak facing your back will protect your hair and keep sparks from coming down your neck. Finally, wear goggles or a welding mask and a clear shield when you are grinding or polishing. You can also wear a mask to prevent breathing dust or noxious fumes (figure 2-12).

2-11.

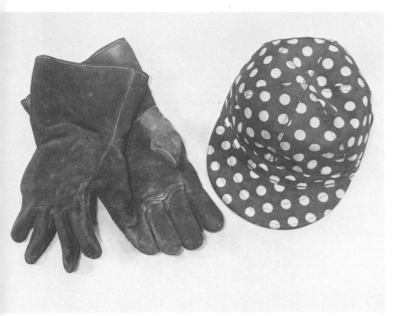

2-12.

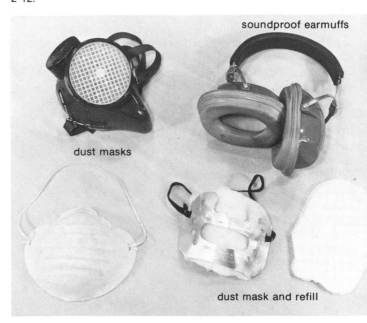

soundproof earmuffs

dust masks

dust mask and refill

SAFETY PRACTICES

Although I have included safety precautions throughout this book wherever they were relevant, it is worthwhile to repeat them here in one place for easy reference. Safety is an important element in metal sculpture, either with oxy-acetylene or with the arc welder: you are dealing with intense heat and flying spark and slag. Danger should not keep us from functioning, but we should understand the necessary precautions and carefully heed them so that we can proceed safely. Do not be careless with your equipment. It is not to be thrown about. Do not use any equipment unless you understand the instructions. Carefully read all instructions that come with your equipment. Safety precautions are listed below under the specific pieces of equipment.

Cylinders

1. Always keep your cylinders upright.
2. Store cylinders away from combustible materials and from other cutting or welding work. Do not store near sources of heat, such as furnaces, or live electric wiring.
3. Never use your tanks as a storage space for tools or allow recessed tops to become filled with water.
4. Make sure that you use the proper cylinders for your equipment. The oxygen tank is usually green, the regulator is marked in green, and it flows through the green hose of your torch. The acetylene tank is black and labeled, the regulator is marked in red, and it flows through the red hose of your torch.
5. Do not use pipe-fitting compounds or thread lubricants to make a connection.
6. Never use a leaking cylinder. Close the valve, tighten the packing nut, and take it outdoors away from any source of ignition. Notify your supplier immediately. If a small leak ignites, put it out with sand, a wet cloth, or a loose glove; spray water continuously on a larger flame.
7. If your tank-valve outlets are frozen, thaw with warm, not boiling, water.
8. Return empty cylinders promptly.
9. Make sure that your T-wrench is always connected to the acetylene tank so that you can turn if off quickly.
10. Never adjust the acetylene regulator over 15 pounds per square inch (6 pounds per square inch is almost always sufficient). Never open the cylinder valve more than one and a half turns.
11. Never release acetylene where it could cause a fire or an explosion, such as in a confined space.
12. Never use oxygen for compressed air or to blow out pipelines (except for blowing hose in new equipment), because it is flammable.
13. Never use oil or grease on your oxygen equipment: they will burn violently.

14. Never allow the flame to come in contact with any part of a cylinder.

Torch

1. Open each valve separately, allowing pure gas to remove any gas mixture in the torch.
2. Keep tip pointed away from yourself and other people.
3. Use a friction lighter or pilot light to ignite your torch—never use matches.
4. Release the pressure in your regulators if you are stopping work for an hour or longer.
5. When tips or nozzles are clogged, use tip cleaners one size smaller than the orifice. Insert into orifice and push straight in and out.
6. If the valve does not shut off completely, clean the seat with a clean rag. If the passages become clogged, blow them clear with your breath.
7. Never repair your hose with tape: it should be spliced and joined with a hose connection by your supplier.
8. In case of a backfire, investigate the cause, correct it, clean your tip, and relight your torch. Backfires are caused by touching the flame tip against the work, overheating the tip by operating the torch at other than proper gas pressures, or by dirt on the seat.
9. If you have a flashback, you will hear a shrill hissing or squealing, which indicates that something is radically wrong. Close the oxygen valve, then close the acetylene valve. Allow the torch to cool before relighting. Blow oxygen through the torch to remove any soot. For the cutting torch, blow oxygen through the preheat valve and cutting orifices.

Working Conditions

1. Be sure you have adequate ventilation at all times, especially when welding brass, bronze, or galvanized iron. Do not weld lead, cadmium, beryllium, or mercury without a suitable airline mask. Avoid dusty or gassy locations.
2. When you are welding a container, be sure it has no flammable or poisonous residue. Even after complete cleansing, a sound safeguard is to fill the container with water before you weld, cut, or heat. Drill a vent to provide release of heated air from inside the container: any confined air, gas, or liquid expands when heated and can cause an explosion.
3. Avoid working in a confined space.
4. When flame cutting, protect your legs, feet, cylinder, and torch hose. A sheet-metal screen will provide protection. Do not drop the ends of your welding rods on the floor: you can slip and fall, and the hot ends are a fire hazard.
5. Be sure your working space is fireproofed. Wall board is fire-resistant, and a concrete floor is safe for welding.

Exposed wooden posts should be covered. Do not leave rags, paper, or cardboard lying about. Heat-shield walls with asbestos or Transite where necessary.

6. If you must weld on a wooden floor, sweep it and wet it down before working.

7. Always keep at least a 2-pound fire extinguisher and pails of water and sand in easy reach.

8. If you are working outdoors, be sure to work in a safe area and avoid setting fire to brush or grass. Autumn leaves must be swept away from the site.

9. When you move metal, be sure you have a sturdy grip and wear protective shoes and gloves.

10. When you are grinding and polishing, wear soundproof earmuffs.

11. Keep ointment on hand in case of burns. Cold water is the best first treatment. Honey or burn ointment can then be applied.

12. Remember that your sphere of vision is limited by the mask. Remain aware of your surrounding environment. Keep your work space relatively empty so that you can move about without stumbling over metal. If you have metal on the floor when you are in the midst of construction, keep your feet flat on the ground and shuffle on the floor when you need to move so that you will not fall over anything or lose your balance. Listen carefully for the sound of fire or falling metal.

Arc Welding

The welding arc emits radiation, which can damage your eyes and burn your skin. The intense arc can penetrate lightweight clothing, and it is reflected from light surfaces.

1. Wear long-sleeve, fire-resistant clothing, including a flameproof apron. Wear a proper arc-welding helmet. It has a dark filter, so make sure you are work-ready before you put it on.

2. Shield the area in which arc welding will take place and provide face shields for anyone who will be looking at the welding.

3. Keep an adequate vent system.

4. Never strike an arc on a cylinder or any pressurized vessel.

5. Do not stand, sit, or in any way touch a wet surface when arc welding and keep body and clothing dry to prevent shock.

6. Be sure equipment is properly grounded and your electrode holder is fully insulated.

7. Inspect cables for wear and keep them dry, free of oil and grease, and protected from falling slag.

8. Always disconnect equipment when not in use.

Moving Sculpture

1. Use a dolly and extra hands if needed. Work in progress can be rolled on the floor, leaned against the table, and lifted from one side.

2. Consider the weight of your pieces before displaying: most floors and walls can handle 100 pounds per square inch.

3. Be sure that your bases are sturdy, that your pieces will not easily fall or topple, and that there are no sharp projectiles that people could walk into. Heat pointed edges to round them.

4. Be sure that your sculpture is carefully constructed so that it will not fall apart.

Paying attention to potential hazards heightens your sense of the importance of your work. Careful work habits will be reflected in your creative expression.

Chapter 3.

Welding and Cutting

In the beginning you are involved with the mechanics of welded sculpture. After you understand the principles and have practiced them, you can begin to think in terms of your creativity with the medium. At first the drama of the welding, the miracle of joining metal together by fusing, will motivate you to practice until you acquire some skill. I was amazed that I could even fill space with my first creations. It wasn't too long, however, before I began to demand sculptural excellence from myself as well. The miracle of sculpture is that you create a tangible object, not the illusion of one. The reality of presence demands craftsmanship. There is nothing that deters more from an artist's creation than flimsy workmanship.

LIGHTING THE TORCH

After you have set up your equipment and checked it for leaks (see Chapter 1), you are ready to light your torch. Adjust the acetylene and oxygen pressure handles (figures 3-1a and b, respectively) to 6 pounds per square inch, or follow the guidelines for welding and cutting in figure 3-2. Position yourself comfortably in front of your table. Get the feel of your torch by resting your thumb along the centerline between the two torch valves and wrapping your fingers around the hoses where they connect to the torch. Since you will be welding for a relatively long period of time, always hold the torch at a balance point. I hold my torch at the point where the hose joins the body (figure 3-3). Practice opening your valves about 1/4 inch and closing them again, then squeeze the sides of your friction lighter to create the sparks. Light your torch by opening the acetylene valve a crack (figure 3-4), placing it close to the spark head of the friction lighter, and making a spark to catch the flame (figure 3-5).

Figure 3-6 shows the different kinds of flames. The first flame, which is long, yellow, and smoky, is called the *acetylene flame*. It consists of three parts: the *inner cone*, which is the small, white cone closest to the torch tip; the surrounding, feathery *intermediate cone*, also called the *excess acetylene feather*; and the outer *enveloping flame*, which is slightly luminous and bluish in color. If your flame is very small, increase it by slowly adding more acetylene, then oxygen. Depending on how much oxygen you add, you can change the quality of the flame.

3-1.

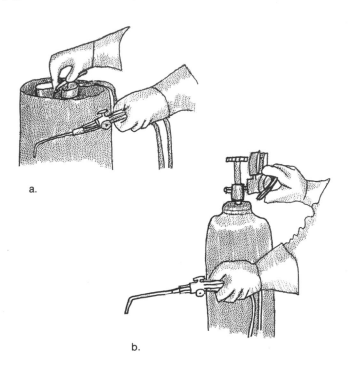

a.

b.

3-2.

WELDING

steel thickness	gas pressures (psi)	
	oxygen	acetylene
to 25 ga.	5-7	5-7
25 ga. to 1/32″	5-7	5-7
1/32″ to 1/16″	5-7	5-7
1/16″ to 3/32″	5-7	5-7
1/8″ to 3/16″	5-7	5-7
1/4″ to 3/8″	5-7	5-7
1/2″ to 5/8″	6-8	6-8
3/4″	6-8	6-8
1″	6-8	6-8

CUTTING

steel thickness	gas pressures (psi)	
	oxygen	acetylene
1/16″ to 1/8″	30-40	5
1/8″ to 1/4″	15-30	5
3/8″ to 1/2″	21-38	5
5/8″	41-48	6
3/4″ to 1″	25-41	6-7
1 1/2″	30-38	7
2″ to 3″	41-58	8
4″	52-60	8
5″ to 6″	55-66	10-11

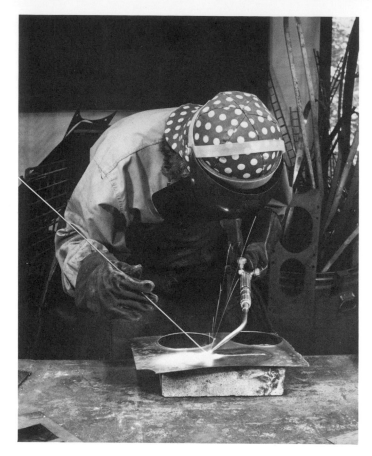

3-3.

3-4.

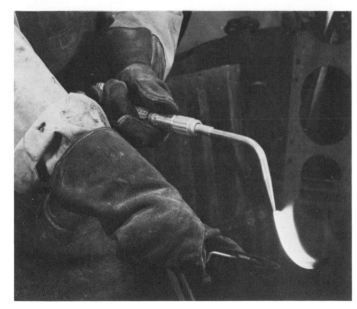

3-5.

3-6.

(reducing or carburizing) flame enveloping flame

inner cone

intermediate cone (excess acetylene feather)

neutral flame

inner cone (no acetylene feather)

oxidizing flame

short, sharp inner cone (no acetylene feather)

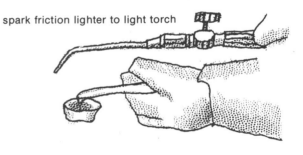

spark friction lighter to light torch

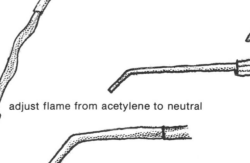

adjust flame from acetylene to neutral

The *neutral flame* is used to weld steel. To obtain this flame, begin with an excess acetylene flame, also called a *reducing* or *carburizing flame*, and either close your acetylene valve slightly or raise your oxygen content until the feather disappears (figure 3-7). The tip or inner cone of the resultant neutral flame is soft.

The *oxidizing flame* is a tight flame used in brazing. To obtain this flame, increase the ratio of oxygen to acetylene by closing your acetylene valve or opening your oxygen valve still further (figure 3-8). It is characterized by a shorter, sharper inner cone. Do not use this flame to weld: it will burn your metal.

The trick to lighting your torch is to admit just the right amount of gas for the proper flame. If your acetylene valve is open too much, the force of the gas will blow the flame away from the end of the tip. Cure this by closing this valve until the flame comes back to the tip's orifice. If the acetylene volume is too low, the flame will smoke. Fix this by increasing the acetylene flow until the smoking stops. The length of the acetylene flame decreases as more oxygen is added. The torch flame can be controlled by reducing or adding either acetylene or oxygen. Experiment with your flame by adjusting both valves.

A good test for proper neutral-flame adjustment is to briefly immerse the flame tip into 2 inches of water. The flame should burn under the water. If you are not supplying enough oxygen, you will have flames on the surface of the water. Increase your oxygen until this burning stops.

To turn off your torch, always turn off the acetylene valve first. Oxygen continues to flow through the orifice and assures a clean torch. Then close your oxygen valve.

If you are only shutting off your equipment for 10 minutes or less, merely close your tank valves by turning to the right (figure 3-9a). The oxygen valve is on top of the cylinder and can be grasped by a full palm. The acetylene valve is turned off with the T-wrench. Release the acetylene and oxygen, respectively, from each hose by opening them one at a time until each has been bled (figure 3-9b). Make sure that each gas has stopped flowing from the hose before you close the valve. Be sure to bleed the acetylene hose first, then the oxygen. The pressure regulator will indicate when the hose is empty. When you shut down your torch for periods longer than 10 minutes, it is essential to release the regulator pressure handles after you have turned off the tank valves and bleed your hoses. Do this by turning the handles to the left until the turning pressure no longer exists.

3-7.

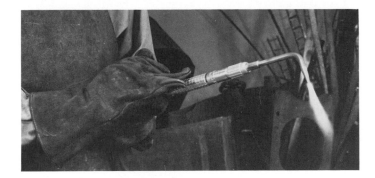

3-8.

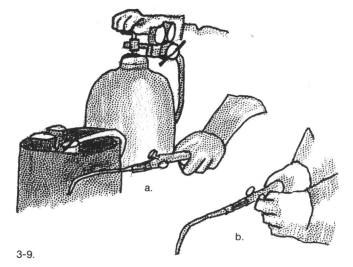

a.

b.

3-9.

OXYACETYLENE WELDING

Oxyacetylene welding is the most versatile technique, the easiest to obtain equipment for, and the most economical and familiar. It includes both fusion welding and braze welding. *Fusion welding* is the joining of two pieces of steel that actually melt and flow together, fusing when the metal cools. In hardening, the metals chemically become one piece. A welding rod is generally used to fill in and build up the welding seam. It is sometimes possible to join sheet steel without a rod.

A good joint is a thorough mixture of the base metal and the rod. Further, the best weld will penetrate through to the other side. It is best to use a rod whose composition is similar to the base metal. The oxyacetylene flame can reach as high as 6,300 degrees Fahrenheit. This heat melts both the edges of the metal and the filler rod.

Braze welding, which is also discussed in this chapter, is used to join dissimilar metals, such as steel and copper. It is possible to braze steel to cast iron; nickel to copper; brass to wrought iron. For similar metals, it is efficient to braze cast iron to cast iron; stainless steel to stainless steel. Brazing is done with a bronze rod and flux, and it leaves a yellowish bronze color in contrast to the base metal. Brazing can also join steel to steel and is used for steel plate (3/16 inches and up), since it does not require as high a temperature as fusion welding. There is also less warping.

Fusion Welding

You are now ready to begin fusion welding sheet steel. Sheet steel is steel 1/8 inch thick or less. This metal heats readily and is good for learning your first welds. Place two strips of sheet steel flat on your table, aligning the two ends. Turn on your gas and light your torch as described above. Be sure your mask or goggles are in position. If you are right-handed, slant your tip about 45 degrees to your right, since you will be welding from right to left; if you are left-handed, 45 degrees to the left, since you will be welding from left to right.

On one of the two sheets of metal, practice heating the metal, moving your torch in a straight line. Heat the metal to cherry red and watch the changes that occur in the metal while you wait for it to become soft and wet. As you hold your torch on the metal, make small, circular motions covering a 1/4-inch circular area, moving your circle along as you move along the line of the metal. You will note that the metal will melt and produce a series of welded puddles, which becomes a welding bead (figure 3-11). Make a few holes by keeping the torch flame in one place (figure 3-12). Watch the changes in the metal just before the hole appears.

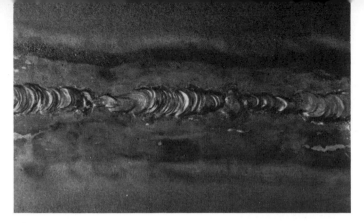

3-10. Irregular weld. (Photo courtesy Union Carbide, Linde Division.)

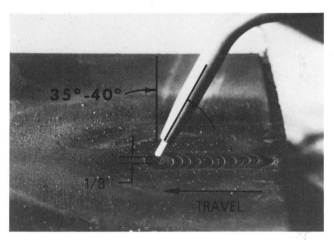

3-11. String bead. (Close-up photos of welds courtesy Hobart Brothers Company.)

3-12. (Photo courtesy Union Carbide, Linde Division.)

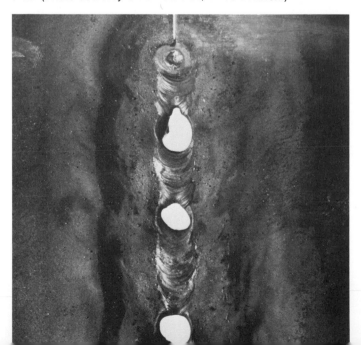

After you have done two or three heat lines, take a 3/32-inch steel welding rod. The rod fits in your hand along an imaginary line from the tip of your third finger across the space between your index finger and thumb. Your thumb holds the rod in place along the outer edge of your knuckle. The rod is held at a 35- to 40-degree angle to your metal. Another position for holding the rod is to have it slide against your index finger, folded over, with your middle finger holding it and your thumb pressing the rod against your middle finger and against the top of your index finger, as in holding a pencil. As your rod is used, you slide up the rod by loosening your hand and letting the rod drop slightly.

To deposit a *stringer bead* with the filler rod (figure 3-13), heat a circle of metal the size of a dime, as before. At the point when the metal is cherry red and begins to soften in the circle, dip the filler rod into the center of the welded puddle. A droplet will fall off at that instant. Raise your filler rod slightly and move on to your next circle on the metal. When that circle is cherry red, dip the rod once more. Travel along the line to create a stringer bead (figure 3-14).

You may notice that when heating, your sheet metal has a tendency to warp: the thinner the metal, the greater the chance of warpage. At this point, it might be wise to practice heating a sheet of metal in different places and watch the rise and fall of the entire sheet as you heat. Metal expands when it is heated and contracts when it is cooled. By playing with the process, you will become familiar with the pattern.

Straightening can be done with your torch. You can straighten warps by hammering and/or by heating the opposite side of the warp. The fact that metal becomes soft and moves easily when it is heated makes possible one of the most creative elements in welded sculpture, *bending*. Metal bends most easily in the direction in which you place the torch to heat it. It is possible to heat the metal and bend and twist it without any difficulty whatsoever.

To make a *butt joint* (figure 3-15), take two sheets of steel of the same thickness about 6 inches long and lay them end to end. If the sheet that you applied your stringer bead to is warped, use another piece of metal or straighten by hammering (figure 3-16). Whenever you join two pieces of metal together, always tack the ends first (figure 3-17). To do this, heat two ends of your sheet steel with your torch, using the circular motion described above. The aim is to have both sides become cherry red at the same time. At that point drop in your rod; the droplet will flow into the metal and join the two ends together. Do the same on the other end of your 6-inch span and for the center.

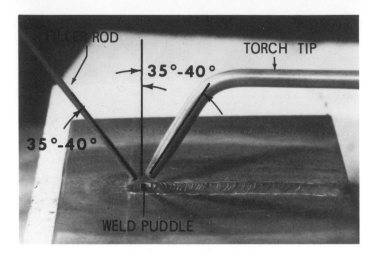

3-13.

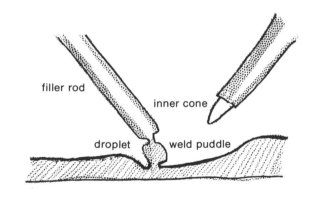

3-14. Filler-rod motion.

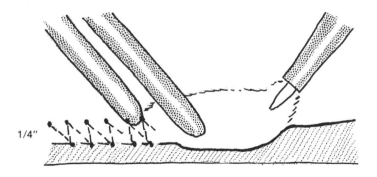

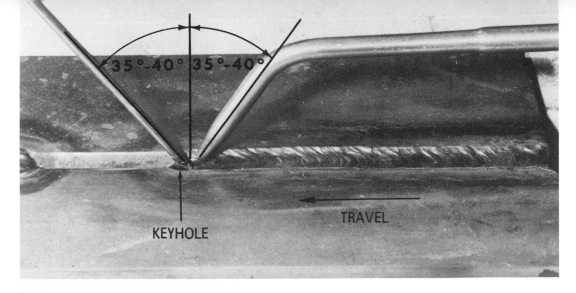

35°-40° 35°-40°

KEYHOLE

TRAVEL

3-15.

3-16.

3-17.

If you are left-handed, as I am, you will weld from left to right; right-handed, from right to left. This is called *forehand welding*. It is the best method for welding thin materials. *Backhand welding* is the reverse and is generally used for metal 1/4 inch thick or more. Here, the torch is pointed in the direction of the completed weld. The beads are fewer and less rippled, and they fuse heavy metal better, because the rod is melted more definitely into the deep crevice of space that is present in thicker metal.

You are now ready to weld the *seam* (figure 3-18). Continue moving your torch in circular fashion; steady it by pressing your elbow against the side of your body. Your forearm is at a 90-degree angle to your body. You may need to do the same with your rod hand until you become familiar with the balance and leverage of the torch and rod.

Move evenly along the seam, remembering to give equal heat to both sides. Bring the metal within the circle to cherry red, then drop the end of the filler rod into the filler of the weld puddle so the drop spreads to the bead. Continue moving up the seam.

If your metal gets too hot, the torch will burn holes in it. Pull your torch tip away from the metal and give it a chance to cool down before you proceed. It is possible to fill a hole by concentrating the torch on the rod tip, allowing it to drop into the hole, and repeating your circular motion in that area until the metal fuses. When you have completed this seam, turn the metal over and weld the other side.

To make a *corner joint* (figure 3-19), take another piece of metal, also 6 inches in length, to add to the first piece. Prop this piece perpendicular to your first sheet or hold it in this position with a pair of pliers for better control, then tack the ends with your torch.

3-18.

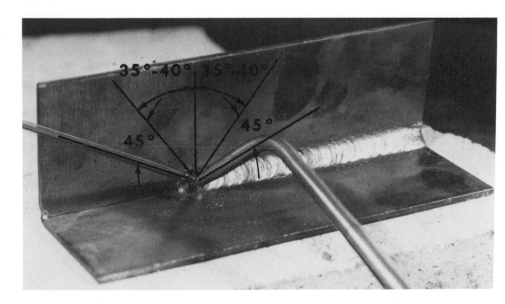

3-19.

A corner-joint weld needs more filler rod in the center of the joint. After tacking the two ends and the center, begin at one end, position your torch at a 45-degree angle, and repeat your circular motion from this end to the other end. Repeat this entire procedure once more to make two right-angle sections that you can join together. Hold the top end with your pliers or press with your hammer against the bottom end and tack in place. Weld the two corner joints on the outside. You now have an almost-completed box. It is important to tack ends and center from outside before you weld the seam (figure 3-20). This secures the position of your metal and provides true alignment.

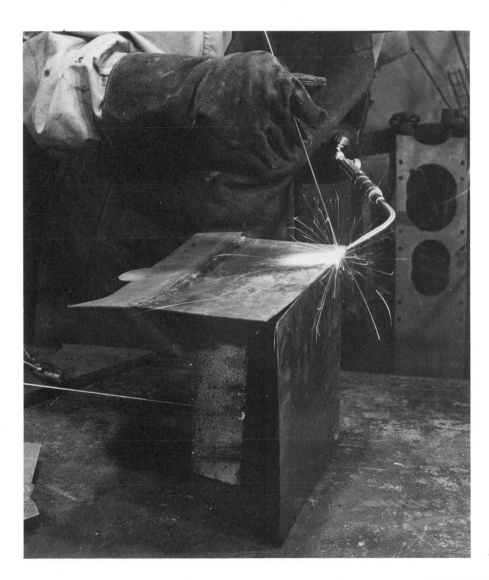

3-20.

Take one more piece of metal to fit the opening of one end of the piece you are working on. Place that piece on the table and hold the open-sided box upright. Tack weld the two catercorner spots and turn upside down. Tack the other two corners. Weld the four sides. You have created your first piece, a container. If you wish, you can make a top for it, either one like a candy box or one with two hinges. Use any box-top design that appeals to you.

It is possible to weld in a vertical position (figure 3-25). This is a skill you will need from time to time. If you do not choose to keep your container as your first work, you can continue practicing different welds by adding strips to this original piece in different vertical and horizontal positions. I suggest practicing overhead joints when you are more experienced. For now, practice all of the other joints illustrated in figure 3-26. The flat weld is the easiest and most common. It is simply welding the seam with your steel laid flat on the table.

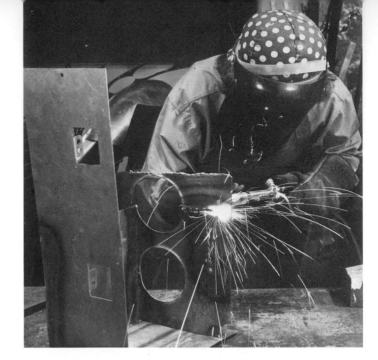

3-22. Use the cutting torch to adjust the lengths.

3-23. Bending.

3-21. The box takes form.

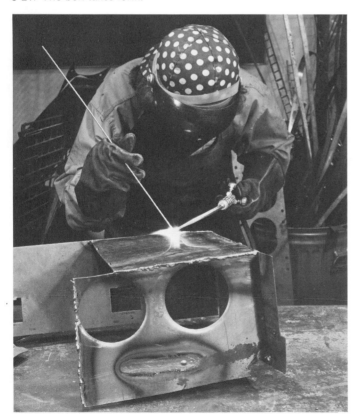

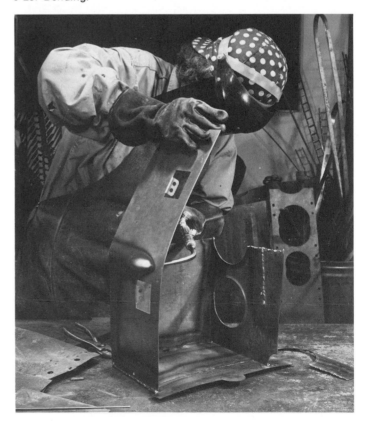

3-24. Continue pressure for tacking.

3-25. Welding a corner joint vertically.

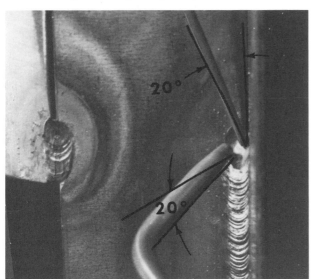

3-26.

butt

corner

lap

tee

If you are not using a flux-coated rod, you must dip your heated bronze rod in the can of bronze flux to coat the rod. Heat (not melt) 2 inches at the end of the rod with your torch, then dip it into the can of flux and pull it out. The rod is now ready for brazing (figure 3-31). When this 2-inch section is consumed in the brazing process, dip the rod in again (figure 3-32). It is usually not necessary to reheat it, because it is already hot from the brazing process. Cover your flux can with the small lid when you are not using it. This will protect your flux from moisture in the air, and it will stay loose and smooth.

After you have cleaned your steel sheet, light your torch by turning the acetylene valve a quarter turn and opening your oxygen until you have a slightly oxidizing (excess oxygen) flame. Heat an area 1 1/2 to 2 1/2 inches square rather lightly with your torch until the area turns blue; this appears as a coating color. Heat a space the size of a dime near the edge to dull red. Melt the flux-coated rod on that red-hot spot. The metal will spread and run ahead thinly and evenly on the hot metal surface. This is called *tinning*. You can use this process to cover an entire piece of sculpture.

A word of caution: your bronze rod contains zinc. If it becomes too hot and burns the bronze, the fumes are toxic. Be sure to have adequate ventilation and be sure not to burn your bronze. The fumes appear as gray smoke. Pull the torch away from the metal. It might be wise to begin your brazing practice outdoors.

There are three principles of brazing: capillary action, wetting, and diffusion. The forces that bring about *capillary action*, which is the drawing of a filler metal onto and in exchange with the parent metal, are cohesion and adhesion. The parent metal must be reasonably smooth and clean for capillary action to take place. The flowing flux, which creates an environment that allows the bronze filler metal to melt and flow, is called *wetting*. *Diffusion* is the actual exchange of atoms that takes place between the parent metal and the filler metal.

Brazing is more than a simple shielding or metal cement: the bronze actually diffuses with the parent metal. Practically all metals can be brazed, even if they are dissimilar. The process takes place by the capillary attraction of a nonferrous filler metal into the weld space of the parent metal. The surfaces must be closely joined, and the joining temperature is about 800 degrees Fahrenheit.

You are now ready to deposit a layer of bronze. Run a layer 1/8 inch thick and 3/4 inch wide along the length of your plate. Maintain a circular motion and dip the rod at the point where the bronze flows into the base metal.

3-33. *Woodsman.* The sculpture was partly brazed for accent. (Photo by Claudia Stephens.)

3-31. (Photo by Claudia Stephens.)

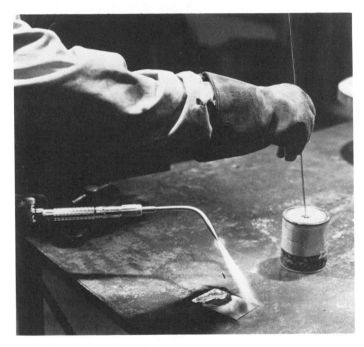

3-32. (Photo by Claudia Stephens.)

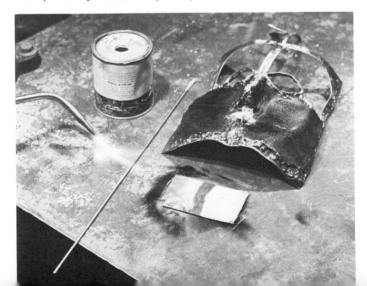

To braze weld a butt joint, place two pieces of steel end to end. Braze tack both ends, heat both sides of the two sheets uniformly to dull red, and insert the rod into the metal so that it flows as you continue your circular motion. A good braze weld looks rather similar to a steel weld except for its golden-bronze color and its flux coating, which must be removed, because it will corrode the metal.

Braze welding can be done more efficiently with a relatively new fuel called Mapp gas, manufactured by Airco Welding Products. It is combined with oxygen, and brazing is done in much the same way as with acetylene. You can usually use the same torch. Mapp gas produces a flame with a hotter middle cone, which is especially suited to the tinning or flowing capacity of a bronze rod. It is less expensive than acetylene and lasts longer. It is actually a liquid acetylinic compound and in this form is not sensitive to shock, so it is a safer gas. Mapp gas does not weld steel very well, however, so it is not really an all-purpose fuel. I would consider it as an adjunct method if you do a lot of brazing.

3-34.

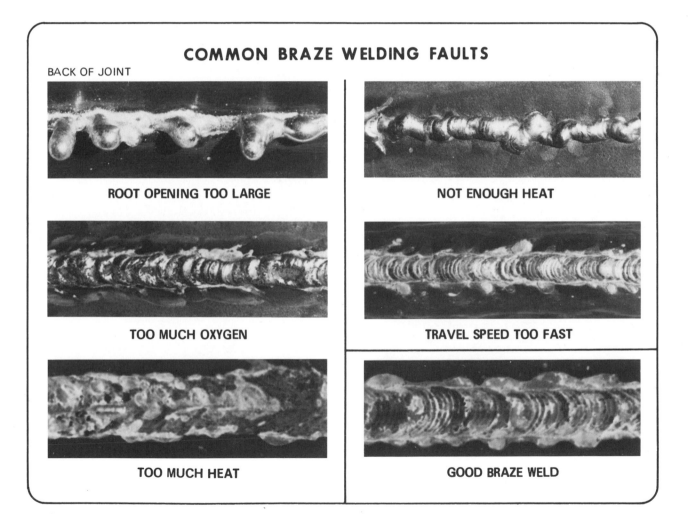

COMMON BRAZE WELDING FAULTS

BACK OF JOINT

ROOT OPENING TOO LARGE

NOT ENOUGH HEAT

TOO MUCH OXYGEN

TRAVEL SPEED TOO FAST

TOO MUCH HEAT

GOOD BRAZE WELD

CUTTING STEEL

Start with a piece of mild steel plate 3/16 inch thick and clean it with a wire brush to remove rust and scale. Draw a line with chalk or soapstone and a ruler as a guide for your torch (figure 3-35a). You can place a steel bar on top of the metal to help you follow your line and keep the torch steady. Lay your plate over two loose firebricks so that your line will be over an open space and your torch can burn through without interference.

3-35.

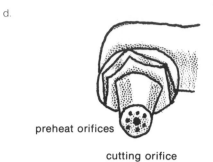

preheat orifices

cutting orifice

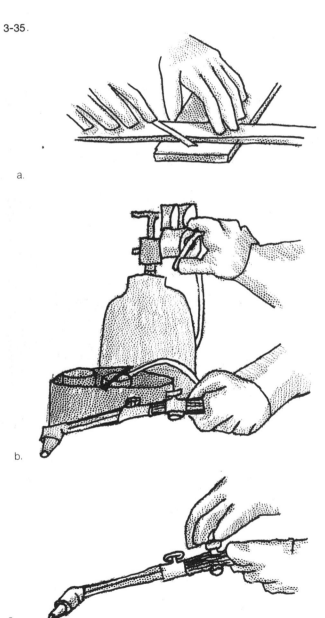

a.

b.

c.

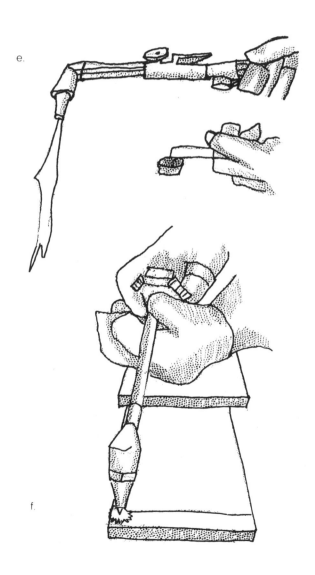

e.

f.

Attach your cutting torch as explained in Chapter 1. Hold the torch with your thumb on the cutting level. Practice keeping it steady while moving from right to left if you are right-handed; left to right, if you are left-handed. By holding your elbow close to your body, you will be able to steady the torch. Practice until you feel you can move slowly and smoothly along the line of your cut.

Adjust your oxygen and acetylene pressure regulators to the proper pressure for the thickness of the metal, as detailed in figure 3-2 (figure 3-35b).

Open the torch-handle oxygen valve wide to transfer oxygen control to the cutting-head valve (figure 3-35c).

Open the outer, preheat oxygen valve (figure 3-35d) on the cutting torch a fraction of a turn, then open the acetylene valve a quarter turn and light the gas at the nozzle with your friction lighter (figure 3-35e). Increase oxygen accordingly to reach the neutral flame. Press and release the oxygen-valve lever to get an accurate pressure reading. If the flame pulls away from the end of the torch, you have too much oxygen. In that case, reduce the flow of oxygen. The flame is adjusted with the preheat valve, but it actually emerges from the cutting valve (figure 3-36). Cutting is done with an oxidizing flame.

3-36.

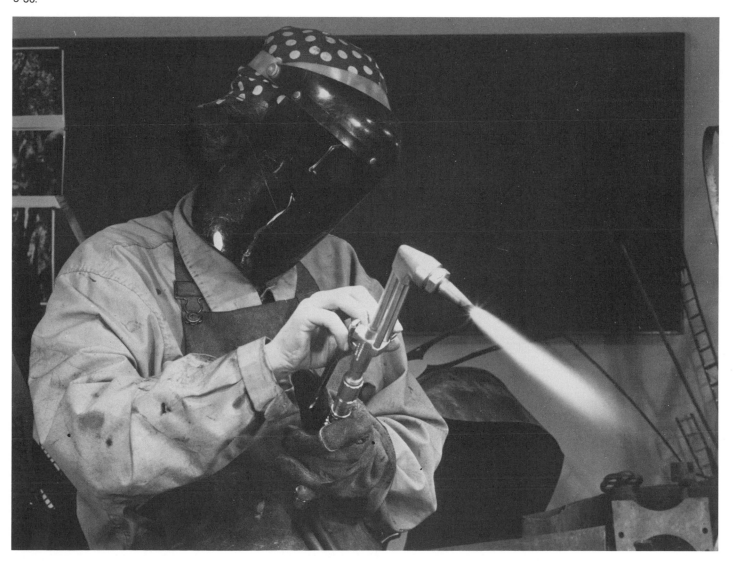

Position the torch with the preheat flame perpendicular to the edge of the plate, keeping the inner cone 1/16 to 1/8 inch away from the work. Hold the torch over the area to be cut (figure 3-35f). The area will turn cherry red. When the metal begins to melt, press your cutting lever to obtain more oxygen and travel along the line of your cut (figure 3-37). It will burn rapidly, making an even, square-edged cut with little slag. Practice cutting angle cuts, circles, and irregular curves. If you press your elbows against your body and move with the torch, it is possible to cut a variety of shapes with steadiness and control.

Your cutting torch can also be used to pierce holes. Use the same pressure nozzle and preheat flame as for regular cutting. Hold the preheat flame in one spot until the surface floats, then raise the torch slightly, keeping the nozzle 1/2 inch away from the surface. Slowly depress your oxygen lever and move slightly to one side, beginning a spiral motion. Continue until you penetrate the plate. Then lower the nozzle and continue the spiral motion until the cut is large enough. Raising the torch and moving it to the side keeps the slag from clogging the nozzle.

To turn off the cutting torch, close the acetylene valve on your hose, then turn off the preheat valve. Remove the cutting head by turning off the oxygen valve on your hose, loosening the connection nut, and twisting and pulling the attachment.

Cutting with the oxyacetylene torch is a dramatic experience, not only because of the quantity of sparks that spray into the air but also because of the speed of cutting. The excess oxygen burns the metal away. Cutting away one area actually preheats the next area so that the cut is smooth and quick. The blowing force of the flame pushes the melted metal away from the plate. It is very important to direct your flame so that slag and spark do not come in your direction. If you are cutting an edge hanging over your table, put a sheet of steel plate in front of your body to protect you from dropping, molten metal.

3-37.

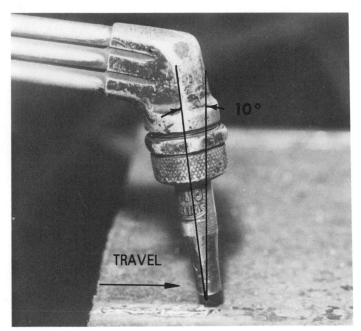

TRAVEL

- **ANGLE TORCH 10° TOWARD DIRECTION OF TRAVEL.**
- **REST TORCH TIP AGAINST STEEL BAR ALIGNED WITH CUT.**

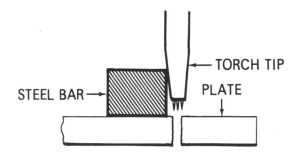

STEEL BAR → ← TORCH TIP

PLATE

- **TRAVEL SMOOTHLY.**

Correct Procedures vs. Common Faults in Hand-Cutting

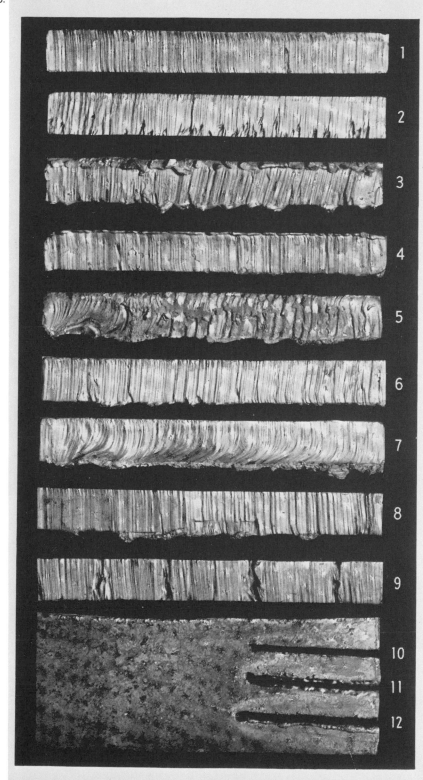

(1) Correct Procedure
Compare this correctly made cut in 1-in. plate with those shown below. The edge is square and the drag lines are vertical and not too pronounced.

(2) Preheat Flames Too Small
Fault: preheat flames too small—only about 1/8 in. long. Result: cutting speed was too slow, causing bad gouging effect at bottom.

(3) Preheat Flames Too Long
Fault: preheat flames too long—about 1/2 inch. Result: top surface has melted over, the cut edge is irregular, and there is too much adhering slag.

(4) Oxygen Pressure Too Low
Fault: oxygen pressure too low. Result: top edge has melted over because of too slow cutting speed.

(5) Oxygen Pressure Too High
Fault: oxygen pressure too high and nozzle size too small. Result: entire control of the cut has been lost.

(6) Cutting Speed Too Slow
Fault: cutting speed too slow. Result: irregularities of drag lines are emphasized.

(7) Cutting Speed Too High
Fault: cutting speed too high. Result: there is a pronounced rake to the drag lines and the cut edge is irregular.

(8) Blowpipe Travel Unsteady
Fault: blowpipe travel unsteady. Result: the cut edge is wavy and irregular.

(9) Lost Cut Not Properly Restarted
Fault: cut lost and not carefully restarted. Result: bad gouges were caused where cut was restarted.

(10) Good Kerf
Compare this view (from the top of the plate) of a good kerf with those below. This cut was made by using correct procedures.

(11) Too Much Preheat
Fault: too much preheat and nozzle too close to plate. Result: bad melting over the top edge occurred.

(12) Too Little Preheat
Fault: too little preheat and flames too far from plate. Result: heat spread has opened up kerf at top. Kerf is too wide and is tapered.

Chapter 4.
Other Welding Metals and Methods

METALS

Three-quarters of the known pure elements are metals. They are found in the *ore* state. There are three different kinds of ores: native, oxide, and sulfide. *Native* ores are metals that can be found in the pure state, such as gold, silver, platinum, and copper. *Oxide* ores consist of oxides, carbonates, and silicates of common metals. *Sulfide* ores are metals combined with sulfur. Metals are also divided into two main groups: ferrous and nonferrous. The *ferrous* metals are iron and alloys containing iron. All other metals are *nonferrous*. Among these are the noble metals, silver, gold, and platinum, which have little application to welded sculpture except for plating, because of their great expense. Their surfaces are stable when exposed to air. Other nonferrous metals that are suitable for welded sculpture are aluminum, copper, and nickel. Brass and bronze are copper alloys and are also suitable for welding. An *alloy* is a combination of metals that forms a new metal, which has its own properties.

A metal can be described by its physical properties, such as atomic weight, melting point, freezing point, boiling point, and specific gravity. A metal can be described by its color; it can be polished to a luster: the harder the metal, the higher the luster. All metals expand in length, width, and thickness when heated, and they contract as they unite with other metals. Metals are *fusible*, that is, they can unite with other metals in the liquid state. This means that they can be smelted, and their impurities can be removed. They can also be combined with other metals to create alloys. Because of this property, metal can be cast, soldered, brazed, and welded.

A metal's *hardness* is measured by the Brinell test. A steel ball one centimeter in diameter is fixed under standard pressure into the surface of the metal. This impression is the measure of hardness. The most *malleable* metal is gold, which can be beaten to a thickness of .000005 inch. The ability of a metal to be drawn into a fine wire is called its *ductility*. The most ductile metals are gold, silver, platinum, iron, copper, aluminum, and nickel.

The *tensile strength* of a metal is its maximum unit resistance before tearing apart. *Shear strength* is the maximum unit load pressing against both sides of a metal before *failure*, which is the actual breaking of the metal, is produced. *Toughness* is the ability of the metal to resist strains. such as twisting, bending, and shock, before breaking.

A metal's *elasticity* is its ability to recover after it has been compressed, bent, or stretched. A *brittle* metal, such as cast iron, lacks tenacity, ductility, and malleability. It is easily fractured or snapped without any warning deformation.

Two classical treatments of metal are: *annealing*, which is the process of heating and cooling metal to make it more workable; and *quenching*, which is the rapid cooling of metal that has been heated to varying temperatures (determined by color). Quenching can be done by placing the metal in water, oil, or brine. High-carbon steel can be tempered (hardened) by heating to cherry red and quenching in water. Brass should be cooled slowly, as rapid quenching may cause it to crack.

The most common welding metals are iron, steel, aluminum, white metal, nickel alloys, stainless steel, and copper. The most common brazing metals are brass, bronze, nickel silver, and copper. Zinc, lead, and mercury are toxic. There is no reason to weld lead or mercury, but zinc is contained in other metals you will use, such as

galvanized steel and brass. Zinc poisoning is not cumulative, but a fever can result from inhaling the fumes. They are released when the temperature of the metal exceeds 800 degrees Fahrenheit. As proper brazing takes place at this temperature, you must learn to keep within the temperature range. If you use a neutral flame for brazing, these toxic fumes will also be produced. Braze with a slightly oxidized flame to coat the surface, but do not let the torch linger in any area after the braze is completed.

Iron

Wrought iron is highly refined and low in carbon. It has a high resistance to corrosion, which explains why handwrought wheels and hinges from earlier days are frequently in such good condition. There is a grain to this metal. It welds at a higher temperature than ordinary steel, 2,700 degrees to 2,770 degrees Fahrenheit. The beauty of welding wrought iron is that the process of approaching the molten state is slower and more easily controlled. It is possible to weld this metal with an ordinary steel rod, although there are commercial low-carbon steel rods that also weld well.

Cast iron is a chromium alloy; it resists corrosion and can be welded like ordinary steel with a neutral flame. There are two types of cast iron, gray and white. Gray cast iron makes a cleaner break. Molten cast iron does not flow but looks like liquid underneath a skin. While it can be welded with flux and cast-iron rods, it is best to braze it. By searing the metal with an oxidizing flame, you can burn out excess carbon and change the character of the metal to resemble steel. It will then be easier to braze weld. The bronze rod should be held in the envelope of the flame. As the cast iron becomes red, dip your rod in the flux. When the cast iron is clearly red, put the rod into the weld and apply it to both sides. If the temperature is right, the bronze will spread over the surface in a tinning layer. Apply the rod again and join the weld up over the tinning layer. Be sure your metal is clean and not overheated: it is difficult to go back over your brazed portion to smooth it, and you will usually lose the weld.

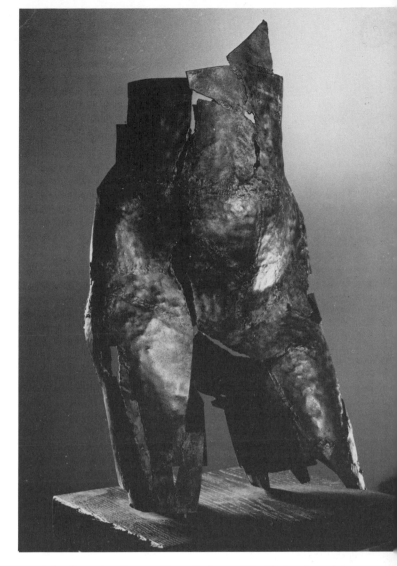

4-1. Julio Gonzalez. *Torso*. Wrought iron, 1935. (Collection of the Museum of Modern Art; photo by Henri Guilbaud.)

Steel

Steel is classified according to carbon content and/or alloy, such as chromium, molybdenum, nickel, or manganese. It is sold under various trade names and specifications. It comes in a variety of shapes—bars, tubes, pipes, sheets, and plates—and sizes (figure 4-2).

High-carbon steel (.50 to 1.60 percent carbon content) is made for hardness, strength, and toughness. It is often heat-treated and commercially treated (forged or rolled). High-carbon steels are used for springs and tools. They melt at lower temperatures than mild steels and spark when overheated. To weld this steel, you must work quickly, keeping the metal heat as low as possible to achieve the weld. Deposit the metal and move on.

Low-carbon steel (.15 to .30 percent carbon content) is also called *mild steel*. It is available in sheets, rods, and bars. Since it is easily welded and machined, it is used for rivets, wire, and structural sections. This is the best steel for oxyacetylene-welded sculpture.

Low-alloy steels maintain high strength and are therefore excellent for work with thinner metal. They generally have .15 percent or less carbon and are easily welded.

Manganese steel contains large amounts of manganese and provides excellent wear resistance.

Stainless steel contains nickel and chromium. It has great corrosion resistance and is very strong. A good flux is needed to weld stainless steel. The tip should be one or two sizes smaller than for other steels of comparable thickness. Slightly more acetylene (about 1/16 inch longer than the inner cone) and a quick forehand weld are required. A silver brazing rod, which is very expensive, diffuses over the surface. (Other rods can also be used for brazing stainless steel. Look these up in the technical handbook that your welding supplier gives you.) To braze weld stainless steel, hold the torch so that the flame reaches the metal at an 80-degree angle. Keeping the tip of the inner cone 1/16 inch from the metal. Keep the torch relatively stable and the end of the rod close to the inner cone while it is in the flame.

Stainless steel expands more than ordinary steel, so guard against buckling and distortion by tack welding and clamping to maintain the shape. Weld at a steady, even speed: if the space between your pieces of metal begins to close in front of the flame, you are welding too fast; if the space keeps opening, you are welding too slow. After the weld is complete, clean off the scale and excess flux. Tig welding, which is described below, is the best method for welding stainless steel.

Corten steel is becoming popular for outdoor sculpture, because it is 40 percent stronger than conventional steel and it develops a protective oxide coating so it does not deteriorate. The finish is rust brown in color and varies according to the conditions of the environment. It takes about four years to attain the self-sealing, permanent coating, and meanwhile the color stains the ground near the sculpture. Corten steel is manufactured in the usual sizes and is worked in much the same manner as ordinary steel. If a proper mixture is made from the base metal, it is possible to use ordinary steel welding rods. The welds will have the same rust resistance as the parent metal. The Reid Avery Company in Dundalk, Maryland, produces a rod especially for Corten steel called Raco 815.

gauge	thickness in fractions of an inch	thickness in decimal parts of an inch
0000000	1/2	.5
000000	15/32	.46875
00000	7/16	.4375
0000	13/32	.40625
000	3/8	.375
00	11/32	.34375
0	5/16	.3125
1	9/32	.28125
2	17/64	.265625
3	1/4	.25
4	15/64	.234375
5	7/32	.21875
6	13/64	.203125
7	3/16	.1875
8	11/64	.171875
9	5/32	.15625
10	9/64	.140625
11	1/8	.125
12	7/64	.109375
13	3/32	.09375
14	5/64	.078125
15	9/128	.0703125
16	1/16	.0625
17	9/160	.05625
18	1/20	.05
19	7/160	.04375
20	3/80	.0375
21	11/320	.034375
22	1/32	.03125
23	9/320	.028125
24	1/40	.025
25	7/320	.021875
26	3/160	.01875
27	11/640	.0171875
28	1/64	.015625
29	9/640	.0140625
30	1/80	.0125
31	7/640	.0109375
32	13/1280	.01015625
33	3/320	.009375
34	11/1280	.00859375
35	5/640	.0078125
36	9/1280	.00703125
37	17/2560	.006640625
38	1/160	.00625

4-2.

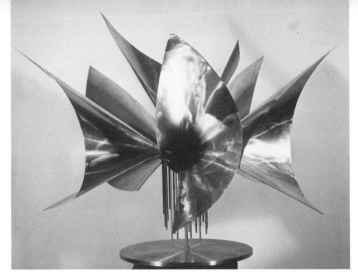

4-4. Francois and Bernard Baschet. *Musical Sculpture.* Stainless steel, 3' diameter. Wings catch the wind and amplify sound. (Collection of the Waddell Gallery; photo by John D. Schiff.)

4-5. Louise Nevelson. *Dawn's Column.* Corten steel, 14' high, 1973. (Collection of the Pace Gallery; permanently installed at Binghamton Civic Center.)

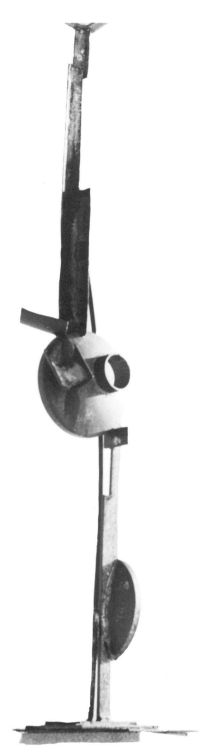

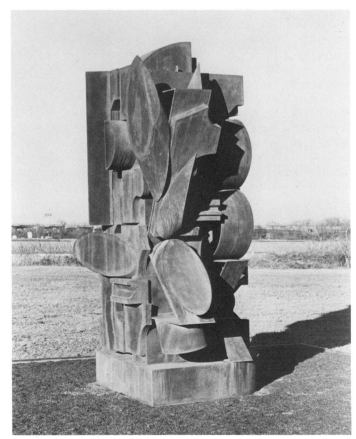

4-3. David Smith. *Tank Totem VI.* Low-carbon steel, 1957. (Collection of David Smith Papers, Archives of American Art, Smithsonian Institution.)

Copper and its Alloys

There are two kinds of copper: *electrolytic copper*, which contains a small amount of oxygen in the form of cuprous oxide and is somewhat difficult to weld; and *deoxidized copper*, which is easier to weld. A silver brazing rod is suggested for electrolytic copper, since this rod melts before the copper and provides a strong bond. For deoxidized copper, use a deoxidized-copper rod. This contains a small amount of silicon, which improves the weld.

Weld copper with a neutral flame. The fusion-welding process is basically the same as for steel, except that you use a tip two sizes larger than you would use for steel. The metal remains solid until it actually reaches its melting point of 1,980 degrees Fahrenheit, at which point it immediately becomes liquid. It has greater heat conductivity than other metals, and the entire piece will become much hotter than a similar steel piece. It also chills more quickly. Flux is generally not required, although occasionally a sparing use of bronze welding flux can assist the weld. Tack weld the metal parts before welding. If you proceed along the weld, you will melt out these tack welds and reweld in the rhythm and continuity of your main seam weld.

Hitting the copper by peening (ball-peen hammer) or hammering (flat-end hammer) is an aftertreatment that raises the tensile strength of copper. If it is then heated red-hot, ductility will be restored, and the weld will be stronger and harder. It is also possible to braze weld copper with a bronze welding rod and flux. Brass contains either copper and zinc or copper, tin, and zinc. Most types are easily welded with flux and a bronze welding rod. The filler rod has a lower melting point than the brass. The lower temperature makes it possible to complete your joint without much change in the grain structure of the metal. This maintains the special characteristics of the metal. Use a larger tip size for welding brass than for the same thickness of mild steel. Clean the metal before working. The weld must be completed quickly, because brass is very fluid when melted and it is very easy to blow holes in this metal. Use flux generously. Do not remelt brazed welds without adding new metal. If the joint seems weak, it can be strengthened by light hammering.

Bronze is probably the most well-known alloy of copper. It is also a traditional sculpture metal. It is a combination of copper and tin. Although tin is a very soft metal with a low melting point, when it is added to copper, it had a hardening property. Some bronzes develop tensile strength up to 50,000 pounds per square inch. They are easy to weld. Use a bronze flux and a bronze rod. The flux forms a protective coating, which prevents oxidation of the parent metal during heating and dissolves oxides that have formed or

have not been removed. It also assists the free flow of the bronze rod. Clean your joint, keep the white cone of the oxidizing flame slightly away from the metal, and do not hold the flame too long in one position. The regular brazing technique is used. The amount of excess oxygen that you should use varies with each type of bronze, so some experimentation is necessary. The adjustment can be determined by noting that too much oxygen will cause a film or coating on the surface. The right adjustment will eliminate the coating and maintain a bright surface on the bronze.

4-6. *The Golden Woman Mask*. Brazed bronze on steel, 14 3/8" high. (Collection of Karl and Henny Hering; photo by Claudia Stephens.)

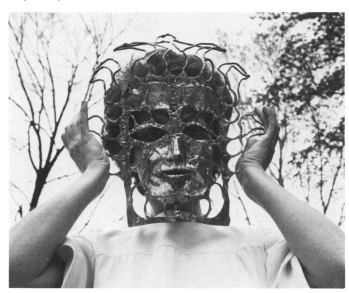

Aluminum

Aluminum is historically a new metal: it was discovered in 1709 and was not produced in quantity until 1824, because cheap electric power is necessary for commercial production. Aluminum is a very light metal, having about one-third the weight of steel. It is malleable, resists corrosion, has thermal and electric conductivity, polishes to a high silver luster, and reflects light and heat. It can be worked by stamping, rolling, spinning, extruding, forging, or sand and dye casting. It can be joined by riveting, welding, and brazing. It can also be soldered. When it is exposed to humid air, it forms an oxide that prevents corrosion. It can be colored by anodizing. Aluminum readily joins with other metals, and there are many aluminum alloys.

The best rod for fuel-gas welding of aluminum is the Eutectrod 19, manufactured by Eutectic-Castolin Institute. It is made from a self-fluxing, low-melting, solder-type alloy that will fill, seal, and build up both sheet and cast metal. The general technique for welding aluminum is the result of its very low melting point, 1,218 degrees Fahrenheit. Aluminum gives no warning as it approaches the melting point, and it becomes very weak and can easily fall apart. Mig welding, which is described later in this chapter, is the best technique for aluminum. To weld aluminum with oxyacetylene equipment, preheat the metal with an excess acetylene flame, covering the area with carbon. Heat the area to be welded with a neutral flame until the carbon is removed, then apply your flux. This is a very quick process, since the flux is liquid. Keeping the torch 1 to 3 inches away from the base-metal surface, place the rod onto the bonding area of the aluminum you wish to weld until the entire space is tinned. To build up a bead, keep the flame parallel to the surface of the aluminum and deposit the alloy rod on the tinned area, only heating the rod. Allow the aluminum to cool slowly. For a heavier bead deposit, use the Eutectrod 21-RC-E rod.

To weld aluminum, it must be free of dirt, scale, grease, and oxides. Use only stainless-steel wire brushes to clean aluminum. With an excess acetylene flame, blacken the metal to be welded. Then, with a carburizing flame, heat until the carbon goes away. At this temperature the flux becomes liquid and melts. Drop a continuing bead of aluminum from the rod into your welding space. Place the flame on the drop of alloy until it flows out and bonds readily. Use a bead-forming technique, continuing to add more alloy. Concentrate your flame on the rod and in the base metal. The base metal will melt readily and fall apart. The flux must be removed after the weld, as it is corrosive. Warm water will wash away the flux.

4-7. Linda Howard. *Spiral to Center.* Aluminum, 72″ long, 1972. (Collection of the Aldrich Museum; photo by Kobler/Dyer Studios.)

METHODS

The four most common welding processes are oxyacetylene welding, which we have concentrated on up to this point, shielded-metal arc welding, gas-tungsten arc welding (tig), and gas-metal arc welding (mig).

Arc Welding

Shielded-metal arc welding, frequently referred to as *arc welding* or *stick-electrode welding*, became a popular manufacturing method in the 1930s. Its main advantage is its speed and strength. The major application of this process is welding mild carbon and low-alloy steels. The welding machine generates electricity in large quantities, which provides the heat for melting the metal. The source of the weld metal is the *covered electrode*, a flux-coated filler rod which transfers the necessary electricity to melt the parent metal. (Some rods have a self-removing flux. This is quite useful, since flux can be difficult to remove if it is not hammered off at the proper moment of cooling.) An arc is struck between the metal to be welded and the covered electrode or stick attached to the electrode holder, which connects via an electrode cable to the welding machine.

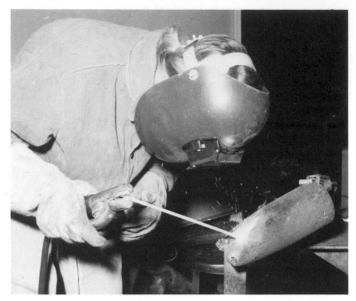

4-8. Stick-electrode welding—note special helmet. (Photo courtesy Hobart Welding School.)

4-9. Shielded-metal arc-welding equipment.

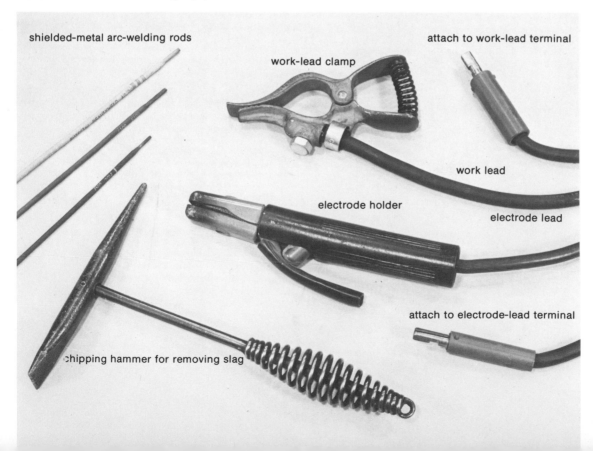

shielded-metal arc-welding rods

work-lead clamp

attach to work-lead terminal

work lead

electrode holder

electrode lead

chipping hammer for removing slag

attach to electrode-lead terminal

The work-lead cable connects at the welding machine and clamps on to the metal that is to be welded, making it possible for the electric current to find its circular joining. The arc creates an intense heat, which melts the edges of the base metal and the electrode at the same time. The melted metal from the electrode moves across the arc and is deposited on the base metal, forming a uniform metal structure equal to the strength of the metal being welded.

Various flux-coated electrodes have been developed to match the various properties of the parent metals. Covered electrodes come in sizes from 1/16 to 5/16 inch in diameter and 9 to 18 inches in length, with 14 inches the most common.

The coating on the electrode produces an inert gas that both protects the arc and the weld formation from the surrounding atmosphere and produces deoxidizers, which purify the weld metal from the electrode. It also forms a slag, which protects the deposited welded metal in its hot state from oxidation. It causes the electrode to separate smoothly by generating ionizing elements. It also supplies alloy elements, which strengthen the deposited metal, and iron powder, which improves the functioning of the electrode. Electrodes are identified by the American Welding Society numbering system, which classifies each electrode according to strength, welding position, usability, and analysis of the deposited metal.

The electrode holder grips the electrode and transfers the welding current from the cable to the electrode. It varies in size according to its current-carrying capacity. The weldng circuit is illustrated in figure 4-10. The cable is usually made of multiple strands of spiral copper wire. The cable is insulated with a covering of rubber or neoprene. The length of the cable should be about 10 to 15 feet. There are various notches and angles at which you can clamp your electrode to the holder. A 90-degree angle is most common.

4-10. (a.) The process of shielded-metal arc welding. (b.) Shielded-metal arc-welding setup.

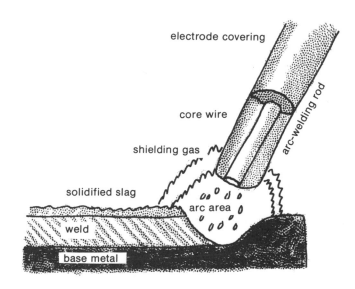

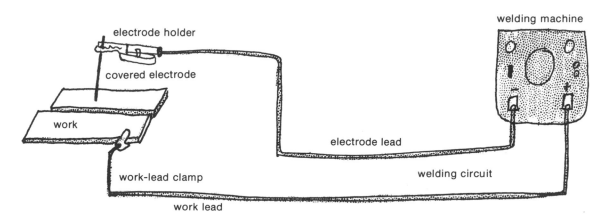

The arc-welding machine (figure 4-11) provides the electric power in the proper current voltage to maintain the welding arc, either AC or DC. Most welding companies have inexpensive AC machines that will weld an adequate variety of metal thicknesses. The AC-transformer type is the smallest, lightest, and least expensive. It is also relatively quiet in operation. It has one knob that can be used to vary the current output. When electric power is not available, the generator can be driven by an internal-combustion gas engine or a diesel engine. The amount of current you regulate for depends on the thickness of your metal.

The higher the amperage, the greater the electric flow that will be transferred through the electrode to the parent metal, which is the metal you will weld. The higher the current, the faster the weld and the thicker the metal.

I should caution you at this point that I do not advise you to teach yourself to arc weld. You need the assistance of someone knowledgeable in this technique. Your welding supplier will be most happy to demonstrate the equipment. Some even give lessons. The Hobart Welding School in Troy, Ohio gives a course for sculptors every July. It is also possible to take a course at a vocational high school. In any event, arc welding is not difficult, but it does require discipline, concentration, and strict adherence to safety practices. I make this recommendation because of the danger of the intense flame and the likelihood, especially in the beginning, of situations that are best handled under supervision.

To begin using the arc-welding machine, set the amount of current. (*Amperage* is the measured amount of current being used. *Voltage* is the measured amount of electrical pressure that pushes the current through the cables across the arc.) Connect the work lead to either the steel table on which your steel rests or the actual steel that is to be welded. If you connect the work lead to the table, be sure the parent lead aligns well enough to pick up the current.

Before you start your welding machine, be certain that your electrode holder is not in any way connected to or touching the work-lead-connected metal. Turn your machine on and put your electrode in the holding. To shut down your machine, turn your power off at the machine. Hang up your leads and remove them, then remove the electrode from the holder and the work lead from the parent metal.

To arc weld a piece of 3/16-inch mild-steel plate with a 1/8-inch electrode, set your machine at 85 to 100 amps. Place your metal on the table. Before you turn your machine on, place your electrode in your electrode holder and practice scratching the electrode onto the steel plate, then practice scratching the electrode as if you were striking a match.

Turn on your machine. Your metal is in place on the table. Attach your work lead to the steel. Your electrode is in place in the electrode holder. You are wearing protective clothing, gloves, and helmet. Your chipping hammers and wire brush are close at hand for removing the flux when the metal cools. Place yourself in position in front of the metal to be welded. *Close your helmet* and tap the metal by holding your electrode vertically and, with an up-and-down tapping motion, touch the steel plate (figure 4-12). Remove your electrode quickly after tapping the plate. This helps you to practice the arc gap and prevents the electrode from welding to the plate.

By holding the electrode at an angle, scratch the end across the work surface. Withdraw the electrode quickly after you have touched the steel plate. If your electrode sticks to the steel, you can break it loose by twisting quickly. If this does not succeed, press the top lever on your electrode holder. This will release your electrode. When the metal has cooled, you can break the electrode off from the metal.

4-11. An all-purpose electric welding machine for stick-electrode, tig, and mig welding.

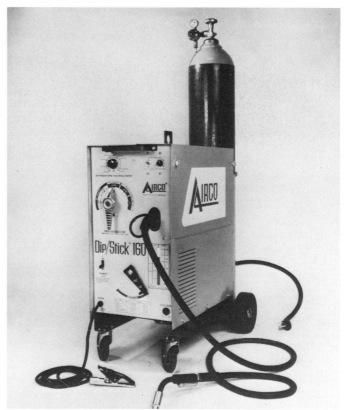

When you are familiar with the equipment of arc welding and the process of striking the arc, you are ready to weld (figure 4-13). For the first weld, weld a line along your 3/16-inch mild-steel plate. What you do is to strike your arc while holding your electrode 1/8 inch away from the metal. This is the *arc length*, which is the distance between the electrode and the metal plate after you have struck an arc—the diameter of the electrode. If you have a smaller electrode, your arc length would be narrower and vice versa.

After you strike your arc on the plate, move the arc length to the edge of the plate for 1 second. Pull your electrode 1/4 inch, or double the arc length, from the plate, then return it to the original length and angle your electrode 5 to 10 degrees so that the point of the electrode is in the opposite direction from the completed weld. Allow your welding crater to widen about twice the diameter of your electrode. Begin to move at an even speed along the line of your weld. The metal will melt off your electrode,

and you will be filling the rod into the metal evenly and slowly.

Your rod will rapidly diminish in size as you fit it into the weld. Arc welding is very impressive and dramatic: all you can see is the immediate area of the weld, which is an enormous aid in concentrating your focus.

After you have made a bead, weld for about 3 inches, then break your arc and withdraw the electrode quickly. *Never* rest your electrode at any time on the metal or steel table that your work lead is attached to or you will strike an arc. If you do this when your eyes are not protected, you can give yourself a flash burn.

When you weld with the arc welder, slag is deposited from the flux of the electrode. This slag must be removed with your chipping hammer. The best time to remove this slag is after the weld has cooled somewhat: it becomes difficult to remove when it has cooled completely. Wear a clear shield when you are chipping to protect your eyes from bits of slag.

4-12. Striking the arc.

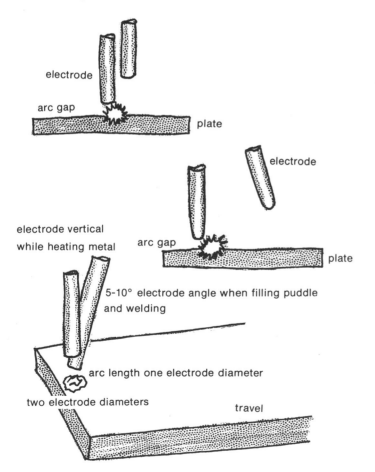

4-13. Welding with the electrode stick.

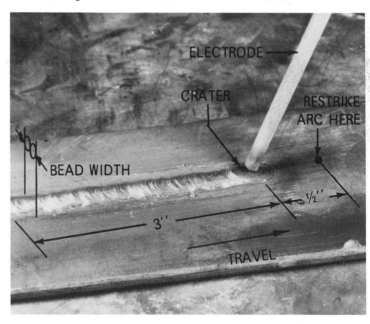

69

After you have removed the slag from your crater, restrike your arc 1/2 inch in front of the crater. Then move the electrode back to the crater, which is the last place that you deposited a bead. Fill this space to bead size and continue.

Next, practice a series of beads in a line next to one another (figure 4-16). After you have completed this series, take two metal plates 3/16 inch thick and align them side by side. Tack weld both ends and begin at one end, depositing your bead along the entire length of the joint. Remove the slag, turn the metal over, and weld the other side of the joint.

There are as many positions for arc welding as for oxy-acetylene welding. There are a variety of weaving motions that you can use to create a successful weld. When you are welding thick pieces of metal, it is sometimes necessary to deposit a second bead over the first bead.

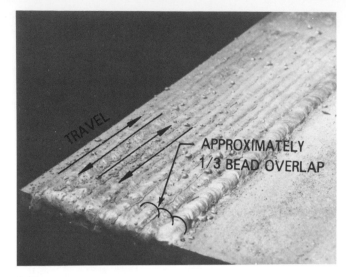

4-16.

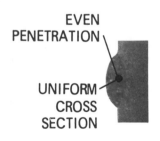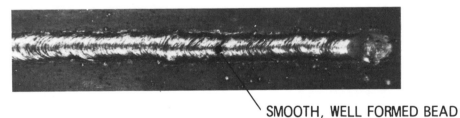

EVEN PENETRATION

UNIFORM CROSS SECTION

SMOOTH, WELL FORMED BEAD

4-14.

4-15.

COMMON WELDING MISTAKES

WELDING CURRENT TOO LOW	WELDING CURRENT TOO HIGH	ARC TOO LONG (voltage too high)	WELDING SPEED TOO FAST	WELDING SPEED TOO SLOW
•	•	•	•	•
TOO MUCH PILING UP OF WELD METAL	UNDERCUTTING ALONG EDGES WEAKENS JOINT	BEAD VERY IRREGULAR	BEAD TOO SMALL, SHAPE IRREGULAR	TOO MUCH PILING UP OF WELD METAL
•	•	•	•	•
OVERLAPPING BEAD, HAS POOR PENETRATION	TOO MUCH SPATTER TO BE CLEANED OFF	POOR PENETRATION	NOT ENOUGH WELD METAL IN CROSS SECTION	TOO MUCH PENETRATION
•	•	•	•	•
COLD AT EDGES	WIDE, FLAT BEAD	WELD METAL NOT PROPERLY SHIELDED	POOR PENETRATION	WASTES TIME AND ELECTRODES

cross view

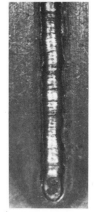
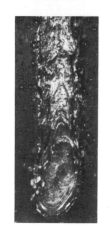
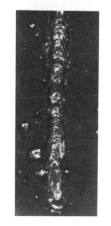
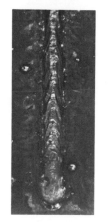
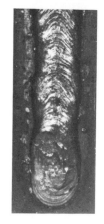

top view

Tig Welding

Tig welding produces high-quality welds with great speed. The equipment is generally too expensive for most welding sculptors, although less expensive models are coming out on the market. Tig welding was invented in the early 1950s specifically for manganese, aluminum, and stainless steel and is mainly used today for nonferrous metals, such as aluminum, nickel alloys, copper alloys, and refractory metals.

In this arc-welding process, the arc is struck between a nonconsumed tungsten electrode and the base metal. An envelope of inert gas emerges from the opening and shields the entire arc area. The heat of the arc melts the edges of the metal but not the tungsten electrode. With a rod, in much the same manner as oxyacetylene welding, the filler metal is added into the arc. The metallurgical joint is as strong as the base metal. The function of the shielding gas is to prevent oxygen and nitrogen in the air from coming into contact with the molten metal, thus ensuring a high-quality deposit. Argon is most often used as the shielding gas. There is no flux or deposit.

Tig welding is very quick and allows great control. It is easier than stick-electrode arc welding, and the welds are more beautiful.

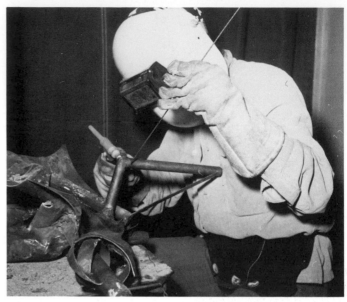

4-18. Tig welding.

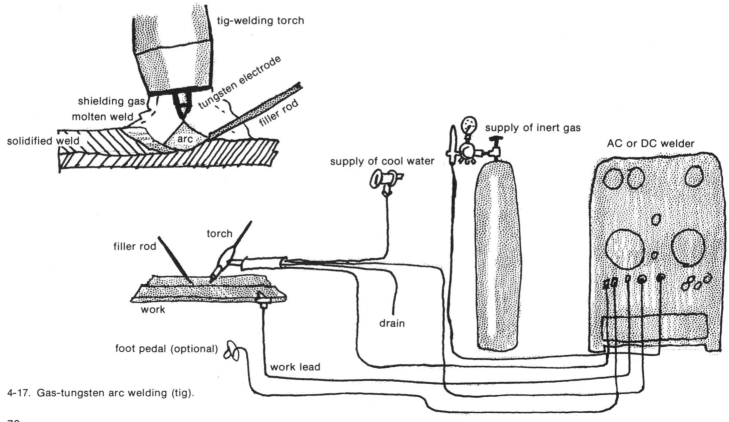

4-17. Gas-tungsten arc welding (tig).

Mig Welding

Mig welding is one of the newest arc-welding processes. It was developed in the 1950s and became popular in the 1960s. The heat is generated between the electrode and the metal to be welded. As in tig welding, gas shielding is used to keep the atmosphere from coming in contact with the molten metal, and there is no flux or deposit on the welded metal. The main difference between mig and tig welding is that in the former the electrode moves through the torch itself in the form of a wire which is automatically and continuously fed into the arc, thus maintaining a steady arc and making it possible to weld continuously.

The electrode wire is the filler rod, and it melts into the heat of the arc and is transferred across the arc to become the deposited weld metal. Here again, the joint is as strong as the base metal. Carbon dioxide is used as the shielding gas. The advantage of this process is its great speed, superior welds, and capacity to use many different metals with relative ease. It produces especially good welds with aluminum.

Since tig and mig welding are electric, they function more quickly at higher currents. More current is used for thick metal than for thinner metal.

Take your time with each of the preliminary steps and be sure you are completely comfortable with the equipment. Pay careful attention to all of the safety precautions throughout any of these welding processes.

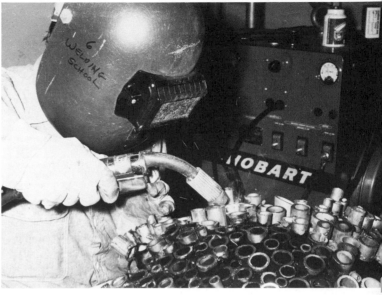

4-20. Mig welding.

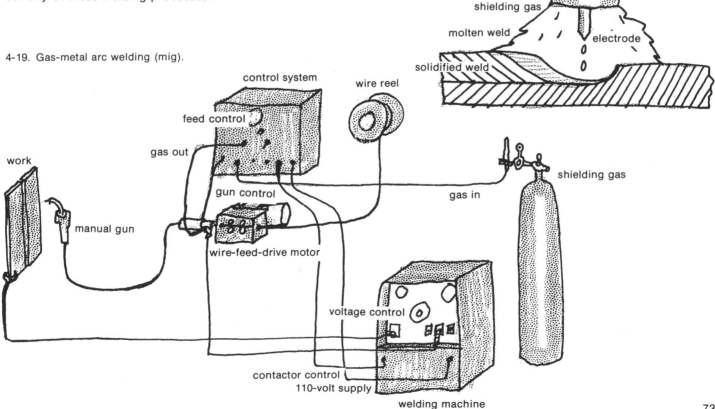

4-19. Gas-metal arc welding (mig).

73

Chapter 5.

Finishing Your Work

Finishing includes all of the final refinements that make a piece ready for show and sale. You will occasionally have to retouch your finish due to wear and tear in exhibiting and shipping. For this reason it is useful to keep a record of the finishing process used for each piece so that you can accurately restore it if necessary.

Although the main element of finishing is the final treatment of the surface, you need to review your piece thoroughly beforehand. Make sure that the welds are secure and that any holes are part of the design and not accidental. In addition, the base must be stable and even. Warpage in the process of making the piece will frequently make it necessary to stabilize the base several times by adding more metal (figure 5-2).

Before treating the surface, be sure there are no sharp projections or rough surfaces that could catch, scratch, or poke an observer and/or mover (figure 5-3). If you are careless about this, the most likely person to be injured is yourself.

Examine your surface carefully in relation to the forms you have created. Consider the texture of the metal and the surface interest that you wish to achieve. It is possible to alter your surface greatly by the use of bas-relief techniques, some of which are unique to welding sculpture: the use of skeleton metal as applied design and the building up of form with the welding bead. It is also possible to do repoussé quite effectively with a variety of hammers, using the welding torch to heat the metal to a soft condition so that it responds readily to the textures formed by the hammers.

It is best to make all of your final alterations before you begin polishing. Reheating the metal destroys the finish, and you will have to begin the process again if you make your final changes after the piece is polished. Moreover, some finishes are toxic when heated, and repainting a piece that has been rewelded is very difficult to do well.

5-1. Sealing and finishing paints.

5-2.

5-3.

TREATING THE SURFACE

Although you work with relatively clean metal, the process of welding causes flux and scale (in brazing and arc welding) to adhere to the metal. While some people find rust and scale attractive, the art of sculpture includes a fine surface treatment. Scale, rust, and flux speed the deterioration of a piece.

Grease, dirt, and oil should be removed before you even begin to work with the metal. A cloth will wipe most of it away. Cleaning should be done away from the welding area. No grease or solvents should have any chance of combining with even a trace of leaking gas. This would be very dangerous. Rust is the major enemy of steel sculpture, as it erodes your finish and eventually deteriorates the piece if it is not protected. It is the humidity that causes the damage. Every artist wants her work to last. Obviously, the best precaution is a permanent finish.

Before getting into specific finishes, begin the finishing process by removing any rust on the piece. To remove rust from steel, brush it with a compound of 1/2 ounce cyanide potassium, 1/2 ounce castile soap, 1 ounce whiting, and sufficient water to form a paste. The steel should then be washed with a solution of 1/2 ounce cyanide potassium and 2 ounces water.

To preserve steel from rust, mix a solution of 1 part caoutchouc to 16 parts turpentine. Dissolve with a gentle heat, then add 8 parts boiling oil. Mix by bringing them to the heat of boiling water and apply to the steel with a brush as with varnish. The solution may be removed with turpentine. Sandpaper, emory cloth, a wire brush attached to a 1/4-inch drill (figure 5-4), or a flexible shaft polisher (figure 5-5) will also remove rust effectively. A bench grinder is useful for small work.

Scale is more difficult to remove, because it is the result of oxidation and it adheres to steel. A high-speed wire brush, a heavy-duty grinder (figure 5-6), and/or a flexible shaft polisher (figure 5-7) will do this job. Sandblasting is also quite effective. Since sandblasting equipment is expensive, have the piece sandblasted by people who have this equipment, such as a foundry, monument (gravestone) makers, or companies who sandblast buildings. Sandblasting leaves a pitted surface, but it can be polished with a wire brush.

Sandblasting is the truly professional way to clean your sculpture. Essentially, this equipment blows sand, glass beads, aluminum oxide, steel shot, and other materials onto the surface and acts as an abrasive to speedily and efficiently remove all unnecessary surface matter. Sand is the cheapest material used in sandblasting, but it loses 80 percent of its cutting power on the first use. Glass beads are the best method for cleaning small pieces.

5-4.

5-5.

5-6.

Sandblasting small items is done in a self-contained unit, which you view through a glass window. You manipulate it with gloves. For larger pieces portable units are used. They are basically drums to which a hose is connected. The sand is sprayed through a nozzle at the end of the hose. The sprayer wears protective clothing and a hood with a see-through window.

You can obtain a great smoothness and luster by continuing to polish your piece in much the same way as a jeweler: by using rouge and a buffing wheel. This equipment can be purchased from a jeweler's-supply house.

Depending on how scrupulously you wish to polish your work, you might want to purchase some flexible shaft polishers. There are two kinds: one for heavy-duty and industrial use, which accommodates a wire brush of 4 or 6 inches in diameter, and another for smaller pieces, which is similar to a dentist's drill and can reach into small crevices.

Flux adheres to the metal in brazing and arc welding. The flux from brazing is a white and/or glassy material that hugs the edges of the welds. Most of it can be washed off with warm water. Your supplier can also sell you a flux dissolver. I wash the flux off in warm water, sometimes adding ammonia, then I polish the work with a wire brush. If the flux is not completely removed, it will grow like yeast on the piece in humid weather. It will not harm the piece immediately, but it should be removed.

The flux that adheres as a result of arc welding must be chipped off the work soon after the weld is completed. If this is not done thoroughly, it becomes quite hard and must be removed with a grinder. A high-speed grinder is best, as it is quickest: 3,000 to 5,000 RPM is sufficient to do the job.

5-7.

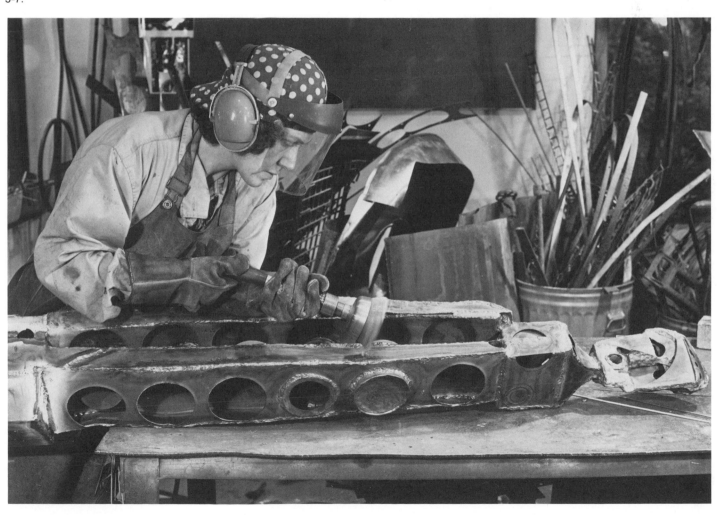

FINISHES

Electroplating

Electroplating is one possible finish for your sculpture. Steel can be galvanized. Galvanized steel is gray in color and will last for several years outdoors. Metals can be further plated in chrome, brass, cadmium, copper, or nickel. While it is possible to plate in gold and silver, this is quite expensive. Any plating that will result in a shiny surface will look best on a piece that has been highly polished and has a smooth surface. Plating tends to exaggerate irregularities, and the work can appear garish. Galvanizing results in a dull finish and does not have this problem.

Electroplating is done by placing the metal in a tub containing a metallic-salt solution. As the electric current passes through the liquid, it dissolves the plating metal (anode) that is immersed in the solution. The plating metal then deposits itself on the sculpture. The process involves the use of acids, and safety precautions include adequate ventilation and protection of the skin and eyes.

Clear Finishes

You can also preserve your work with a clear finish. Remember, however, that metal lives in the environment and is subject to change. Steel blackens with age; bronze varies—it can turn brown, black, or green, depending on the quality of the air.

Clear finishes can be purchased from your hardware store. There are several different kinds—oil, wax, acrylic spray, polyurethane (the same type that is used for wood), and epoxy. Epoxy is the most permanent, but it is very shiny, and there is no way to dull the finish without losing clarity. Epoxy can be thinned with paint thinner (xylene or toluene) and acetone.

Experiment with the various clear finishes to discover their possibilities and your own preferences. There are many other commercial finishes, and I recommend that you ask the paint companies which is best for your particular needs and purposes.

Brazed Finishes

It is possible to cover a steel or copper piece with bronze by brazing. The entire piece is tinned, a rather slow but attractive process. There are torches that spray bronze and other metal powder onto steel, but my own experience with them has not been satisfying. The layer of bronze is too thin.

Nickel silver is another strong and attractive surface on steel. Silver can also be flowed onto steel, but silver rods are costly. Bronze rods are the least expensive brazing material, and the results are very attractive. Unless two or three layers of bronze are made, the finish will not last

outdoors.

Brazed work should be polished and preserved with a clear finish.

Corten Steel

While Corten steel may be finished to preserve its gray color, when it is allowed to weather in the environment, it turns a cinnamon color that is self-sealing.

Before the weathering process is complete, a white deposit sometimes accumulates on the metal. This is due to ferrous sulfate and disappears upon complete weathering of the surface.

After a sculpture made with Corten steel is complete, scale and flux can be removed by sandblasting. The metal may then be exposed to the elements. Since the weathering process stains the ground around the sculpture until it is complete, care should be exercised in placing the work.

Paint Finishes

The secret of a good paint finish is proper treatment of the metal before it receives the final coats of paint. Sand or grit blasting is ideal. If sandblasting equipment is not available, sandpaper and wire brushing is a second alternative.

If you plan to paint on steel, your work should be protected against the severest exposure, which is a humid, salty seacoast. You need a protective film 8 mils (.008 inch) thick, which should be attained with three coats of paint.

The first two coats should be a rust-inhibiting primer applied to a 3-mils dry-film thickness per coat. Usually primers are half that thickness when applied.

A sandblasted surface provides a good tooth for the primer paint. It is a good idea to use a white primer, which provides good contrast to the metal surface, to assure complete coverage of the surface. For the second coat use a primer of similar formulation but in a different color for the same reason.

The finish coat should be a silicone-alkyd-type enamel, which can be purchased in various colors and degrees of luster. This provides a 2-mils dry-film thickness, which is also durable and retains color, gloss, and general appearance.

Both primer and paint may be applied by brush, spray, or roller, using common sense to achieve the proper results.

Painting can be applied to sculpture as if it were a two-dimensional surface. The sculpture of early civilizations was often ornately painted.

Novel Surfaces

Experimentation often yields creative results. Silver and gold leaf can be applied to metal sculpture in much the same manner as to wood. Sand and fabric can be adhered

to metal with a good bonding glue and/or epoxy. You can consider combining other materials such as wood, glass, and plastic. The possibilities are many. It is up to you to decide which kinds of finishes you wish to experiment with and thereby learn your art.

Patinas

By using chemicals, various patinas or colorations can be achieved on metals. There are three basic ways to achieve this: by dipping the metal into a chemical bath, by applying chemicals to the cold metal surface, and by applying chemicals to a heated metal surface.

The quickest and least complicated is the hot method. Great care must be taken, however, to prevent toxic fumes and spatter of the corrosive chemicals. Noncorroding or enamel tubs, which take up a great deal of space, must be used for dipping. Cold application of chemicals is a very slow method. There are many recipes for coloring bronze, copper, zinc, brass, and steel. They can be found in books on casting and metal techniques. Patinas are the traditional method of applying color to metal. These colorations are subject to change in the environment, but the surfaces can be preserved with the various clear finishes.

Experimentation is an important part of finishing sculpture. It is important to be sure that the finishing method is in keeping with the spirit and tone of the sculpture. The particular nature of your piece can inspire you to explore and understand new directions in finishing.

FABRICATORS

A *fabricator* is an industrial metalworking company that is prepared to create a finished piece from mechanical drawings. The drawings can be made from a full-size mock-up, and the artist can participate fully or not at all in the process. Fabricators are generally employed when the sculpture to be created is unusually large.

By using a fabricator, the artist, if she can afford this expense, can greatly increase her productivity. My own feeling, however, is that the pride of creation is dimmed without active participation on the part of the artist.

In a minor way local welding shops can be employed as fabricators. They can be approached to arc weld certain crucial sections if you don't have an arc welder.

If you are constructing large works, it pays to consult with a fabricator, as they are familiar with the stresses on large-scale pieces of metal. This information is important to the safety and durability of your work.

5-8. Copy of the original mock-up approved by Picasso.

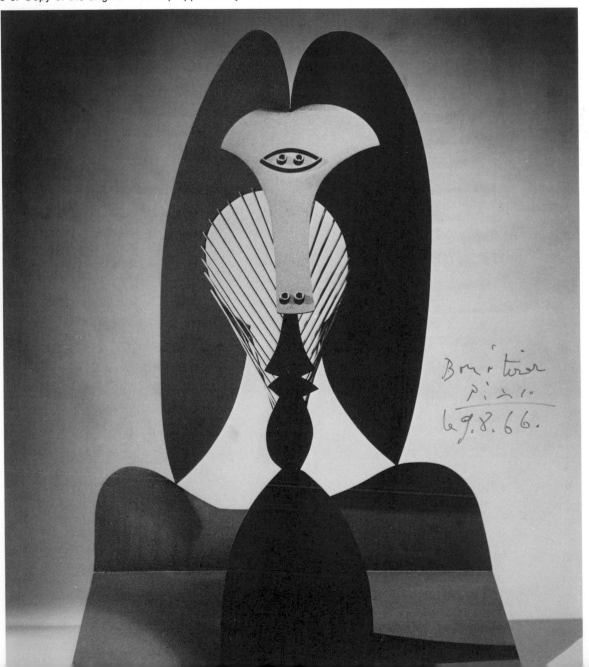

5-9. Finished "nose" and its "adornments" at the fabricator's—made of Corten steel.

5-10. Preassembly of the complete Picasso sculpture, now installed in Chicago at the Gary Plant of U.S. Steel's American Bridge Division.

Chapter 6.

Projects

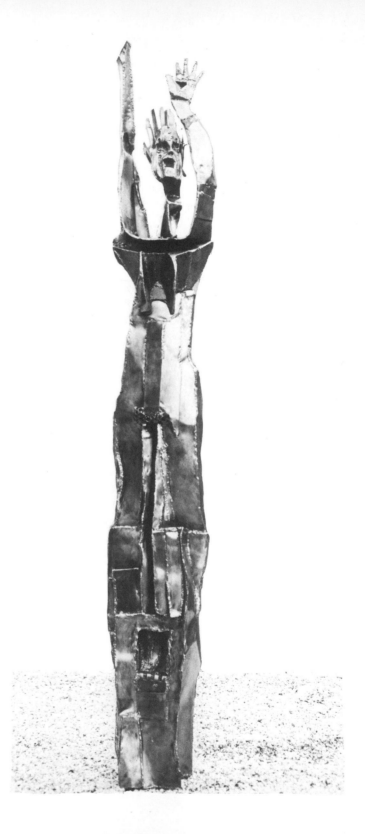

Now that you have learned how to weld, it is important that you immediately put your new-found skills to use by establishing a regular work pattern and some idea about developing a continuous body of work.

There are many ways to approach this. Everyone has her own particular vantage point, and it is for you to decide what is best for yourself. This chapter offers suggestions for organizing your beginning path as a welding sculptor.

Since your skills are still tentative, remember that you are also practicing welding and brazing techniques, which means that you should be prepared to discard and begin again. Knowing when to stop and what to eliminate is an important part of your creativity. In building form—bending and joining your metal to form your created works—you will make errors. Sometimes, however, your errors can be used creatively to help you create a unique piece. I have always found that my new work is consistent with my past work. This goes beyond a conscious commitment to a theme—it is an expression of the way I move, my intrinsic sense of form and balance, as well as the consistency of my inner spirit. Observe your work as it emerges towards completion; it will be very telling to you about yourself and often full of surprises. To create art is to say something.

Some people have a more immediate rooting in the communication process involved when they create a functional object. The function can help you focus on the problems of form and often proves to be a good way to introduce you to the fundamentals of construction. You will develop your welding skills at the same time.

6-1. *Transcending Effort.*

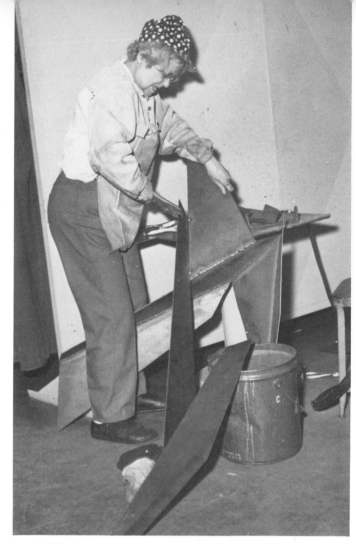

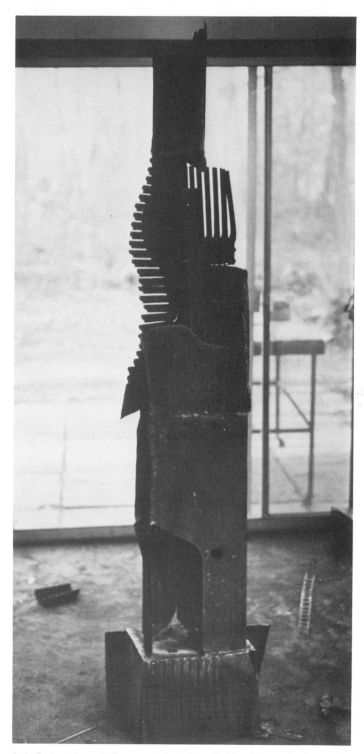

6-2. Positioning work. (Photo courtesy Hobart Welding School.)

6-3. Steel cut up for the construction of *Beloved*.

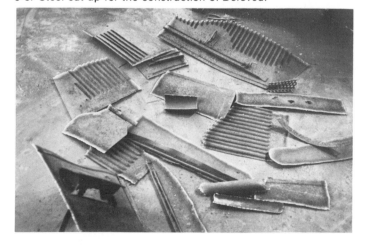

6-4. *Beloved*, partially completed. The finished piece is shown in figures 8-23, 8-24, and 8-25.

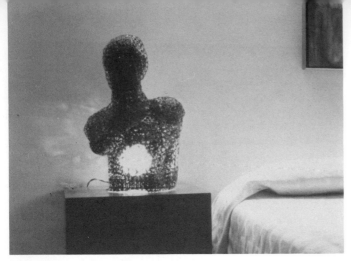

6-5. *Venus.* Painted steel with light inside, 24 1/2″ high.

6-6. Norman Tinker. *Tongs.* Steel, 24″ high.

Functional objects should at the very least be designed well. They move into the arena of functional sculpture when they begin to say something about the human condition. Here are some suggestions.

Containers: cauldrons, wine holders, pitchers, trays, bowls, humidors, serving dishes, magazine racks, boxes.

Holders (of people, things): chairs, benches, tables, candelabra, lamps, bookends, barbecue and fireplace equipment, studio equipment such as a table, anvil, cylinder holder, hat stand.

Adornments: body sculpture, jewelry, mirrors.

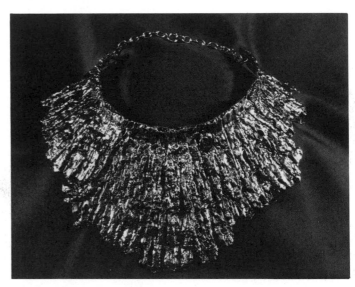

6-7. Judith Brown. Welded jewelry.

6-8. *The Third Face.* Steel, 9 1/2″ x 11″. This wall sculpture holds a mirror in the center.

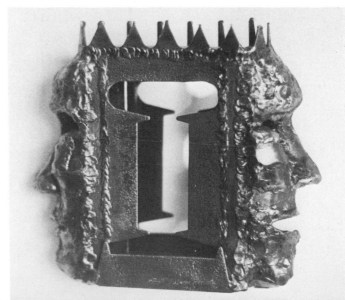

You can also make some useful studio equipment. For a portable firebrick welding surface (figure 6-9a), select five, seven, or ten firebricks and arrange accordingly on a flat surface. Then weld strips of angle iron so that they strap around the firebrick. Remember to leave some space so that you can remove the brick. Now weld some strips of steel as strap supports for the bottom side. You now have a work surface, which you can place on a suitable stand.

An anvil (figure 6-9b) is good for bending and flattening small work. Chalk outline a piece of scrap steel rail about 15 inches long to the shape of an anvil. Cut out the form with the cutting torch. Drill or flame pierce four holes to attach it to a solid support. The shape of the horn and any rough edges can be ground down with a portable grinding wheel. The finished anvil will weigh about 75 pounds.

A simple shop bench (figure 6-9c) can be made from a piece of 1/4-inch steel plate about 14 inches wide. Cut 14 inches off each end and reweld at a 90-degree angle. Brace the inside angles with an angle iron and cut hand holes in the two sides.

To make a welding table (figure 6-9d), you need firebricks. They are generally 3 3/4 inches wide, 8 1/8 inches long, and 2 3/8 inches deep. Make a welded frame with a piece of angle iron 28 by 48 inches and 2 inches thick. Brace the frame by welding steel strips as you did with the portable welding surface. Cover a section with steel plate to increase tabletop versatility. The legs are 28-inch lengths of 2-inch angle iron. Brace across the bottom with more angle iron. Weld casters on the legs for portability. Weld hooks and bars for C-clamps, rods, and your friction lighter. A shelf of metal across the leg bracing can serve for storage space.

angle iron

firebrick

a.

weld bands

angle iron

15"

b.

horn

pierce

28"

14"

hand hold

c.

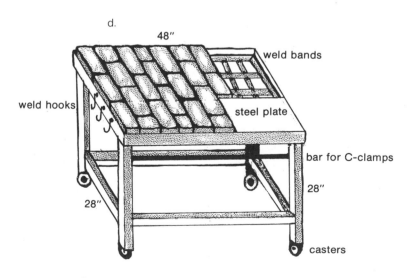

d.

48"

weld bands

weld hooks

steel plate

bar for C-clamps

28"

28"

casters

The objects in our daily lives—the things we touch and handle, what surrounds us in our environment—are expressions of our complete being. Containers, holders, and adornments are more than material necessities or vanities: they are familiar touchstones to our very existence and indeed profound representations of our lives, spanning the spectrum from trivia to tragedy, from joy to total fulfillment. Naturally, such objects are to be handled with care, and those of us who create these objects on an individual basis are indeed creating art.

The functional objects and functional sculpture illustrated on these pages can be a stimulus for you. Look at them with an eye towards using them as a jumping-off point for your own designs and ideas.

If you wish to be exacting, you can work carefully with logical and mechanical techniques, using the drawings of studio equipment shown in figure 6-9. Follow the directions to create a useful replica of what is represented.

It is, of course, unethical to copy sculpture. All creation is meant as a catalyst to your own creativity. Photographs of sculpture can reveal what has been done and what is being done. We always glean from the past, but if we create a replica of it, we are denying the ongoing process of life, and our work emanates sterility and irrelevance.

The terrifying thing about being an artist is that you are on your own. Sculpture fills space that is usually full of useful objects that people need. If they are to make room for your work, it has to be something that speaks to people. While we all recognize that many people do things because they want to be "in" or "good," as working artists our concern is truly with the most profound insight, feeling, belief, and search.

Sculpture is created out of concepts. While it fills the space of tables, walls, floors, and landscape, it is meant to make a statement. A statement is a life's work. The sculptor's statement is a joining of the individual to the culture, to the facts of existence and nonexistence.

Statements can be created from joinings—unity, chaos and order, emotion and experience. A statement is the result of exploring relationships: human, the natural world, optical phenomena, technical wizardry.

6-10. Cutting the skeleton metal.

6-11. Polishing the steel before brazing.

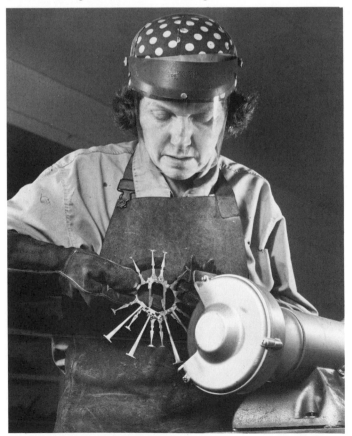

6-12. Brazing with Mapp gas and a small, portable Airco welding unit.

6-13. Completed neckpiece. (Photo by Janet Benton.)

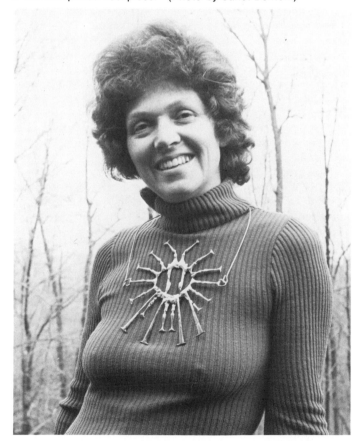

PART 2
Chapter 7.
Presenting Your Work

You are an artist because there is something deep within you that demands expression through an art medium. When you have developed your art and your technique and transformed them into a body of work, you are ready to expose your work to the outside world. The practicalities of presenting your work include not only creating work of professional caliber but also a system for showing it to the art public. To be an artist is also to be a businesswoman.

You must understand at the outset that to reach the audience you want is a long and laborious process: in addition to excellence of work some new skills are required. In the past artists were encouraged to ignore the practical aspects of art; the starving artist was romanticized. Even today many artists feel that dealing directly with selling their work is somehow diminishing.

Marketing is time-consuming, but it is definitely important. I believe that it is possible for an artist to make a living at her art; the fact that this is difficult should not deter you. You have to decide when to take the plunge—to devote your energies to supporting yourself economically through your art. When you are training is not the time; the first years of gaining experience are usually frail money years. You might want to consider an art-related job in which you can be learning about the art world while you are earning pragmatic dollars.

THE BODY OF WORK
In the process of developing your art you will get in touch with yourself on many levels and begin to make some serious decisions about what you want to do as an artist. You will choose a theme which is meaningful to you. Out of this focus comes the body of work. A body of work is a series of works that is consistent and begins to show an individual style; there is a common logic to the various pieces. When you have arrived at this point, you are ready to have a show, which will establish your existence as an artist to the outside world.

You may decide not to have a show immediately, but do begin to approach the art world from diverse angles. For example, there are juried shows listed in art magazines and posted on bulletin boards of local art schools. The listing will tell you how to enter. While these shows continue year after year, most entries are rejected, due to the vast volume of work received. Frequently a show will receive 1,000 to 3,000 entries and accept 30 to 100. This does not indicate that the world is overflowing with artists but with artists at this level.

I don't recommend juried shows as the only way to begin to receive recognition, because of the built-in frustration of intense competition and rejection. Talent really is something you must work at. If you want to be an artist, you will find the knowledge and the skill to develop your work to the level that you desire. It doesn't matter who you are—you will always come upon some brutal criticism that is devastating.

Rejection can be actual physical pain, which in time passes. A threat to your self-esteem should force you to reevaluate actions and activities and to center back to what it is you want to do, to say, and to achieve. Think of new, resourceful ways to follow your direction. The most hand-slapping sense of rejection may be the realization that the level of your work is not as lofty and/or deep as you imagined. Since developing as an artist is an ongoing process, your work improves with time. There is nothing to be ashamed of in facing exactly where you are at the present time.

There is an audience and a market for every level of work. Aspire to reach the audience and the level that you are both capable of and comfortable with. Marketing your work is taking a risk. Most of the people who are exposed to your work will not buy. You don't need many buyers to keep your work moving, but you need to become known in order to communicate your art and gather your buyers.

The first premise is that art is salable. People are genuinely interested in art, though by and large it remains a mystery to them. If you can help bridge that mystery, you will have an audience. Furthermore, in this world of automation and repetition, an original image has enormous power for those that hunger for it. Our insatiable populace sooner or later takes a turn at art. Many people experience much boredom in their lives. Good art offers, at the very least, relief from this boredom. Art also has status. We must recognize that this status is important to the credibility of the artist. Art remains after cultures have declined. People of wealth collect art, and the illusion of wealth surrounds it. In times of inflation art of recognized value is sought after.

These facts offer the artist real practical power. The art-buying public is growing rapidly, and it offers the contemporary artist an increased possibility of making a living through art. In the beginning your most immediate market is your friends and people who have an opportunity to visit your home. Make it known that your work is for sale. Anyone who knows you should know that you are serious about your work. Most artists' homes are an art environment; this environment speaks of their work. When your home is used socially, it is very clear that you are an artist. Think about exchanging work with your artist friends. This is a good way to expand your exposure among people interested in art; it helps you to establish your existence as an artist as well as being a very enjoyable part of your life. Feel free to call or write people you think would be interested in your work and invite them to visit your studio.

7-1. Exhibition, 1973, at the Museum of Art, Science, and Industry, Bridgeport, Connecticut.

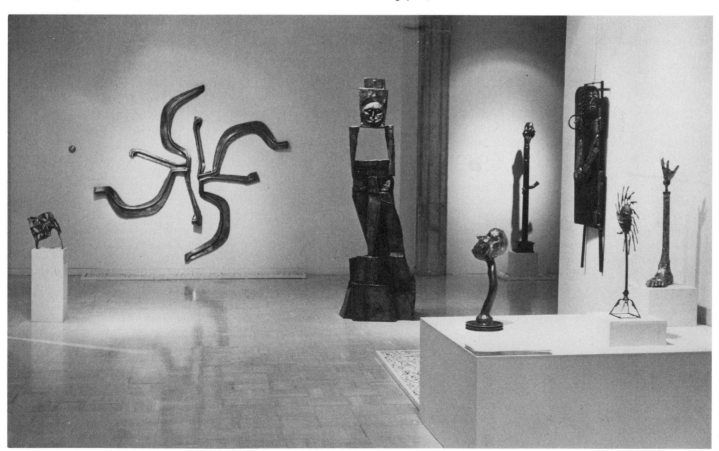

PHOTOGRAPHING YOUR SCULPTURE

It is important to keep a photographic record of your work, first as a good, portable way to introduce your work to galleries, magazines, and potential collectors; and secondly, to identify your pieces. It is more reasonable economically if you can teach yourself photography or if you have a good friend or relative who knows how to photograph art. If you can afford it, invest in the services of a good art photographer. Consider taking a course on art-object photography.

I have found black-and-white, 8-by-10-inch photos to be generally the most effective and useful means of presentation. A portfolio with the photos inserted under glassine or clear plastic is the format that most people enjoy and are comfortable with.

Color slides are also important, however, not only for their verité to color, but because galleries, museums, registries, and university art departments rely heavily on them. Slides are easy to store and catalog, and they can be shown to a large audience. The simplest way to present slides for an invidual showing is in a slide sheet, which fits into your portfolio. Color enlargements are expensive, but I think they are valuable from time to time. Duplicates of slides are cheaper, but you run a risk of inaccurate color.

If you are taking your own pictures, use a 35-mm, single-lens-reflex camera. Two cameras are good: you can take black-and-white photos and color slides at the same time. A lens with a longer focal length can improve the projection of your piece, and a polarizing filter will reduce glare.

To photograph sculpture, natural lighting is best; I find it worthwhile to wait for a pristine snow day. The snow background is exquisite for sculpture. Carting the sculptures about for photographing is work, but it is important to have a good background. Wall pieces can be photographed from above in the snow.

If you have flat ground and a good sky, you are in luck for your free-standing sculpture. Trees can present a problem: adjust for a diffused background, keeping the sculpture in clear focus. By using infrared film and a Wratten-25 lens, you can turn the trees white, which makes a dramatic picture and keeps your spring, summer, or fall foliage from melting into the sculpture when both foliage and scupture are in the same tonal range.

If you can't find a suitable outdoor background, purchase a mat white-and-black shade (back to back). This is used by portrait-photography studios—ask a photographic-supply house or your local photo shop where you can purchase it. You might want to try a slide screen. I often tack white paper behind the smaller pieces and place white paper on a table that I keep outside against the house for this purpose. You can join smaller white sheets together with surgical adhesive tape; the line can be erased when the photo is reproduced.

Indoor settings with artificial light complicate the photographic session, since shadows are cast both by the piece as a whole and by the forms within the work. You must decide if you want sharp contrast or softer, more diffused lighting. Basic lighting is one dominant light source, such as a spotlight (with or without a diffuser). Think of this light source as the sun. Supplementary lighting will develop the atmosphere and mood for the photo. Place this lighting further away or use bulbs of lesser intensity.

As soon as it is practical, photograph each new piece from several angles in both black and white and slides to get a comprehensive record. After you have gathered a good set of photos that show your work accurately and handsomely, think about how to present it. Your slide case and portfolio should be unique to help you attract the interest of dealer and collector. I have two portfolios: one for photographs and one for publicity. These I never leave with anyone—I show them personally. Since I keep extra copies of the best photos, I can make up a small portfolio to leave with a prospective buyer for a reasonable length of time.

PLACING YOUR WORK

It is up to you to decide when you wish to approach the public. If you have not established a biography, it may seem difficult to place your work. There are no hard and fast rules for becoming known and establishing a market. It is up to you to seek out and respond to opportunities as they appear around you.

Local Sources

Many communities have local art shows where you can begin to get experience in exposing your work. Sometimes there are prizes and cash awards. Local libraries and banks are often interested in work of upcoming artists and are usually easy to approach. They may offer you solo or group exhibitions, and they are good places to become familiar with the mechanics of selecting and placing your pieces and the procedure of brochure, mailing, opening, and publicity.

Some local stores are agreeable to hanging art. You can also try business offices—doctors, dentists, realtors, and travel agents. All of these places deal with people who spend money, who will have a chance to see your work. A fashionable dress shop whose proprietor is interested in the arts may put you in touch with a group of collectors. Print business cards and leave them at the shop. Local merchants might want to feature you in their regular advertisements, since an association with art can draw new business to the shops and improve their image. Most likely

your work will be included in their insurance, but you may have to provide your own policy. Decide how to handle sales—if the shop "works" for you, it deserves a commission.

Museum exhibitions will make you known to a wider audience, so they indirectly help you increase sales. Local museums in smaller communities are very approachable, and they usually have substantial space, some prestige, and good access to the media.

Galleries
After you have had some local exposure, you may want to approach the galleries. Galleries offer the artist certain important services. They sell your work (but not as often as you would expect). They price your work realistically. They have a following. They provide an environment for your work that furthers your existence as an artist. The better the gallery, the better your image. Galleries have a clear idea of what sells and choose accordingly. The commission they take varies, depending on the location: 33 1/3 percent has been a traditional commission for many years, but many galleries take 40 percent or more. You must approach a gallery with a clear sense of fair exchange. Many artists feel exploited by the gallery system. You should be aware of the limits of what a gallery can do for an artist, especially an unknown artist. It will set a realistic price, introduce your work to some new buyers, and provide an ambience, but you must also help the gallery sell your work. The time the gallery can spend on promoting your work is limited, because they are also promoting the work of other artists.

While New York City is supposed to represent success, most exhibits there are not successful. The competition is keen, and the artist is so often expected to absorb most of the costs. Your local communities (take a tristate area) will probably be more directly profitable and helpful to your budding career. There is no reason for you to pay for a show or be required to donate a piece to a gallery.

Take your relationships with the people who offer you an opportunity to show very seriously. Sometimes very difficult things happen as a result of inadequate communication. You can find things done very badly or not done at all that you had assumed to be obvious and understood. Every aspect of exhibiting must be discussed and clearly defined before you agree to an exhibition.

Your search for a gallery will be simpler if you keep up with the art world. By following the art magazines (see the appendix), you will develop an idea about which galleries may be interested in your particular art. The Yellow Pages are a good source of art galleries in your area. Visit them to see if you want them to handle your work. Introduce yourself and express your interest. Make it a point not to interrupt any sales in your eagerness to speak with the director. If there is interest on both sides, begin to discuss the various possibilities of showing with them. This could be on consignment (your work is on loan to the gallery and for sale). You can start this way and see if your work has a good response with their clientele. If you are successful, you can participate in a group and/or solo show. An advantage to the group show is that it brings in the other artists' audience, so you receive more exposure. A solo show is good for the ego, and it is very telling to see the impact of your work en masse. You must, however, have enough of a following to warrant a solo show. The event itself will extend your following, but it is my experience that buyers appear more readily after they have heard about you from several sources over a period of time.

Private Shows
There are many other ways to exhibit your work besides galleries. One of the most enjoyable is a private show, either of your work individually or along with some artist friends, in someone's home—your own, a collector's, or another artist's.

Invite a group of people (30-200) whom you know are interested in your work. Make it understood that the work is for sale. I have always done very well at these showings; people bring their friends, and I extend my mailing list. And if you have the show at your own home, you don't have to transport the work.

I usually follow the showing with individual appointments for people who have expressed special interest in seeing the work again to decide on a specific piece. When people express an interest in my work, I frequently offer them an appointment at their convenience to view my work, whether or not I am having a show. I enjoy the person-to-person contact and have found that the collector does as well. This is the most elegant way to sell your work. You are literally at home, which gives you a great advantage. Collectors love to see your studio.

When you are trying to sell a piece, allow the client time to look over everything. As she selects pieces that especially interest her, pull them out of their resting place and show them individually. An interested buyer will definitely aid you in making the sale. I always find the comments interesting, and I enjoy the enthusiasm as the person finally decides on a favorite piece. I always feel I have made a friend along with a collector.

Handle a sale as though you know the client is going to choose at least one piece. I frequently let my clients take a few pieces home on approval for a few days. If a decision is reached, write out a bill of sale, which is needed for insurance purposes. Selling in this manner generally means instant payment.

Organizations

Another source for exhibiting your work is an organization (see the appendix). You can join one that exists already or invent one for the purpose of exhibiting your work. People of like minds tend to gather together. You and your artist friends need a place and a vehicle for showing your work.

It is very simple to start an organization. It isn't necessary for you to immediately go through the formalities of a national charter. Gather together a group of people with a similar set of goals, which you arrive at and begin to act upon. Send out a press release, and you are in business. The organization will last as long as symbiosis continues. Be careful not to get into the pitfalls of domination and petty power politics. Responsibility should be held by everyone: leadership is not something that fits in the hands of one or two members of the group but is interchangeable. This can safeguard your group from the abuses of hierarchy. Everyone has special skills, which they can easily contribute to the group without feeling put upon. Remember, the function of the group is to help all of its members.

If you share a concept that is strong enough to hold your organization together, the many ramifications should be discussed by each member of the group in turn. Knowledge of everyone's ideas creates an atmosphere of understanding and communication that makes it possible for each person to function independently while still understanding the goals of the group. This technique is a definite contribution to smooth, interpersonal, group success. Your group may want to formalize into a co-op gallery to deal with rent, maintenance, and steady shows. You may be content to use community facilities for occasional events. Think of getting support from your local arts council or other local patrons of the arts. If you can get your community involved, you will increase attendance and eventual sales.

Innovative Opportunities

The general gallery exhibition does not expose your work to a very large group of people. The world is full of intelligent and sensitive people who are interested in art but have no way of experiencing it in the normal channels of their life. If you can enter their sphere in some way, perhaps in the content of your work, you are opening the door to new buyers as well as to a new audience. With my approach of bringing sculpture into what can be described as the world of performance, I am able to expose my work to the general community (PTA and library groups), the university, the women's movement, and the religious community. Furthermore, by giving a presentation, I am able to be paid for this aspect of my work. Sometimes I discover a new collector and thereby foster sales as well.

Developing your own projects and methods for showing your work is a good way to bypass the tedium of being accepted by the establishment, and you will be part of what is happening in the arts.

MOUNTING AN EXHIBITION

The mechanics of an exhibition are as follows: find the space, agree to a time, and work out who will take responsibility for what. This varies from place to place. Some galleries expect an artist to pay for the "privilege" of a show. I don't think that this is necessary or desirable, although it is very common for the artist to assume many of the expenses. Here again, the arrangements are flexible. If you have an exhibit in a museum, they frequently have at least a limited budget. Regardless of where you exhibit, agree on a timetable for printing, mailing, press releases, advertising, and delivery and return of sculpture. Who does what is where the art of negotiation comes in, and I suggest you read a book on the art of negotiation. The elements of an exhibit are generally: transporting the work; setting up the show; expenses for the opening, brochure, mailing, advertisements, and publicity; mechanics of payment; return of unsold work.

Transporting the Work

Galleries generally will not agree to transport the work. It pays to ask and to further ask if they will return it, since transportation can be costly. You can rent a station wagon or a van, hire someone with an open truck, or hire a traditional mover. Naturally, the cost of transportation increases with the size of the vehicle and the number of helpers. I try to construct most of my work so that it will fit in my car. Some of my work comes apart.

In general, if the exhibit directors want you more than you want them, they will provide more services. Keep in mind that when you control the elements of the exhibit, you are more likely to get what you want. If the gallery arranges for transportation, they will sometimes take their time on the return. This can be frustrating, and you may consider packing the work up yourself. You can often work out a one-way deal in which you pay for shipping the work there and they pay for shipping the unsold work back. I think it might be better the other way around. Be flexible and decide what is right for you.

Packing and shipping are costly and time-consuming. For exhibitions within commuting distance it is best to wrap and stack your sculpture using a car as the container. If at all possible, try to have the long-distance places assume responsibility and cost of shipping. Wrap the scupture in fabric, foam, or newspapers (once I had work returned to me packed in popcorn)—anything that provides cushioning and stability is good. Small pieces can

travel in supermarket cartons. For extra safety pack a smaller carton filled with sculpture inside a larger carton with padding between the two. Save the foam that packages come in to wedge between pieces of sculpture. Always be sure that the work is free from any defect that could cause damage. Painted pieces deserve extra care to preserve the finish. It is relatively easy to pack small pieces, because welded sculpture is rather sturdy and small pieces are usually not that heavy. Larger pieces must be crated in wooden boxes constructed to the size of their contents. I suggest that you work with a reputable mover. There are several movers who specialize in fine art—check the Yellow Pages. Sculpture is professionally packed by wedging, bracing, or floating. Wedging and bracing involve packing material that is cut to fit the contours of the sculpture. If the sculpture is heavier than the box, the packaging material must also be sturdy enough to absorb blows and keep the sculpture from pushing through the box. Floating is surrounding the piece with a soft, cushiony protective material. It is the easiest method to do on your own.

It is simplest and cheapest to ship by United Parcel and/or parcel post. They both have insurance, weight, and size limitations.

United Parcel: $100 automatically insured; maximum insurance, $5,000. 50-pound weight limit; 108-inch length-and-girth-combined limit. They will not insure nonreplaceable items. To make a claim, show the value via bill, invoice, or certified appraisal slip within a year. There is a slight charge for pickup.

Parcel post: Maximum insurance, $200. Beyond that value you must register the package and send it by priority mail, which is more costly. Weight limit, 40 pounds; size limit, 84 inches length and girth combined.

Railway Express Agency: Costly. The work must either be crated or in heavy cartons with cushioning. No size limit. Automatically insured for $550; beyond that a special contract can be drawn up. Slight charge for pickup.

Naturally, all packages must be clearly labeled with address, return address, and any other information you may wish to include, such as a packing slip indicating contents of the package or the bill of sale. The further the package has to go, the more costly the shipping fees are.

Setting up the Show

Once the work has arrived, participate in hanging it. Working with gallery and museum exhibition directors can teach you a great deal about how to hang, but as an artist, you have a sense about the work that should help in mounting a good show. It is always necessary to have assistance, as it is a physically wearing job. It is sometimes exasperating to be left alone with this important task, but it is more exasperating to leave the work with someone else and be dissatisfied with the results.

Sculpture is generally displayed on pedestals or hung on the wall. I have also suspended pieces from the ceiling, which is a very effective device. It pays to make a floor plan of the space and to mentally try out different arrangements before you actually begin. Since sculpture is heavy, this will save you a great deal of energy. Sometimes special panels and bases need to be made. A museum will have a budget and a director to handle this. Galleries tend to be more frugal on special exhibition mountings.

You will probably discover that you are consistent in the variety of sizes that you choose to work with. It is a good idea to create work in sizes that are suitable for home, garden, and large buildings. Examine your pieces to decide on appropriate bases. A good, all-purpose base height is 28 inches. Large pieces, of course, require a smaller base, if any. A wooden base, painted white, is best and cheapest. Black laminated plastic is lovely but expensive.

The design of your exhibition must be logical. Keep in mind that people will be walking around and through the exhibit. Each piece must have a breathing space. At first I tended to exhibit too much work. Sometimes it is a good idea to think of the space in units and to have panels constructed marking off your space. Some pieces need a vista; others work best in an intimate space. Give the best locations to the strongest work and only show your best work. You will know which pieces command dramatic attention.

Although your work speaks for itself, people come to an understanding of it through many different directions. We are a verbal society, and words help people to understand and appreciate what you have done. It is helpful to have some written material on hand describing your themes and philosophy and a biography to familiarize people with your background (see below). You should also make a list of the work on exhibition: number and price the various pieces. Some galleries do not have the prices on display. I prefer to be very direct and have the prices on a sheet that is readily available to the viewer. Make up this list for your gallery; they will reproduce it for the exhibition.

The Opening

The opening of an exhibition is your main opportunity for selling your work. Although a gallery does not expose your work to a very large number of people, it does introduce you to an art-buying public. Most of the people who buy my work, however, know me or have heard of me prior to the exhibit.

Most of the people at the opening will be those to whom you send invitations. You should invite different people to your openings for different reasons. First, there are your

friends with whom you want to share this important event. An exhibition has a social aspect. You also need your friends for moral support—showing your work is a vulnerable experience. Secondly, you invite people who are interested in your work for its artistic merit; their comments will be helpful to you. Past collectors usually have a continuing interest in your work and deserve your attention. They often bring along prospective collectors and buy yet another of your works. Finally, there are new people who have clearly expressed interest in your work. All of these people are needed for a successful show.

The gallery itself may invite new people to your opening and/or bring in prospective buyers individually before or after the opening. Some people will buy at the opening, but most will require a special telephone call and an appointment to see the work again privately with you and/or the gallery director before making their final selection. Watch the people who come to the opening and mentally mark down prospective buyers. Your gallery can help you with this.

Part of the mechanics of an opening are refreshments: serve wine, nuts, raisins, canapés, hard liquor, sherry—whatever your budget and taste desire. An opening usually takes place in the evening and lasts 2 to 3 hours. The time changes seasonally—later in the warmer months, earlier in the winter months. New York City openings are frequently on Tuesday evenings, but weekend openings are also common.

Insurance
Inquire about the insurance coverage at places where your work is shown. Many galleries and juried shows do not take responsibility for exhibited work. If this is the case, you may want to take out your own insurance, which is called a fine-arts policy. Since your inventory is always in flux, you will have to keep a current record of the pieces to be insured. Insure the work at your price, not including the commission paid to the gallery. Notify the insurance company of changes in your inventory.

You can include work in your own collection in your homeowner's policy. Artwork temporarily stored at home is not covered—this requires a rider to your policy. Generally, this is inexpensive. The price of insuring your art within an ordinary fire-and-homeowner's policy varies, depending on the precautions you take, and it only covers the cost of the materials. If you have the work appraised in order to receive your market-value price, the premium cost will be greater.

Always insure your work in transit. A floating policy will cover your work no matter where it is. Check around with several insurance companies before taking out any policy.

Payment
Discuss with the exhibit director the manner of payment. Usually you will be paid at the end of the exhibit, but sometimes buyers don't pay immediately, and you have to wait for your money. You can usually clear up matters of this sort by talking to the director, although it may be necessary to ask for a piece to be returned. Once a gallery didn't pay me for the sale of a small piece; I threatened to take the matter up in small-claims court and was immediately paid. This ended my relationship with the gallery, which was fine. There is no need for such problems.

PROMOTION AND PUBLICITY
Reviews
Art critics generally come before the opening—the large art magazines, as much as a month before. This usually means storing your best pieces at the gallery before you bring the main body of your work for the show. I am no expert on the vagaries of being reviewed. Some reviewers are steeped in the hierarchy and do not look at a newcomer's work seriously. Among the body of reviewers, however, chances are that some will give you your due and arrive at a thoughtful and serious review.

There are many more review avenues than the main art magazines. Local papers and magazines cover the arts in that area. Keep a listing of these sources. In time you will develop a relationshp with them, and they will get to know your work. As you become more known, the traffic and quality of people traveling through your exhibition will grow.

Prior to your exhibit, send out a press release. Your gallery can help you with this. Include the necessary information: who, what, where, when, how, and why. In addition to the facts, make your release interesting and provocative so it will be included in the media. The media are barraged with news. Be clear, direct, and concise—everything on one page. This press release can be used later in your publicity packet.

Try some more unusual kinds of publicity—I had buttons made for one exhibition, which I gave out at every opportunity, and I have also organized several street processions. These activities will attract the attention of the media. Exposure on radio and TV forces you to be extremely articulate about your work, a helpful skill in all phases of marketing.

Keep a file on all newspaper clippings from your exhibits and record your media (radio and TV) exposure. Keep a record of your participation in panel discussions and other group presentations. Make copies of reviews and articles in which you are mentioned and keep these available for the packets you send to the media, interested galleries, collectors, and for grant applications.

Biography

It is important to print up a biography and to keep it relatively up-to-date. It is a handy giveaway to the press and to people who introduce you at a lecture, show, or presentation. Include what you want people to say about you and your work. If you include your marital and/or motherhood status, these will be the first things people will notice. It is to your professional advantage to establish your individual identity. In general, a biography includes education and professional experience. Education includes schools, special people who have been your teachers, and degrees. While there are standard categories, feel free to invent your own. As a general guide, include exhibitions, group and solo; special projects; grants; organizations; community work; special publicity features; books and articles; and awards. You can also describe people, events, or experiences that have influenced or inspired you.

The Brochure

The brochure is the most important single item of your show. It will remain a publicity device long after the show is over. Give serious thought to this printed piece. In addition to the practical details of what, where, and when, include some biographical information. The brochure is also an invitaton to the exhibition. You can include a special invitation to the opening, a card that fits inside. You can invite the entire mailing to the opening if you don't think you will be inundated with hordes of people. I always include photographs of new work that will be exhibited at the show, the theme, and some descriptive paragraphs on myself and my work. After the exhibit I continue to send out these brochures to people I am newly acquainting to my work.

When you have printed brochures for several exhibitions, you will have a packet that includes biography, brochures, and copies of newspaper clippings and articles. This packet helps to acquaint new people with your work. It is important to have identifying material that you can give away freely.

It is worth studying advertising design so that you are knowledgeable in layout and printer's terms. This way you can deal effectively with the printer and save a great deal of money in the long run by designing your own brochure and getting exactly what you want. Art-supply stores have a kind of type called *press type*, which you can use for your headings. A body of type can either be purchased from the printer (typeset), or you can rent the use of an IBM Executive typewriter, which uses printer's spacing. Your photographs can be reduced or enlarged—reduction is less distorting. Experiment with different folds, sizes, colors of paper, etc. Decide if you want an envelope—this can depend on the size of the mailing and how much you like to stuff envelopes. Be sure for the future that it will fit into a convenient-size envelope, either business or 9-by-12-inch manilla, for future mailings.

The Mailing List

Keep an ongoing mailing list. Whenever you come upon people who seem to be interested in your work, add them to the current list. After a while this list will become varied geographically, and when you have a show in a specific area, you can pull out names of people who live in the area. If you type your list on four-sheet carbons, which can be purchased at your local stationery store, you can send out three mailings before you have to reproduce your list.

Your success in terms of sales will be largely due to your handling of the opening and the quality of your mailing. Make sure to invite the press. They are more likely to come if they know you or a mutual friend. This begins to happen as you become better known. The local media (outside of the major cities) will come because not too much is happening in the arts and every event is newsworthy. This is not to be discounted, since being something that is happening is terrific.

Advertising

It is common to take out ads in the art pages of newspapers and magazines. This is something you must decide in terms of your budget and your desire to advertise. Decide in your own locality which are the best places for you to advertise and if the advertisement will in fact bring you enough of a return to warrant the expense. Call the media in which you wish to advertise and ask them how soon before publication they require the copy (usually 4 weeks in advance). You can do your own layout and create a unique ad. Remember to be clear and direct and to have an original image. The areas for innovation are endless.

RECORDS
Identification

When you first begin to work, each piece is clearly identified in your mind. You remember where each one has been shown and to whom it has been sold. As time goes by, however, you create many pieces and begin to need an orderly system to record, identify, and describe when and where it was shown, to whom it was sold, and the price.

When I am finished with a piece of sculpture, I immediately sign and number it with an electric engraving tool. I place the number behind my signature, either inside or on the back of the piece. If you wish to copyright your piece, add © and the year after your name. I list the new piece in my catalog, which also serves as my price list, right away; I include dimensions, material, and title. I get

two contact sheets for my black-and-white photos. I cut out the small photos from one of these contact sheets and put them on 3-by-5-inch cards that have the same information as the catalog. I put the slides in front of the identifying cards. Duplicate the best slides and keep them on hand in slide sheets ready to send out immediately. If you label each photograph and slide with your name and address and put *return* on the label, you might save yourself some money by getting an occasional photo returned. *Never* loan the last slide of a particular piece. Also label the catalog number, title, medium, and size. I file the photos numerically, which helps in identifying the work.

Each piece of sculpture has a personal history—how it was constructed, what inspired you, your life at that time—and a history of where it was shown. You may find it useful to keep this record, since buyers often like to hear about the piece they buy.

Collectors and Exhibits
Keep a file for every gallery that you do business with and a collector's file. My own filing system includes addresses, correspondence, exhibitions, and grants.

Keep a current yearly file for new addresses and a master list. As you collect new addresses, have them typed on four-sheet-carbon address lists so that you can send out a sheet for an exhibition or special event without having to reduplicate the list. List correspondence alphabetically with separate files for special projects and persons. Each activity should have its own file.

Under exhibitions I include any transaction in which work leaves the studio. Nothing should leave your studio without a signed record of the terms. This keeps everything clear and businesslike.

Under the grant file, include every application you have ever submitted. Xerox a copy for yourself if it is not included in the application. At the end of the grant year you have to submit a presentation of accomplishments and an expense accounting. Keep clippings and receipts in the file until you write up the report. If you intend to continually apply for grants, it pays to keep the deadline marked on the file. I have missed a few deadlines by tucking the files away and getting back to them after the time had gone by.

Keep current material on file in a calendar portfolio, which includes folders for each month. File all timely material that involves ongoing preparation, such as exhibitions, general appearances (panels and media), and project deadlines.

Price List
A recorded price list is very important. It is bad practice to quote different prices for the same piece: sooner or later this will be discovered and prove embarrassing to you. I keep one set of prices, regardless of who sells my work, because I feel that my work sells at a definite price and I know that with time the price goes up.

Since I have sold a great deal of work on my own, I do not lower my price for people who come to my studio. I feel that I earn my own commission by opening my home and studio and giving my time for this purpose. I would rather sell my work exclusively through galleries so that I could devote more time to the actual production of sculpture. Still, I derive a certain amount of independence from selling my own work. I am not subject to the whims of the gallery.

I began by pricing my work very low. As sales and quality increased, so did my prices. I generally decide upon the price after I finish a piece and do not usually change it, regardless of how my future prices increase. I have, however, reserved some of my best earlier pieces for my own collection, but I probably would create a similar piece on commission.

When I have a showing, the gallery usually increases my prices, and the work generally sells at their prices. It is to their advantage to price realistically for their clientele.

Sadly, women's art generally sells at a lower price than men's work. It is helpful in this situation to be prolific and not to underprice yourself. It is good to have a range of prices so that many people can afford to buy your work. Your major pieces may not sell as often, but they are an important addition to your work and represent your highest achievement. The existence of this work helps to sell your smaller pieces.

Don't discount your small sales: each sale frequently leads to another as you continue to produce high-quality work. If you have too much work on hand, consider a "sale." There is no reason for artists not to use ordinary marketing techniques. If you are moving, be sure to have a sale. All of the people who admire your work but have never bought any will come out of the woodwork.

To arrive at a price, take into account the excellence of the piece, the market's ability to pay, and the actual cost in time and materials. A record of labor hours and material costs, including assistant's hours, is helpful not only in helping you arrive at a price for your sculpture but in determining how long it takes for you to complete a new work. Keep a work log, including overhead expenses, just as any business would do in setting a price. Remember to include photographs, brochures, and packing and shipping, storing, and the time spent finding a collector in the cost of your work.

As your reputation grows, so will your prices, but be careful not to price yourself out of your market. Prices are generally higher in the cities, especially New York City, but

competition is extremely keen. By attending exhibits and noting the prices of actual sales coupled with the quality of work, you will begin to understand the value of art.

You can experiment with pricing, but you must learn to be an objective judge of the quality of your own work. Pay attention to people's comments: the work they like the best will fetch the highest prices. Remember, you want to sell. A good price is one that sells your work and gives you a reasonable profit.

Accounting and Tax Records

A system of accounting is important for many reasons. It helps you, in pricing your work, not to ignore what might appear to be hidden costs so that you do not find yourself actually subsidizing your collectors. It gives you a clear idea of the ratio of income to expenses so that you can balance your books and keep yourself solvent. You must keep records for tax purposes. Many of your business expenses are tax-deductible. Keeping a record of these will assure that, in the case of a tax audit, you will be able to prove your expenses.

The expenses of being a sculptor are varied. The cost of your materials is the most immediate but not necessarily the most expensive. Setting up a studio is not just a matter of purchasing a torch and putting up a table, although the ease of starting in just this way is what enables us all to begin. You will eventually want to have a roof. This will consume heat and electricity. If your studio is in your home, you should include a percentage of your house costs as studio maintenance. These are genuine costs and should not be discounted. My own house is almost exclusively used to maintain my art. My home is a showcase for my work, where I do business, which includes maintaining an office with an assistant and actually constructing work in my studio. I also use my home as a sales gallery and entertain people in the art world.

All of the attendant costs, including supplies, food and drink, costs for entertaining collectors, mileage, parking fees, tolls, taxis, meals away from home, photography, brochures, rental equipment, depreciable equipment, consultant's fees, salaries, maintenance, memberships, books and magazines, publicity, show fees, and state taxes, are part of the cost of doing business as an artist. A day in the city looking for a gallery costs you money and time. Keep a record of these costs in an accounting book, listing the various categories of costs.

Select a form of record keeping that suits your particular sense of organization. I use a ledger book that is divided into *income* and *expenses*. The advantage of a ledger is that you have a great deal of information readily available, and you can keep an up-to-date account of your income and expenses.

If you are selling your own work, you must obtain a sales-tax number from the State Tax Commissioner. Write to your commissioner, and you will receive the necessary information. This is important, not only because it is legal but also because it establishes the reality of your doing business as an artist. You can also register your business at your local town hall. Go to the town hall, tell them that you wish to register a DBA (doing business as), and you will receive a form that you fill out to become officially registered as a business in that community.

You must keep a record of different categories of sales and whether or not they are subject to tax. You report your gross receipts of sculpture sales, then a list of out-of-state sales and sales for resale, such as those to an art show or gallery. These you do not pay tax on. When you make your sales, collect the sales tax in addition to the sales price. When you sell for resale, record the reseller's tax number. It is useful to keep a form of every sales transaction. You might want to keep four file boxes for your running accounts: accounts receivable, paid and unpaid, and accounts payable, paid and unpaid. I use my checking account to keep these records. When I deposit a check, I list who it is from; when I pay a bill, I record the purpose. I store bills to be paid in the checkbook and the unpaid accounts receivable on the income side of my accounts ledger. It is important to develop a system that is not overly time-consuming yet keeps all of the necessary information at hand.

You should, of course, have a will. As an artist, your art is part of your estate. It is important that you have an able executor for the arts aspects of your estate, someone who is an intelligent appraiser and is familiar with the art-tax situation.

Your sales establish the market value of your work. The Internal Revenue Department definitely does not support artists in its tax policies. If you donate your work or give it as a gift to an individual or institution, you can only deduct the cost of the materials. A collector, however, can donate from her collection and deduct the market value of the work from her taxes. If you have a great deal of work on hand at the time of your death, it is likely that the work will be taxed at its current market value, regardless of how slowly the work actually sells. The market value of your work can actually rise or fall, depending on how the work is handled from that point on. The income-tax people are not sensitive to the vagaries of the art market and tend to assume a given stability in prices that in fact is not the case, so it is important to have able people to handle your work and estate in the event of your death. It is possible to have the artwork evaluated either at the date of death or six months later.

Although you cannot deduct the worth of your pieces beyond their material cost, you probably should consider giving your work throughout your lifetime to those whom you wish to own it. You can give away $3,000 a year to as many people as you want (or a total of $6,000 if your spouse agrees to join with you in gift giving). Beyond that amount you must pay a gift tax, unless you deduct this sum from your $30,000 lifetime exemption. It is possible to give away a work worth over $3,000 over a period of more than one year. Document these gifts by a federal-gift-tax return to establish the question of ownership. If you exchange art with another artist and donate that art to a charitable institution, you can deduct the fair market value from your income tax and vice versa.

GRANTS

Grants are an ideal way to help support your art. They are very difficult to get and require a great deal of time making proposals and keeping records, but if you receive a grant, it is worth it. Unfortunately, the batting average is pretty poor—rather similar to entering juried shows. Stick it out and you will eventually win. Each year the sum of money available for the arts is growing. The best immediate source for funds is probably your state commission on the arts (the addresses for each state commission are listed in the appendix), and your local library will have sourcebooks on foundations active in the arts.

I considered applying for grants years before I actually made the plunge. Grant sources often do not even reply, and you may be told that your work does not fit into their category, but they do not always explain their category. It has been my experience that in order to receive a grant, you must be very articulate about your work. Write a proposal that describes what you expect to do, your aims, projected costs, and a personal statement that gives the funding source a clear idea about your work, what motivates it, and where you are going as an artist. I think it is a good idea to visit the funding agent soon after you decide to apply for a grant. The person-to-person contact will help you determine exactly how to prepare your proposal. Call for an appointment and arrive with a presentation of your work. If you cannot visit, at least telephone for help with your proposal.

The advantages of participating in the search for grants are many. Articulating your projects is very helpful to the development of your work. If you decide to develop a series of pieces around a certain theme, the reinforcement of developing a proposal is helpful to you in clarifying your ideas. Further, if you receive the grant, it is in essence a contract, and you must fulfill this obligation and privilege. This assures productivity. The prestige that the grant gives you is very helpful in the minds of those establishing the worth of your project.

To apply for a grant, write for an application. It is important that you describe your work fully and include many photographs. The granting body is also interested in letters of recommendation. Some want to know how you are reaching the public and want letters from responsible people in the community rather than from the known greats. Some want you to write a personal statement describing what your art means to you; they consider it important to know quite honestly the forces and philosophy that motivate your work. Other granting agencies don't want this personal approach. It is my impression that they award their grants on a superelite system. You must be well known and well placed to receive those grants. Since most grants are for artists under 35 years of age, it is difficult for women to compete if they have chosen to have children. Children consume many years and give women a late start in their art. The vast majority of grants provide only partial support to the artist—they pay only the project costs, not including living expenses. There are different categories of grants: for some you must be nominated before you can apply; others are residence fellowships.

AGENTS

An agent is someone who promotes and sells your work. An agent receives a fee, which is usually a commission on sales. It can vary from 10 to 50 percent. The more your agent does for you, the larger the fee. If you have an exclusive agreement with your agent, all sales are made through her. If you also sell on your own, she might agree to a lesser percentage on her sales. If you expect your agent to work hard for you, you have to make it worthwhile. Realistically speaking, you may not be able to afford an agent until your prices are high enough to support the two of you. Remember, however, that the work of the agent will increase both your sales and your prices. A good agent carries her own weight.

There is nothing magical about being an agent. Furthermore, there is no reason for you not to consider hiring someone who may be new in the field. Someone who is especially interested in your work and perhaps has found a few buyers for you out of this natural enthusiasm might be just the person for you.

While it is important to have a good, clear contract with people you work with, a letter of agreement is another, less formal way of cementing an agreement. Type one up, listing all points discussed and agreed upon. Any agreement between the two of you is legally binding. The important points to be discussed and agreed upon between artist and agent are:

1. Geographic area of the agent's territory and whether

the agent has exclusive rights to this area.

2. Length of time for this agreement (one year is a good beginning) and conditions for renewal.

3. Commission. This is a negotiable and varied percentage of sales. If your material cost is high, consider having it deducted from the sale price before the commission is taken. Gallery agents take anywhere from 33 1/3 to 50 percent. You may wish to exclude your agent from commissions on sales that you get on your own. The gallery commission on a commission (order for special new work) can be less than the sale of work already produced.

4. Services received for this commission. In the case of a gallery it is the exhibition and perhaps publicity, mailing, the opening party, transportation, and a brochure as well. If you hire an agent independently of a gallery, you can negotiate the work load. Are you the only artist represented by your agent? If not, be sure you are one of a kind in her group. Will your agent be responsible for shipping and packing, dealing with exhibition possibilities and directors, working with museums, taking care of photographs, sending out packets, keeping records of sales, sending out press releases, making sure you get good media coverage, and arranging for personal appearances? Be sure you appoint work that your agent is capable of doing: there is no point in loading her down. You want a successful agent, not a resentful and short-lived one.

5. Accounts. If your agent handles your accounts, you should receive a regular statement that will keep you informed as to what has been sold, the price, how much money has been collected, the commission, and how much money is due you. Clearly spell out how money is to be transacted between you and your agent.

6. Advance. Museums sometimes pay a fee for construction of new works. Galleries can be asked to advance against future sales and should be bound to purchase that amount of sculpture if sales do not match the advance. If the gallery insists upon a higher commission as part of the advance clause, the advance is not worth it to you.

7. Price. The price of your work must be clearly decided and maintained, although in some circumstances, such as museum purchases, you may want to lower your price.

8. Death clause. Decide if you want the agreement terminated upon death or if you want the agent to sell the work on hand and pay the proceeds to the estate.

9. Insurance. Your agent will be storing some of your work, so decide who is insuring it, who pays the premiums, and the percentage of value that is to be insured.

Regardless of your contract, the working relationship depends on the good will of the people working together.

The contract sets the framework for responsibility. The success of the relationship, however, depends more on each person's skill at fulfilling her responsibilities and the endless subtleties of interpersonal relationships. If your agent doesn't work for you, terminate the agreement as soon as possible. Agents are like galleries: they are fine if you are willing to keep fully abreast of the work and do a lot of work as well. But they are both necessary. I am wary of giving away any autonomy in deciding where and to whom I will show my work. As the scope of your art increases, however, it is impossible to handle all of the practical aspects on your own. An agent can be an answer.

COMMISSIONS

A commission is an order, at an agreed-upon price, to create art for a particular purpose, customer, and/or site. A simple commission is frequently an order for a piece similar to one you have completed and either have sold or do not want to sell. Whether or not you wish to do commissions is a personal decision. While a large commission usually brings in a good sum of money, it ties up your creativity on one piece for a considerable span of time. Some artists are more suited to this type of work than others. Not all commissions are large projects, however, and you can work the larger ones from a model to mechanical drawings and have them constructed by a fabricator according to your specifications.

The elements of a commission are as follows:

1. Maquette. It is common for the artist to submit a maquette (a small model of the proposed piece). It is reasonable to expect payment for this maquette.

2. Contract. After the preliminaries are discussed—site, materials, cost, timetable, and mechanics of delivery—it is time to draw up a contract. The contract should spell out exactly what is to take place between the parties. If an agent is the facilitator, your arrangement with the agent is in addition to the contract between you and the buyer.

3. Assistants. A large commission may require the use of studio assistants or fabricators. The cost to you must be carefully calculated. Although commissions of large works usually carry large price tags, so do material, construction, and shipping costs, to say nothing of the bulk of time spent working on the piece. All of your records will put you in a good position to estimate costs of material and the amount of time it takes you to construct a work. Agree in advance what the method of payment will be; this is put into the contract.

If you are interested in commissions, contact interior designers and architects and inform them of your work. Check at your town hall for local construction permits. You will come upon people who are interested in a particular subject matter or piece for a particular place or purpose.

The main problem with commissions is a lack of communication. Sometimes communities are displeased with commissioned pieces for their community. You must learn the skills of interpersonal relationships and keep your word. If you say the piece will be completed on a certain date, allow yourself enough time for any mishap so that you are sure that you will actually be able to produce the completed work by the specified date.

It is reasonable to expect one-third payment upon signing the contract (agreeing to do the work). Another one-third is due halfway through, when your client can see the work and you can discuss any necessary changes. The last one-third is due upon delivery. You may arrange for a specified fee above the cost of construction and materials. In this case you can send all your construction-cost bills to your buyer with the assurance that these bills are covered and are not your responsibility.

As an artist, much of your life is devoted to developing your art. While you are in the process of learning the skills, you naturally think about the pleasure of being a recognized artist. It is often a surprise to learn that in order to establish yourself as an artist, it is necessary to be extremely hard-working and diligent in pursuing not only the immediacy of your art but every opportunity that will provide you with exposure, sales, and recognition. The rewards are not necessarily so luxuriant, but they are interesting. It is for each of you to decide exactly what kind of environment suits you and exactly what kind of life you wish. Some artists feel that if they don't live in New York City, their chances of success are dim. You should recognize that the art market is growing annually (more people attend art events than sports events) and that the opportunities within each community are increasing as well. If you are sensitive to this potential, you can help your solvency and your position as an artist. You should further understand that the success of one artist is helpful to all. (Growing businesses in a community draw more people to all of the stores.) Successful artists will whet the public's appetite for art and improve everyone's potential sales. More people are collecting, and more people are becoming interested in following artists' careers. Encourage potential collectors and you encourage yourself.

PART 3
Chapter 8.
My Approach to Art

MY PATH IN BECOMING

My decision to become an artist came unconsciously, rather innocently, to my life. Later, I was overwhelmed with a surging need for this way of life when I realized that the intensity of my life experience could be resolved in the creation of art. This feeling was born out of an awareness of the incredible beauty and enormity of life. Through the process of making art, my life renews itself.

Until I had accumulated a vast body of work, I had no faith that I could continue to create. Some people call my dedication discipline, but actually I am driven. This force is stronger than the usual logic and practicality that dictate day-to-day activities. I know that in order to create art, I have to create the time and space in which to concentrate on my work. This effort continues to this day.

My first experience with serious art came at the Museum of Modern Art in New York City. The first artist to catch my attention on that first day's visit at age sixteen was Cézanne. I identified with his continual and underlying struggle, which resolved itself in each painting in a sense of being at one with the forces of life. Picasso, Matisse, and Van Gogh entered my life, and I studied each painting as if it were my intimate lover.

It wasn't until I had finally chosen welded sculpture as my medium that I recognized the love I have always had for form and how I have always been attracted to metal. Since I grew up in New York City, I have endless visual memories of the city. I remember driving with my father over bridges and through tunnels, especially at night when form and space become monumental without the distraction of color and endless detail. I absorbed the city's space, alternately crowded and vast. At all hours and in ever-changing light, I saw the magic of rivers, sidewalks, steps, block forms of

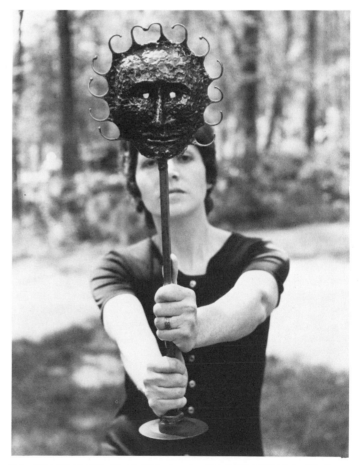

8-1. *The Changing Mask (Timeless).* Steel, 22 1/2" high. (Collection of Kay Kelley Mersereau; photo by Arnold Benton.)

buildings, windows, iron fences. Endless days of walking, running, and climbing. I examined the hardware in the subway train, door knobs and hinges, old metal, nineteenth-century ironwork, my mother's metal pots, window latches, metal gates, sewer grates. I learned that art is abundant and it is to be lived with. Now, when I see form, it is almost the same as touching it.

Hints of a schism between my sex and my devotion to art continually emerged. Being complimented for drawing like a man puzzled me for years. My enthusiasm and commitment were frivolous amusements in other people's minds. I defended myself by withdrawing from public display.

During my last year in college, many things came together for me as a young artist. I was studying sculpture with John Ferren, a teacher whom I admired and who gave me a great deal of support. He astounded me one day telling me that I had an enormous talent and that I should treat it with care and not be glib about it. Over the years that followed, I kept his encouragement in the center of my mind and drank from it in the many moments when there was absolutely nothing to reinforce my existence as an artist.

In my innocence and trust I thought I had come upon a time when I could include love in my life. My background insisted that this occur in the form of marriage. I married at the age of twenty, not realizing that my development as an artist would be hampered in any way. I did not know that I would be without what I had been surrounded by in school—constant review of my work and constant peer rapport.

I spent the next few years following my husband on the rungs of his career—having abortions and babies and experiencing rather completely what millions of American women know as life. I found myself succumbing to feelings of fragmentation, dependency, and inadequacy. Constant moving and constant children had the effect of war on my mind. Who was I? Where was I? Where was my life? That person that had begun to be purposeful was being swiftly obliterated. The time span was seven years, during which I had ample opportunity to examine every element of myself in isolation. I came to know clearly in the midst of all of this that I was indeed an artist.

In my early attempts to show my work publicly, I was always questioned as to my husband's profession. The wedding band was an enormous handicap. Much later, I discarded it, and this problem disappeared.

I began to establish myself as a painter. Although I had finally arrived at a plateau in my work where I was producing a consistent style, I had a growing uneasiness that an essential part of myself had not yet emerged. I was restless with the two-dimensional surface. Emotionally, I had completed my childbearing years and an extremely difficult time in my life. I needed to move into some other area to establish the new, coming phase of my life.

Soon after this period of restlessness, I moved my home for the last time. When I walked in the door of the house where I now live, I knew it was a sculptor's house, that it was my house, and that I would become a sculptor. No sculptor had lived there before, but there was space for a studio on the ground floor, which was unfinished at the time.

I had to overcome an enormous amount of fear in order to feel comfortable with the welding torch. Taking on the physical apparatus, taking command, was counter to what I had experienced in my life those past seven years. When my instructor told me that I couldn't change the gas tanks because a woman wasn't strong enough, I was thrown into fury and despair. When I think of these insane limitations and how I took them so seriously, I have great sympathy for women who have not been able to find their sense of direction.

In the beginning, I worked like the person I was, in fragments. In making sculpture, I discovered how to put my life together. The act of completing a work literally thrust me into the life I wanted to lead. Early in my life, when I had decided to become an artist, I had had an inner vision of being able to hold the physical material of my art in such a way as to bring it into existence with my hands. In welding, I wear a mask, a heavy apron, and gloves. I heat the metal and make it bend so smoothly and gracefully; I cut the metal, rigid metal, into endless shapes; I join the pieces by causing them to flow together with the heat of the flame. Welding was a return to my adolescent vision. It was fulfillment. At that beginning time I felt that even if I went no further, this experience in itself gave me astounding satisfaction. It was as thrilling as the moment of birth. It was my birth.

FIRST WORKS

After 6 months I completed my first work, *Wending Woman* (see figure 8-2). It remains a special piece to me. The inspiration came from a friend's gift of metal. This friend, the husband of a woman who had been my dearest friend for many years, brought me some metal that he had dug up from the backyard of his colonial house. The metal was pitted with age, and it was my opportunity to transform the love I had felt for this woman friend, who had sadly died. I put my sense of the power of her life into a work of art. The way I felt about that sculpture was the way I felt about myself. It was an experiment. A woman on her way. She has focus; she is strong, sure, and gentle.

This was the first piece I sold in a New York gallery. My price was $150, and the gallery owner called me up and

asked me if I would take $125. I felt that I was selling my soul but knew that to become a professional artist, I had to be able to let go of my work.

Once I had completed this piece of sculpture, the dam burst: since then, to date, I have created well over 300 works.

From the beginning my work has expressed woman. My difficulty in combining art with the traditional role of women caused me to relate feminism to the development of my work. While I struggled for the time to work, I had to cope with the problems and demands of children and family.

Since I had a large body of work by the end of the year, I immediately began to show and to sell. After so many years of working in isolation, I was thrilled and surprised to see how I thrived on social approval. Selling a piece stimulated me to create ten more. The first two years were years of experimentation. What could I do? How large could I work; how small? How could I use paint? What would happen if I brazed a piece? My first focus was on the figure.

I worked with skeleton metal and created a whole body of open figures. One day, while sitting in my house surrounded by these works, I realized that there was another level to what I had created. I loved the idea of the open figure with light and air moving through. It reinforced my feeling about being an open person with no need to hide, regardless of my human acts. I felt that what is human can be understood, accepted, and even cherished as that. I was fascinated with the linear quality of the skeletal material that embraced space. Openness—negative space—became as significant as form in the work. I used skeleton metal, which is the cast-off metal of industry, the negative space of industry in tangible form. Using industry's negative space as my sculptural form is a kind of upside-down logic, which I feel is so real about life. Things are never what they seem, and I adore playing with things that are upside-down, inside-out.

In studying the work of other sculptors I developed an insight specifically associated with welded scupture. It is a unique art form arising of the nature and experience of welding itself. Bertoia has created the most beautiful work with rods. Lee Bontecou uses these rods as an armature, and her canvases stretch over a welded frame. So many sculptors exploit the raw, volcanic nature of the flowing bead. Others construct in a patchwork manner, joining large pieces of metal, while still others use the torch as if it were glue and create a building-block structure.

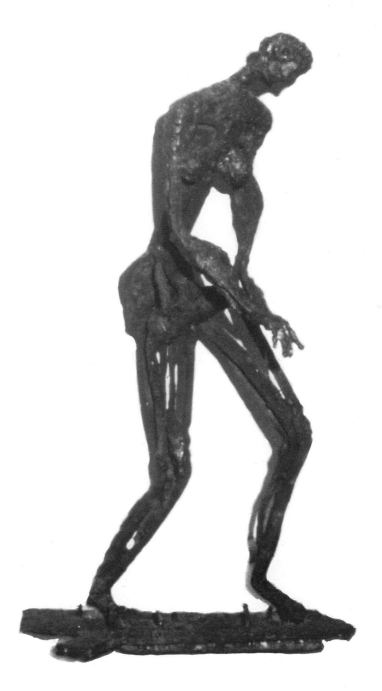

8-2. *Wending Woman.* Steel, 12″ high.

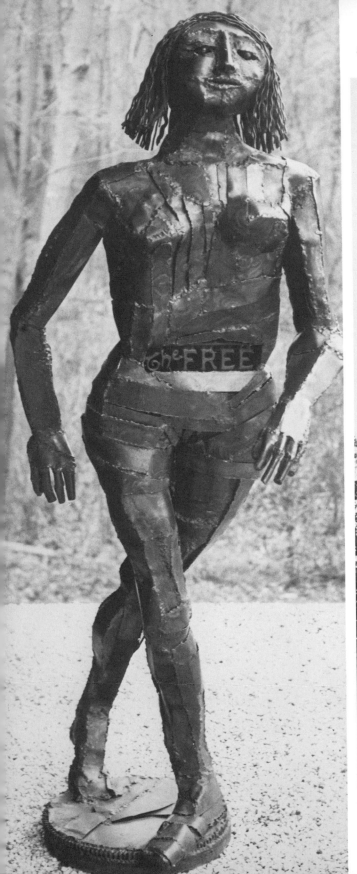

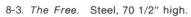
8-3. *The Free.* Steel, 70 1/2" high.

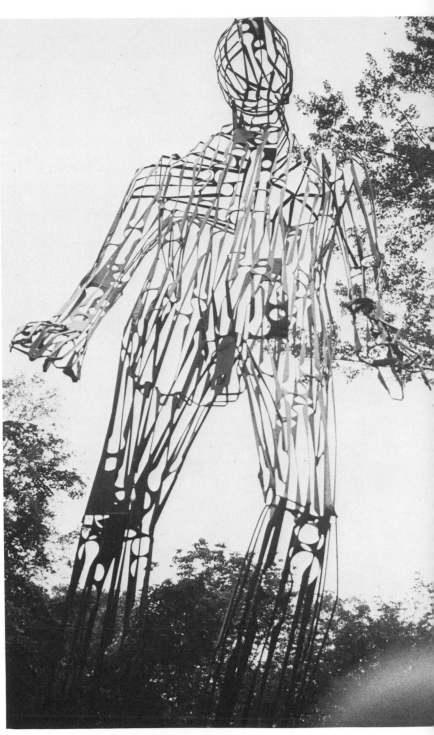

8-4. *Adam.* Painted steel, 88" high. (Photo by Susan Kleckner.)

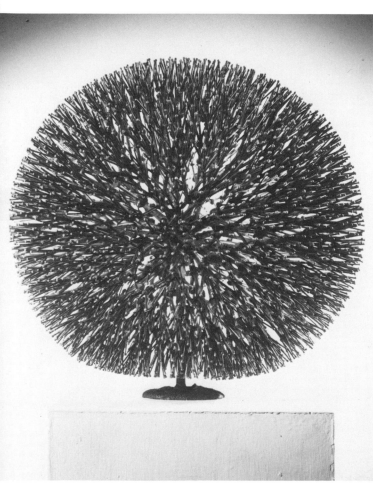

8-5. Harry Bertoia. *Welded Sphere.* Bronze. (Photo by W. B. Nickerson.)

8-6. Lee Bontecou. Untitled. Welded steel with canvas, 21″ high, 1964. (Collection of the Sonnabend Gallery; photo by Rudolph Burckhardt.)

I came to know power with the welding torch. Strangely, covered with all the protective devices, I forgot my supposed female weakness. The roar of the torch erased commonplace reality, and I was able to get in touch with the deepest parts of myself to discover my ability and to draw it into my art. This was my happiest life experience, for it reinforced an insistent sense of self and self-worth in a way that I valued and that was solely mine. It seemed strange to see that the physical paraphernalia, which appears superficially as an obstacle to the creation of sculpture, actually is an aid.

I began to play with the idea of sound. I noticed the ringing sounds of the metal as I worked. I created a series of bells and chimes, some of which were selected by the Museum of Contemporary Crafts in New York City for their Sound Show. They requested that the work be handled by the audience. I found my self inordinately pleased by this aspect and further discovered that my work was made more beautiful by being held and rubbed. It took on a new luster and seemed to vibrate from the touch of people's hands. Now I feel that my work remains in a potential state until it becomes an object of life and is experienced in a unique way by the art audience. Allowing people to handle my work is a very concrete beginning in helping them understand that art is not untouchable. I wish to share my understanding that art is meant to be lived with, to be an integral part of everyone's life. I create my art with this in mind.

My 18-foot climbing sculpture in Spanish Harlem was meant to be physically climbed upon. The people of the ghetto surrounded me in fascination as I worked. Time and again they told me how they loved and hungered for what I experienced when I saw Cézanne's work at the Museum of Modern Art. My point in bringing this out is that I believe that people have a hunger for art and that as an artist it is my job to satisfy that hunger. Surrounded by my sculpture in my house, I saw something more in its openness, an emanation of hollowness. I do not mean this superficially. I recalled a time of excruciating pain when one of my children went to the hospital, where she was to die. I felt my arms so empty; my body was an eggshell, hollow, completely reamed. How ironic and interesting it is to see the spirit work its way into art. I understood that I was now ready to fill the inside. When I revealed that painful time in my art, the empty space became a free space. It served to eliminate a whole body of limits from my life. I began to put new, solid figures inside the open figures. I put babies inside pregnant women, men inside women, women inside men. I soon exhausted the possibilities.

It wasn't until I had completed the series of open figures with figures inside them that I was able to allow the finished work to speak to me of inner potential working its way out. This was a central part of my being and what I had to communicate as an artist. Putting on the welding mask was the ritual. This act signified transition from traditional wife and mother into my newly awakened explorations into what was to become my art. I gave considerable thought to the dichotomy of being covered In order to reveal myself.

8-7. *Bell.* Steel, 17" high. (Photo by Arnold Benton.)

8-8. *Climbing Sculpture.* 1969.

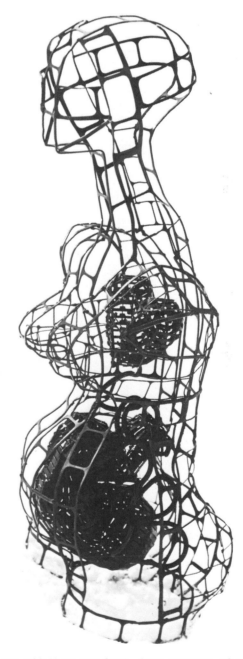

8-9. *Woman with Heart and Soul.* Steel, 36" high. (Collection of and photo by Arnold Benton.)

Meanwhile, I was becoming immersed in the women's movement. When it emerged, I was already very well read, and I became politically involved. As an artist I had to find in the feminist movement the peer group that I had so sadly lacked over the years.

I became acutely aware of the masks that women wear in life. As a sculptor I dealt with the pain of this confinement by beginning to create a body of masks. I immediately understood their dramatic implications. The women in my art workshop moved, danced, and improvised with my masks and created a theater so startling, so fascinating that I knew they had given me the greatest gift of all, the direction that my work was to move in for years to come. These women told me by their actions, by their respect of my work, that they thought I had what I always wanted, power.

With power comes responsibility. My intense excitement made me impatient for fruition. I was afraid that if I didn't make great progress at that point, I would lose my opportunity. There was a great deal of trial and error, which is the greatest simplification of experience. I attempted many things with many people without the slightest idea of how to do them, and in the process I learned. I do not believe that any human being can become an artist without the interaction of other people who are seriously involved in your work. I was able for years to hang on to bits of encouragement, but that was a dormant life. In order to flower, you have to have the sun.

My masks were intended to satisfy many needs. For me, creating the work itself in the studio is only one part of the process: the existence of a sculpture is like an anonymous flower in an anonymous field. I have to make sure that the flower is found, I have to create a path, and if need be, I have to transplant the flower.

At this point I think it is important to define what feminism means to me. Yes, of course, equal rights, equal pay, child care, health care, equal opportunity. But the most crucial part for me is that my existence as a woman and my life experience, seeing the world with my woman's body, is as valid (regardless of all the lore to the contrary) as that of any man.

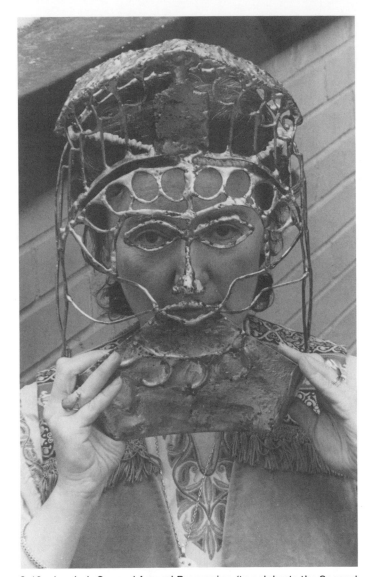

8-10. *Jezebel*. Second Annual Procession (to celebrate the Second Coming of the Great Goddess.). (Photo by Cherel Winett.)

Up until now the life stories of women have not been told in a manner that allows people to identify with women in the same way that they are educated to identify with men. With my masks I have personally developed a series of ritual tales, which I present before audiences. The mask is a perfect symbol for the act of transformation that I had experienced in the welding process. The ritual tales provide an inviting environment for people to handle the masks, put them on, and allow a dialogue to take place between themselves and the masks. I always create a mask with this in mind; it is important to me that the audience with whom I communicate shares my experience in creating the work.

Artists have the capacity to translate their life experience in a way that can be identified with by the audience: we all share the basic realities of life—birth and death, sex and love, family devotion and mutual aid, sacrifice and transcendence, human pride and cosmic awe. My dedication as an artist is to experience the ultimate realities again and again on many levels and to transform them into my art so that they can be reexperienced and understood by the art audience.

Since I am convinced that women's perceptions of these ultimate realities have not yet been allowed to enrich our culture, I feel honored to have been able to discover that sense of higher purpose that the art of the past has found in religion, in nature, and in celebrating the powers that be. The emerging consciousness of women in an important step in the development of hu(wo)manity.

8-11. *Medici Mask.* Steel, painted red, 23″ high. (Collection of Roy and Susan Pfeil: photo by Arnold Benton.)

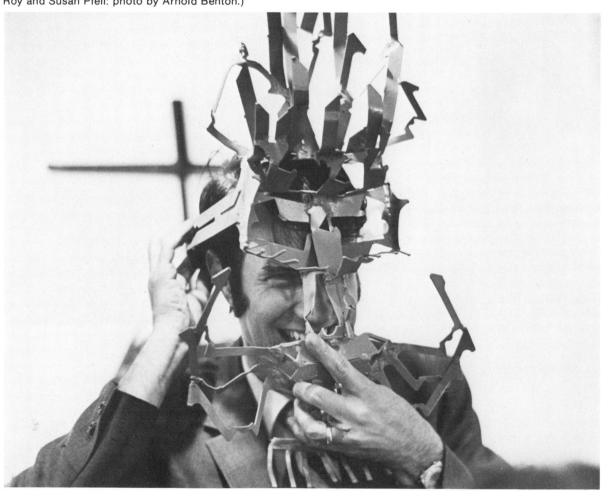

MASK AND RITUAL SCULPTURE

Masks represent three levels of consciousness: disguise, symbol, and transformation. In disguise we can pretend we are not who we are. This is the most superficial level and the one at which most men and women stop growing in their lives. These masks, to name a few, are clothes, wigs, false eyelashes, makeup, and beards. They are often used to stop any exploration into the inner self by either the viewer or the mask wearer. This level does not interest me, although I know and understand that in accepting the theme of mask I must work with this element as well as with the others.

The level of symbol is the most oppressive, for the mask wearer can do nothing that will enable the viewer to see her in any way other than wearing the mask. This is the mask of sex, race, religion, profession, role, status—doctor, mother, child, whore, nun, doorman.

The highest form of mask is transformation. This mask allows the wearer to call up the elements of the self that have not yet had a chance to live. A correlation in life can be seen as follows: we are born with physical attributes, which are our disguise in a world that brands us to particular strata of environment, wealth, and status. Our life role is to transform these givens, to come to terms with the deepest, unspoken parts of ourselves, and to become complete, unique beings.

Many cultures use masks to allow this important process to find a way into their lives. My masks are a product of our own culture. They are in no way African or Greek, Japanese or Indian. They do share elements to some extent, for the American culture has access to all cultures and the process of living and creating art somehow assimilates parts of them. To date I have developed three ritual tales, which I call *Women of Myth and Heritage*. They arise out of a strong conviction that the stories of women have never been told from our own point of view. I am interested in bringing women out of the role of victim, which we so often portray in art and experience in our lives, into full and complete, self-defined human beings. The subtleties and complexities of our lives are worthy of the finest artistic treatment. We cannot expect to be understood until we make ourselves known.

The first story, *Sarah and Hagar*, is commonly known as the story of Abraham and Isaac. I have chosen to make the two women the central characters. I have culled from the Bible for two reasons. First, these women are believable people to me. Their life experience is still familiar today. Their psychology is the psychology of the past, which is responsible in so many ways for the present. I approach the story from a contemporary point of view: who, for example, has thought of Sarah's agony as the mother of Isaac, the child for whom she longed for so many years?

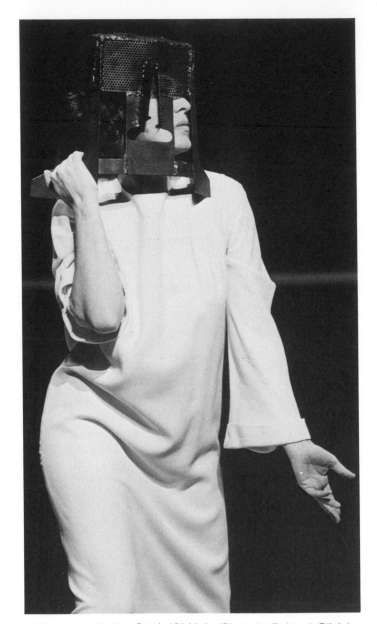

8-12. *Sarah's Mask.* Steel, 12″ high. (Photo by Deborah Blish.)

110

What was her experience as Abraham left to perform God's command to sacrifice, to murder her only child? Second, I wanted to explore the individuality and the interrelationship of two women in the midst of the patriarchy. The Bible is a symbol for the patriarchal philosophy in full bloom. I wanted to reveal unequivocally the oppression of women.

The story itself follows the biblical tale literally. Through the subtlety and sounds of the voice, mask communicates the varied messages. The story evolves into a dialogue with the masks, in which the openings of the masks emphasize aspects of the face and become a poetic joining. Body movement is a crucial part of the story, and some people describe it as a dance. I do not consider myself an actress: I come to the story with the integrity of the sculptured mask, wed it to the integrity of the tale, and allow my thinking and my body to move with the mask through this emotional experience.

8-13. *Calling Mask (Hagar's Mask).* Steel, 12 1/2" high. (Photo by Deborah Blish.)

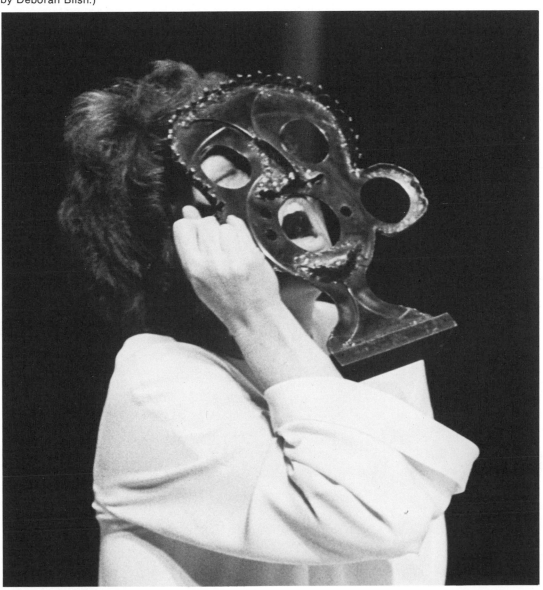

My second tale, *Mary Adeline and the Birthstory*, was a church commission to develop the theme of Mary. I was reluctant to deal directly with the deified woman of the Bible, but I was interested in what was human about her. Which of her life experiences are shared by all women and have not been told? I chose to focus on illegitimacy and childbirth and to glean from my own life rather than from the traditional story. Mary Adeline is a girl I grew up with who became pregnant at the age of fourteen. The tale of her life is told very simply with a half mask. There are long pauses between the sentences to give the audience a chance to absorb the impact of the words. Although her physical presence resembles a priestess, I tell the story as if I were still a young girl. The story itself is about giving birth to my first child. It is told very simply with little body movement, and the mask conveys an enormous power. Our childbearing experience is seen in relation to the emotional ideal of childbirth.

8-14. *Half Mask (Mary Adeline's Mask)*. 9″ high. (Photo by Claudia Stephens.)

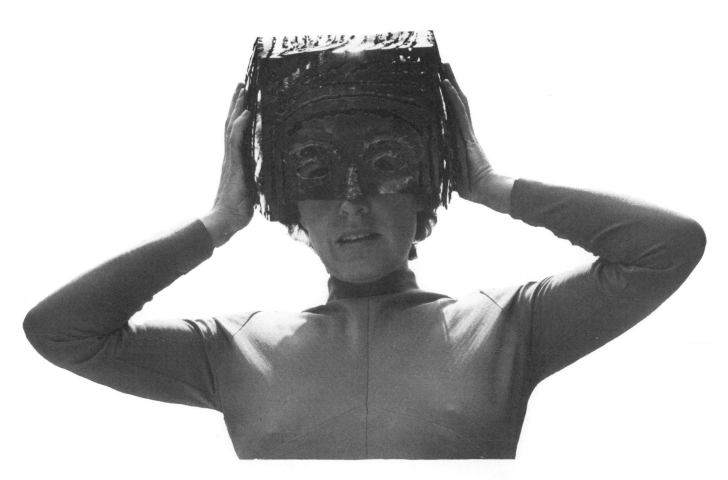

8-15. *Eternity (Birthstory Mask).* Steel, 41″ high. (Photo by Claudia Stephens.)

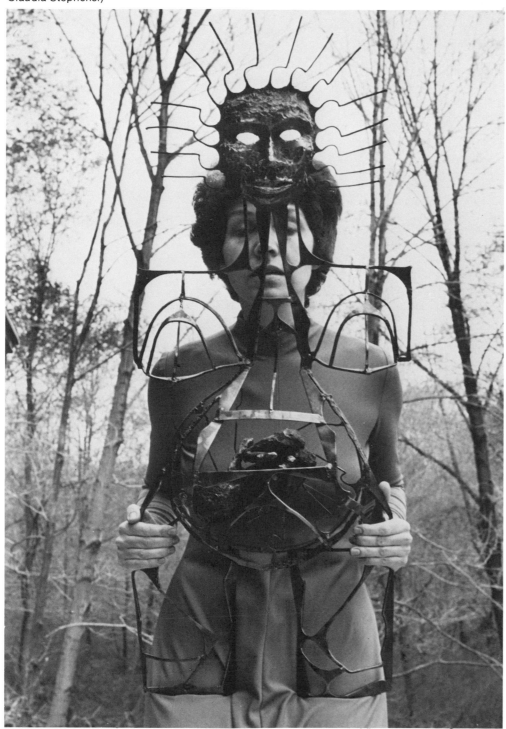

Lilith is my most recent story. It deals with the Jewish mythological figure who was the first wife of Adam. She left the garden of Eden rather than be subservient to a man. Her saga is full of great triumph and drama. I see this story as a reawakening of the tale of the first liberated woman who leaves the cocoon of the single man, experiences great trials in her independence and expansion, and resolves her life in the midst of a community.

Working with the masks leads the audience not to view the woman narrator from a biased perspective. The mask rivets the eyes of the audience on the story and causes the face to be seen in ever-changing ways. The audience has to constantly shift and readjust its focus, which is essential in establishing a rethinking towards women.

The mask is an ideal theme for me, not only because it can be held and examined from all angles, but also because it includes the viewer in the art experience. When people try the mask on and allow it to speak to them, they have an immediate physical proximity. I intend this to stimulate their thought in the same manner as my thought is stimulated when I work on the form of my sculpture.

A wise women once told me that how a work is received is as important as how it is given. This, of course, is in tune with my belief that a work is not completed until it has been received. I now ask for something more than passive receptivity: I ask my audience to return to me their experience in knowing my work. It is with this in mind that I have developed my Lifestory Workshops, in which I guide people into storytelling with my masks.

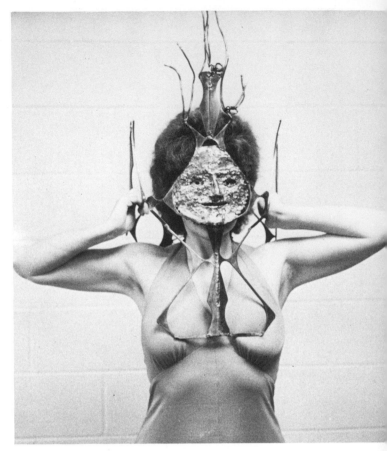

8-16. *Lilith's Mask.* Copper-coated steel, 37" high. (Photo by Claudia Stephens.)

8-17. Detail of *Lilith's Mask.* (Photo by Susan Duling.)

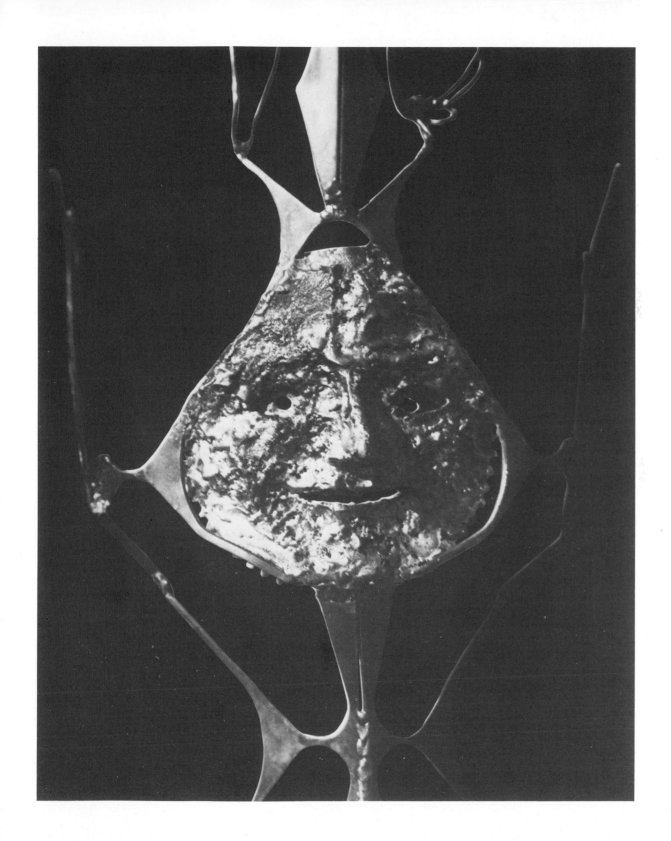

I usually conduct a Lifestory Workshop after a group has seen one of my Mask and Ritual Tales. I have a chance to communicate with the audience in many ways: besides receiving my story, there is a dialogue afterwards with the audience, in which I begin to perceive their varied reactions. As a preamble to the workshop, we speak about the masks in general. I suggest that they be handled and tried on. I ask the group to concentrate on their own thoughts as they are working with the masks. Then I ask them to choose a mask that they wish to experience more fully. The dialogue that they will present is not a prepared tale, but they are encouraged to concentrate on the thoughts that come to them. I suggest a simple framework as a takeoff point, such as giving the mask a name, a home, an action, a place, or a time.

I do not consider the masks to be theater in any traditional sense. They are a transforming ritual, in which both myself and the audience are changed in the reliving of an experience. Stylized and stark, with total simplicity, a new reality is exposed. People have often said that by using the masks, I become maskless, and after experiencing my works, the masks of others become more apparent.

This moves into another aspect of my work, ritual sculpture. A ritual is a marking of an important event through a series of acts that are timeless and unique at the same time. Giving birth is a ritual. How the culture handles this important event gives it its societal stamp. Ritual is similar to mask in many ways. Though it marks the ultimate realities in a demonstrative way, its true purpose is transcendence. Cultures often fail to develop the paths to transcendence. Mask and ritual in most cultures are controlled by men. It is therefore doubly significant for a woman to explore these powers.

I believe that the true aim of culture is to carry people through the turning points in their lives, to provide them with paths to reach their inner strength, and to furnish a social environment in which these important changes can take place and be completed.

I am aware that art transmits knowledge. This knowledge is intended to help people understand themselves and pass through the life cycle. Living is a physical presence; sculpture is an expression of that presence. From my point of view it is crucial that sculpture be touched. This conviction has a definite root in my womanhood. I have experienced and perceived my body as containing another being. My request that people enter my masks is specifically female. I have spent years nurturing young children, holding them, touching and being touched by them, learning to love from them; this knowledge I bring to my art with the simple request that the physical presence of my art be known not only with the eyes but experienced physically as well.

I have a love of form that comes to me through my eyes, my body walking in space, living in space, and through the touching of bodies. My own body is my constant touchstone. When I was a young mother, my scale was compressed, as the body of my child was the scale that I was in constant touch with. The touching of a man's body gives me a different sense of form. As my hands move over what I touch, what touches me, images and thoughts play on my mind. These same connections between touch and physical presence are dominant when I create my sculpture. This dialogue in my mind becomes tangible to me as sculpture emerges out of my work. The fact that I want my work to be touched also symbolizes my desire to touch others with my art. I put this in my work and know that it is there to be discovered again and again.

8-18. *The Maiden Mask.* Brazed bronze on steel, 12 3/4" high.

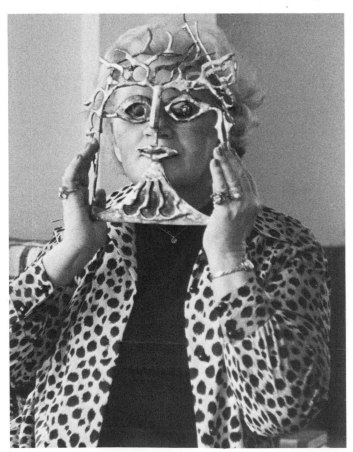

116

as in sculpture come to me in many ways. Sometimes
series appear in dreams. At times I become aware of
up of important matriarchical symbols that have
d through my mind as touchstones for years—spirals,
oon, snakes, the double-headed axe, the goddess. A
of the great, primitive earth mothers has always
potent in my mind and memory. Primitive art has
s spoken to me in the most profound ways, a power
eaps out from past culture and remains so immediate.
mmediacy is my goal with my own art.
remarkable thing about art is that you create while
ve through the total spectrum of human experience
eeling. If you are indeed an artist, this totality will flow
our work. This is the magic of art. The other side of
nagic is that the viewer absorbs all that you have put
he work.
have developed my art for a new participatory
nce, for the many people who are eager to get in
with the world of art but who find the traditional

channels elitist and limiting, people who can be reached
through the worlds in which they live and work. In telling
my mask-ritual tales, I have been able to expose my work
to a variety of community groups: schools, churches, and
women's groups as well as the traditional art audience.

My work interests me. It feeds my whole life, and my
whole life feeds my art. My work is a merging of the spirit
with what I feel is possible for me in this world. My art
expresses my view of life. I communicate with others
through the common knowledge of all people. I seek to
touch the parts in ourselves that seek the joy of new under-
standing. I want my work to be a deep experience that my
audience can use to help their lives. When I feel growth
and achievement in my own work, I feel beautiful.

I have steadily continued to create a group of larger
works. Although I have always been interested in
maintaining a body of pure sculpture, it took me a long
time to totally understand the relationship between my
story telling with masks and my creation of sculpture.

The White Queen (Mask). Painted steel, 19″ high. (Collec-
f Donald and Geraldine Sirene; photo by Arnold Benton.)

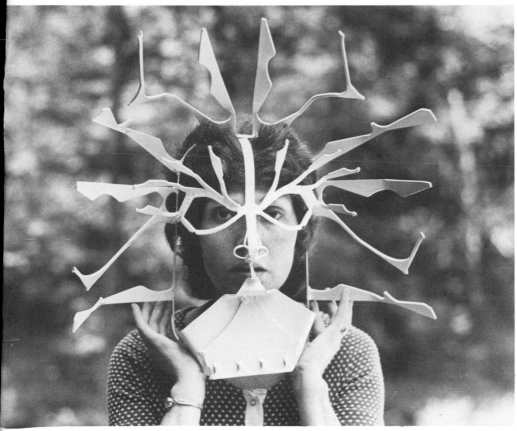

Metal in no way approximates the human body; it is a substance of our mechanized society. It represents in many ways the patriarchy, the untouchable, the hierarchical. As a sculptor mastering metal, I have gained strength as a human being. I have found it to be controllable. I have transcended its rigidity and weight with the welding torch. I use light metals, so my work is transportable. I use the thinnest possible metal to maintain light weight and strength at the same time. The large pieces often come in sections that fit together. Each section in itself is a work of art. The sections represent aspects of culture, each worthy in its own right. They all join together to become a totality that works.

8-19. *Fertile Donation Box.* Steel, partly brazed with bronze, 31" high.

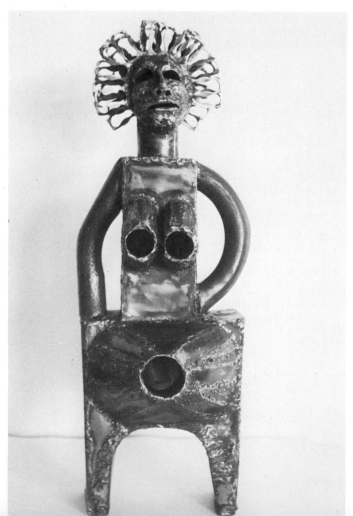

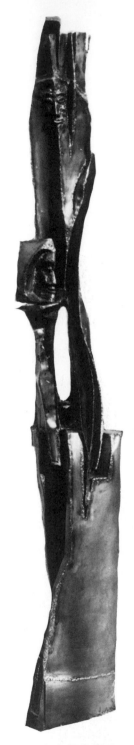

8-20. *Tower.* Copper-coated steel, three sections, of the theater set for *I Am a Woman.*

Ide
whol
a gr
drifte
the r
sens
been
alwa
that
This
Th
you
and
into
art's
into
I
audi
touch

8-21.
tion

Metal in no way approximates the human body; it is a substance of our mechanized society. It represents in many ways the patriarchy, the untouchable, the hierarchical. As a sculptor mastering metal, I have gained strength as a human being. I have found it to be controllable. I have transcended its rigidity and weight with the welding torch. I use light metals, so my work is transportable. I use the thinnest possible metal to maintain light weight and strength at the same time. The large pieces often come in sections that fit together. Each section in itself is a work of art. The sections represent aspects of culture, each worthy in its own right. They all join together to become a totality that works.

8-19. *Fertile Donation Box.* Steel, partly brazed with bronze, 31″ high.

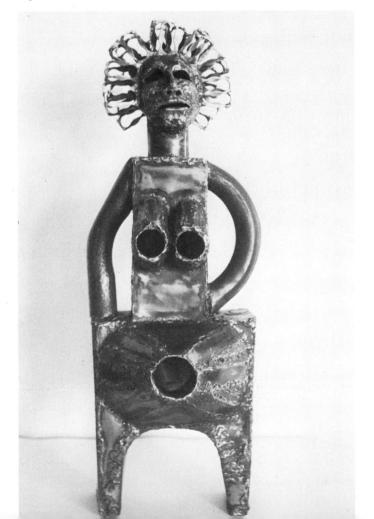

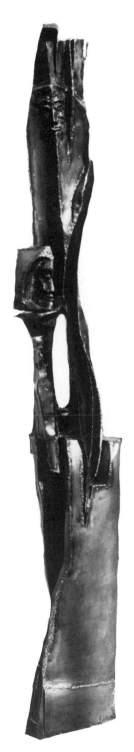

8-20. *Tower.* Copper-coated steel, three sections, 108″ high. Part of the theater set for *I Am a Woman.*

Ideas in sculpture come to me in many ways. Sometimes whole series appear in dreams. At times I become aware of a group of important matriarchical symbols that have drifted through my mind as touchstones for years—spirals, the moon, snakes, the double-headed axe, the goddess. A sense of the great, primitive earth mothers has always been potent in my mind and memory. Primitive art has always spoken to me in the most profound ways, a power that leaps out from past culture and remains so immediate. This immediacy is my goal with my own art.

The remarkable thing about art is that you create while you live through the total spectrum of human experience and feeling. If you are indeed an artist, this totality will flow into your work. This is the magic of art. The other side of art's magic is that the viewer absorbs all that you have put into the work.

I have developed my art for a new participatory audience, for the many people who are eager to get in touch with the world of art but who find the traditional channels elitist and limiting, people who can be reached through the worlds in which they live and work. In telling my mask-ritual tales, I have been able to expose my work to a variety of community groups: schools, churches, and women's groups as well as the traditional art audience.

My work interests me. It feeds my whole life, and my whole life feeds my art. My work is a merging of the spirit with what I feel is possible for me in this world. My art expresses my view of life. I communicate with others through the common knowledge of all people. I seek to touch the parts in ourselves that seek the joy of new understanding. I want my work to be a deep experience that my audience can use to help their lives. When I feel growth and achievement in my own work, I feel beautiful.

I have steadily continued to create a group of larger works. Although I have always been interested in maintaining a body of pure sculpture, it took me a long time to totally understand the relationship between my story telling with masks and my creation of sculpture.

8-21. *The White Queen (Mask).* Painted steel, 19″ high. (Collection of Donald and Geraldine Sirene; photo by Arnold Benton.)

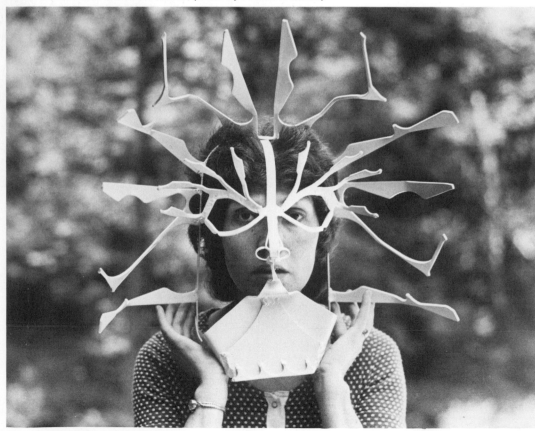

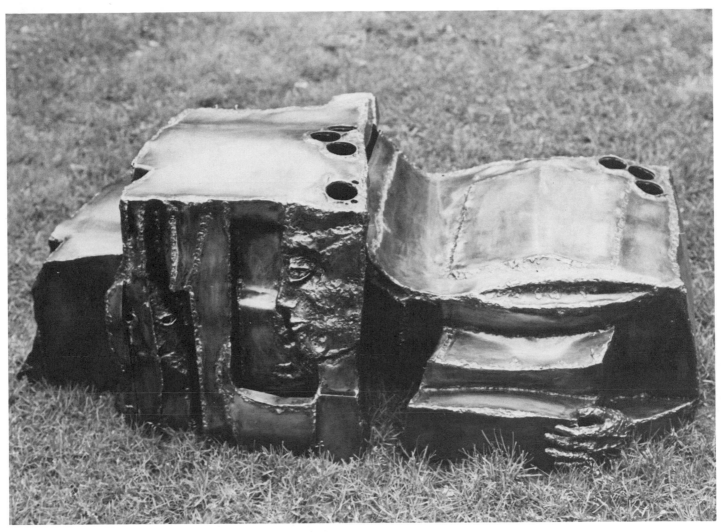

8-22. *Protection.* Bronze-coated steel, two sections, 50 1/4″ long.
Part of the theater set for *I Am a Woman.* (Photo by Claudia
Stephens.)

With recent work, such as *Beloved*, I have experienced a growing sense, as the work itself took complete form, of my spirit within the work. It entered the work througout the process of its creation, especially in the details and the final finishing. As I moved about the sculpture, I felt the same sense of presence that I experience in the midst of a mask narrative tale when my body is moving with the mask and my head is indeed enveloped inside it.

The movement and rhythm of my own body entered the completed work. Unlike Michelangelo, who chipped away the marble block to find the sculpture locked inside, my sculpture grows as if by osmosis, and in the process of its taking form, I experience it speaking as my own spirit. Clearly, my work does not duplicate my physical form but rather some complex sense of self that I am in touch with and am able to transfer into sculpture.

This represents more than my body form and rhythm: it is a patchwork of all of the people and experiences that thread through my life. The residue that stays with me finds its way into the detail finishing as well as into the blocked-out forms.

My work and I are part of and respond to the music of nature, the rhythm of the seasons, and the headlines and hardware of the western world. Sculpture centers me and holds me to the ground in this life in time and space.

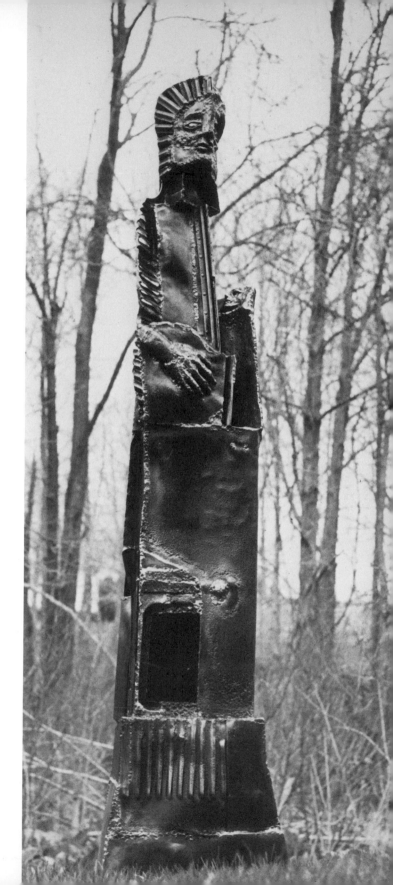

8-23, 8-24, and 8-25. *Beloved.* Polyurethane-coated steel, 79" high.

120

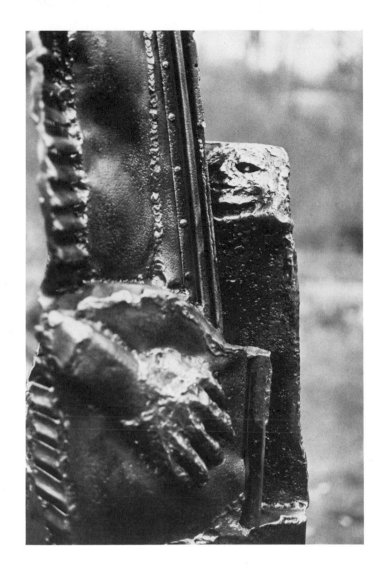

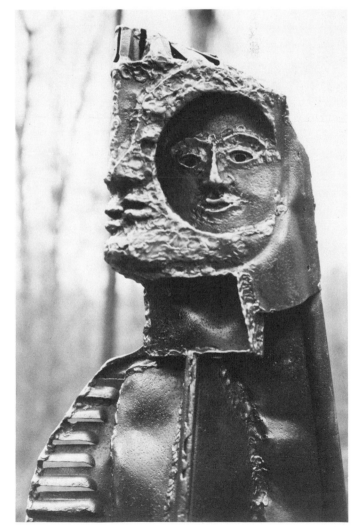

Chapter 9.
The Woman Artist

In myth and history women have been seen as hand-maidens to the arts, but the woman artist persists in her dreams of greatness and autonomy. Though the muses are imagined as giving inspiration to men, can we not notice that they come in a group, sing and dance, paint and sculpt for themselves as well?

Women artists have a special contribution to make at this time. Our gift is the ability to transform our own lives into art. Our responsibility is to share with others what we have learned about ourselves as women in this era of new possibility.

Although our lifestyle in general has discouraged the assertiveness and ego strength that are necessary to pursue and achieve a life in art, this period in time is unique; women artists support each other, and a nurturing evironment for women in art is being created. There have always been women of excellence who have striven to achieve greatness in art as in other pursuits. There are many women artists of the past for art historians to redis-cover and many contemporary women artists to celebrate. I have largely chosen the work of women artists to illustrate this book.

Sculpture definitely bears the stigma of a "masculine" art. Pursuing this art as a woman requires a degree of ego strength that will not wilt at the astonishment of those who do not consider it possible for women even to be artists, much less sculptors. It is upsetting to discover that there are many people who are astounded at your ability to weld and who view your work as nothing more than a fluke or novelty. This book is meant to dispel this prejudice. Comments about what you can or cannot do are best dealt with by direct eye-to-eye contact and simple but firm state-ments. These usually give you the option to direct the conversation to your own liking and to define yourself and your art.

Throughout history, striving and gifted women who have sought fulfillment in the assertive male world have not been accepted by men or women. Since most people have been conditioned to view women only in traditional roles, they are not flexible enough to respond to women artists. Men who support their wives take a patronizing role, and women who accept their traditional role tend to view striving women with envy and resentment. There is at present a great thrust by many creative and talented women who want a place in the larger world. Many of us understand the value of the new women's community in providing emotional, psychological, pragmatic, and political support for our dreams and efforts. Our entire culture is already receiving great creative impetus by women who have entered the mainstream.

In my opinion the motivations for becoming an artist are different for women than for men. It has been socially acceptable for a woman to be a nonachieving artist and to receive some measure of status by maintaining a menial, service, low-paying, or volunteer job in the art world. Art schools are largely peopled by women paying for men to teach them art. They do an enormous amount of work to keep museums and galleries afloat. Local communities mount annual art shows, which are staffed by volunteer women who give away endless hours of their time in order to maintain some contact with the art world. The depth of their sincerity does not mask the fact that they are largely supporting a system in which their work is primarily unpaid. This is detrimental to the art world in general. People do not value what is given away.

9-1. *Minoan Snake Goddess.* Copper-coated steel, 71" high.
(Photo by Airco.)

9-2. Doris Chase. *Sculpture for Kerry Park* (Seattle). Corten steel, 15' high.

Competition for jobs in the art world is very keen. When paying jobs are scarce, women are the last to be hired. Although more women graduate from art schools than men, the percentage of women teaching in these schools is still minuscule. Students in art schools view endless slides of great art, but only rarely do they see the work of women artists. It is not yet in the interest of the current art establishment to further the work of women. Although some galleries are run by women, they are often token women of the prior generation who have dedicated themselves to encouraging and establishing the careers of men. They have not generally supported women artists. In 1970 a woman gallery director expressed serious interest in my work but told me that she hesitated to handle it because she did not want her gallery to become known as a "women's gallery." Now, in 1975, many women's galleries have been established with great pride and professionalism. They have begun to find a market by bypassing the establishment.

Many women artists are married and have children. This situation limits the autonomy of women artists, since, as artists, they are tortured by a yearning stronger than sex, to do their work. It is natural for the artist-wife's identity to diminish and for her to become removed from her art. New alternatives to the traditional roles must be invented to help women artists gain economic independence and recognition.

We can elevate our position as well as the position of art if we work toward making our efforts economically rewarding for ourselves and our communities. To exist as artists, we must learn to earn our living as artists. As women in art begin to exert themselves on their own behalf and on that of their sister artists, men will assume more responsibility for their homes, children, and personal lives. The establishment will change.

In order to function as an artist, you must have equal opportunity to study art and to set up work space and time, and you must have acceptance as an artist and a place to show and sell your work. To satisfy these requirements, you need a certain element of economic security. One of the traditional realms open to you is teaching art to children. I did this and paid for all my studio equipment.

In order to establish studio space, it may be necessary to double people up in rooms and/or requisition the living room or dining room. It is crucial that the space be permanent and that no pressure be applied to clean it or otherwise remove the signs of work. It is extraordinary how many women attempt to work without a studio. It is an important step in self-assertion to find the space. Consider sharing a rented studio with other artists—this establishes your autonomy from the home environment immediately.

Along with a studio you need a disciplined amount of time in which to work. This can be more difficult psycho-logically than establishing the studio. The problem lies in convincing those with whom you live of your right to working space and time. The traditional world demands that a woman be available to her "loved ones," but if she is not so available, they will learn to do things on their own and become self-reliant. Once it is recognized that separations can heighten love and that being yourself is an important value in life, it becomes easier to assert and establish working time.

Above and beyond the physical necessities, a sympathetic environment must be found to support the drive and sense of self-worth that you must maintain in order to pursue your actual work. In order to develop and achieve, you need intimate friends who actively support you as an artist and as a person.

To be a woman artist, you must be a feminist on some level. In order to achieve a body of work, you must be assertive and believe in your art as the center of your life. You cannot allow yourself to be bound by narrow social strictures. Merely by existing as an artist you live counter to the culture and evolve an individual lifestyle.

9-3. Adele Beres. *First Sculpture.*

How can the achieving woman artist transcend the traditional view of women as passive, helpless and lesser beings? By thinking of herself as part of a community: the role of the token woman is undesirable, because we need acceptance as women among women. We have been taught by our culture that we have to choose between marriage and a career. (This is a rather recent expansion of choice: prior to this century our alternatives were marriage and "miserable" spinsterhood.) Fulfillment in isolation is a cruel search. Most vital and successful art emerges out of a peer group.

The peer group is an essential link between studio and public. The peer group is the first to learn of an artist's new work and the first to respond. These valuable people are really privy to the process of creation. They see the development of the body of work by knowing the artist as a friend over a period of years. At the same time the peer group is the emotional intimate of the artist's inner life. While in the past we have been erroneously led to believe that a single love object (man) could provide this support, in reality we need a much broader response. Excessive dependency, which is encouraged by a relationship with only one other person, is destructive to the art process. For immediate peer support organize and participate in a gathering of women artists from your local art school, form a consciousness-raising group, and discuss where you are and how to move forward.

In my search for a peer group I was involved in such a gathering with other women artists. We discussed many aspects and problems of being a woman artist. The environment of the peer group was invaluable on many levels. It allowed each of us to be accepted as artists and as serious individuals. It was an educational process whereby we learned to get a handle on our ideas and feelings and to articulate them in a supportive atmosphere. Each of us received responses from other members of the group, which gave many of us the courage to assert ourselves in both domestic and art situations. It became clear immediately that the woman artist cannot be separated from her life as a woman.

The traditional roles are clearly punitive to women. If you are married and/or living with a man, you are expected to move your home close to his work and drop the thread of your own career. To establish a career in art, however, you have to become known in your own community, and moving around makes this impossible. Since it is so difficult for women to find work, why shouldn't the man follow the woman?

On the other hand, loving and being loved can increase your drive and discipline to create a great deal of work. We create art in the midst of emotion, and we tend to prefer an atmosphere of love. The woman artist has special difficul-ties. While the wife of a male artist often handles the business and exhibition aspects, the woman artist is usually left to handle these by herself. To get any help at all is a great difficulty for women artists, especially in transition phases. A love relationship often seems to increase a man's output, but a woman always has to struggle with being diminished professionally. The tendency is to fall into the traditional role when emotions of love take over. When a man is in love, he is never expected to stop working.

I see the healthy woman artist possessing great autonomy in her relationships with men. A career can provide a stabilizing center that offers a wide spectrum of experience and involvement and cushions the vagaries of life.

9-4. Jean Woodham. *Revelation.* Welded bronze, 25 1/2" high.

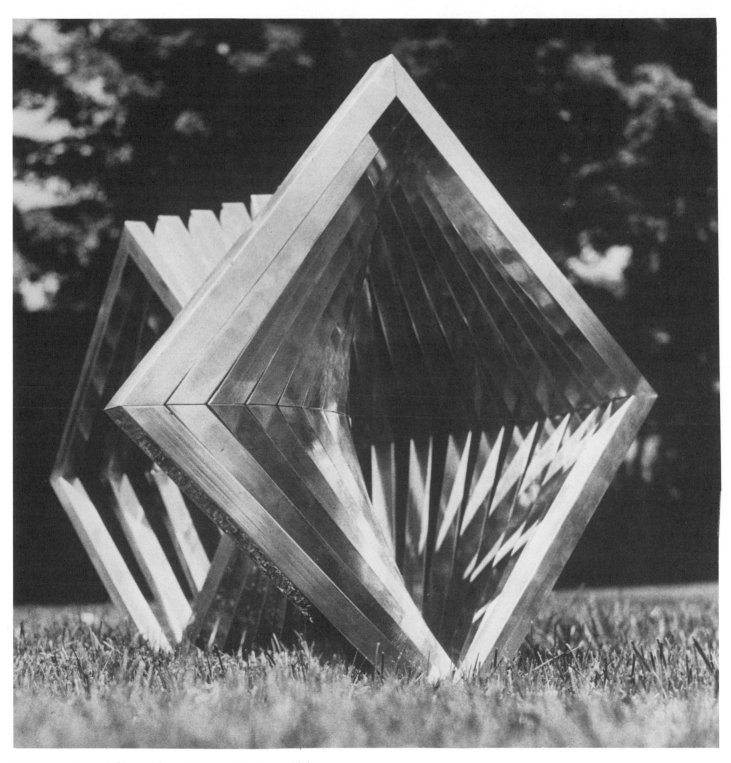

9-5. Linda Howard. *Sixteen Squares*. Aluminum, 22″ high.

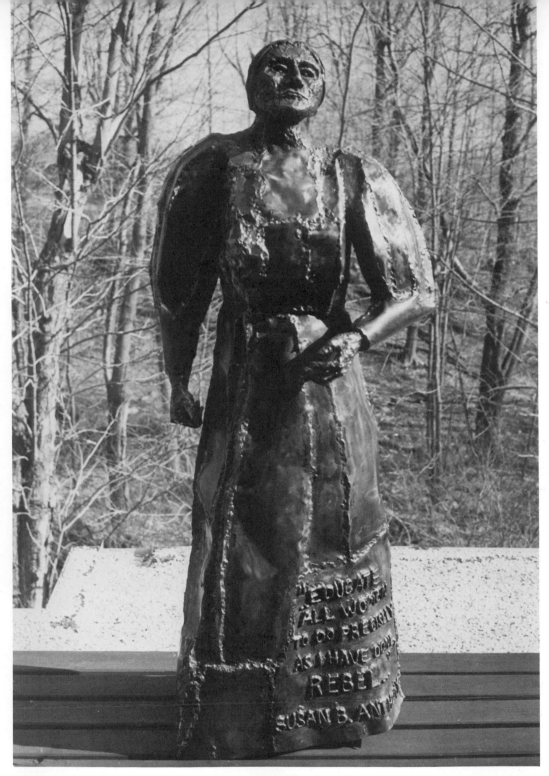

9-6. *Susan B. Anthony.* Steel, 46 1/2″ high. (Collection of David
and Ellen Mishkin.) A bronze casting has been made of this
sculpture.

Even the traditional life experience of women has never become a part of our universal understanding. How ironic that a woman is defined as existing within this realm, and yet her point of view of what this experience means to her life is not expressed in the arts of our culture!

Women are becoming influential in changing the focus of current art, which appears too often to celebrate a misuse of power. Descriptions of excellence so often abound with phallic imagery—mammoth, thrusting, potent, monumental—which places too much emphasis on scale and the single image. Many people have come to question the merit of this seemingly meaningless art activity. It seems rootless, vague, lacking in spiritual depth. A tremendous creative growth is happening among women, and they are creating exciting art.

Many women are now exploring their sexuality as a theme for their art. Women's sexuality has only been recorded from the male point of view. It will be interesting to see what arises. So far, there has been a great deal of purging of past violations, which is a clearing of channels before new viewpoints emerge.

9-7. *Great Goddess Torso.* Brazed bronze, 15 1/4" high. (Photo by Arnold Benton.)

9-8. *Opening Door.* Polyurethane-coated steel, 52" high. (Collection of Louis and Paula Reens.)

One of the most difficult problems that the woman artist has to face is general believability, having her work viewed seriously. The general public tends to perceive things only in relation to the culture at large. Therefore, it is very important to consider the environment in which you show your work. What you say about your work is what others will say, since most people do not seem to be in touch with their true responses and tend to see what they are led to see. Of course, you will discover people who understand art, and these people will seek you out, but they are not the first in line when you begin to show your work. As your work improves, so will your audience.

I see women as the major audience for women artists. As women gain in self-respect and understand the need to support other women, our opportunities, success, and professionalism will grow. The increasing number of women's art festivals provide a grass-roots training ground for professional women artists. The establishment picks up on the established. We must nurture our own as well as exist in the larger world.

9-9. Lila Katzen. *Oracle.* Corten and brushed stainless steel, 1974.

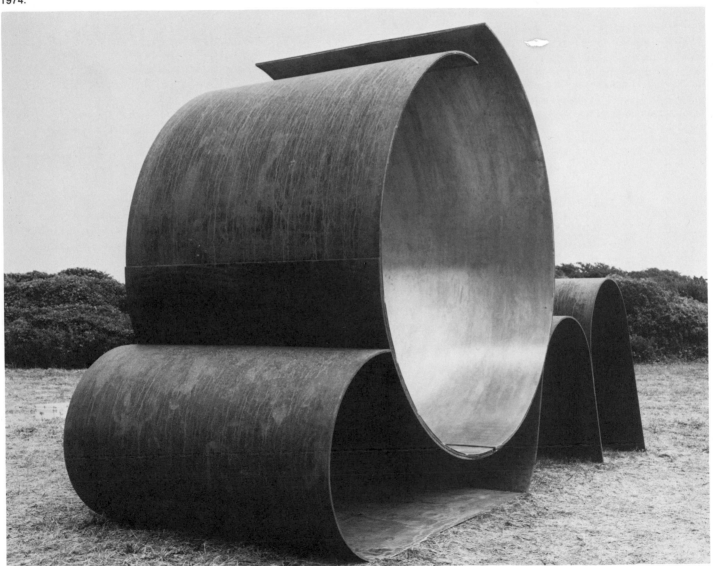

130

We must change our life experience so it no longer handicaps us, and we must educate the world to see the value of the work that we provide. Women have been handicapped in art as in other aspects of this world. Our capacities and strengths have been turned against us so that in loving we are asked to renounce our autonomy; in bringing children into the world and nurturing them we are denied access to the machinations of industrial society. At an age when most men have clearly established their economic worth, we are entering the business world statistically later in life and lacking this experience.

Contrary to many artists' feelings, I do not believe that organizations destroy the artist. I know that efforts to limit and pigeonhole the artist are enormously destructive, but I also know that new opportunities must be created to make art an integral part of our lives. I see women in art organizations providing us with what we need: places to learn, peer support, a space to show our work, and opportunities to become economically self-sufficient.

As we grow to understand ourselves, we will boldly reveal, practice, and nurture our ability. If the establishment is reluctant to include us, we will create our own museums, foundations, and community spaces; draw upon new audiences; and bypass the rigidity of the past. Then the establishment will want us, and we wil be in a position to insist upon our goals.

I see certain trends developing in women's art. It can be characterized as:

1. Self-defined: the self is the center of expression.

2. Communal, not elitist or untouchable: knowledge is shared, the talents of others are nurtured, and an international network of women artists is encouraged.

3. Professional: responsibility is assumed for practical aspects, including marketing and distribution.

4. Multifaceted: not only a mixed media of technology but a union of various art forms.

5. Historical: our heritage as women artists is reawakened and our traditional past reexamined.

9-10. First Annual Procession, Mask and Ritual Sculpture, New York, 1971. (Photo by Susan Pfeil.)

9-11. *Half Mask.* Steel, 9″ high.

10-3. Francois and Bernard Baschet. *Musical Fountain* (Hemisfair 1968, San Antonio, Texas). The public plays with 56 water valves, which operate jets that make watermills turn and play chimes—a synthesis of sound, shape, movement, and public participation.

Sensuality is our experience of the physical world, which includes the perception of our senses and our sexuality. As the mature human being comes to know the power of sexuality and its relation to creativity, we can appreciate how moralistic precepts have denied women freedom and access to this part of themselves. Universal sexual experiences that are culturally hampered hinder the naturalness and completeness of the person. Changing attitudes are providing an environment for new expression. The explosion of women's creativity has an impact upon men, who can now find it acceptable to get in touch with feminine elements in themselves. Sensuality is linked to our effectiveness and capacity for creative action and realization. Sculpture involves more of the senses than just the eyes. As a physical presence, it lives in a relationship to our bodies. As a concrete form, its multitextures can be touched.

10-4. *Pelvic Woman.* Steel, 20″ high. Part of the road-touring set for *I Am a Woman.*

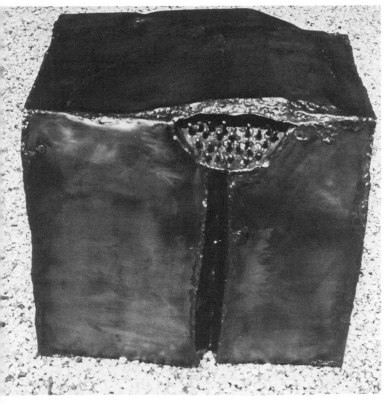

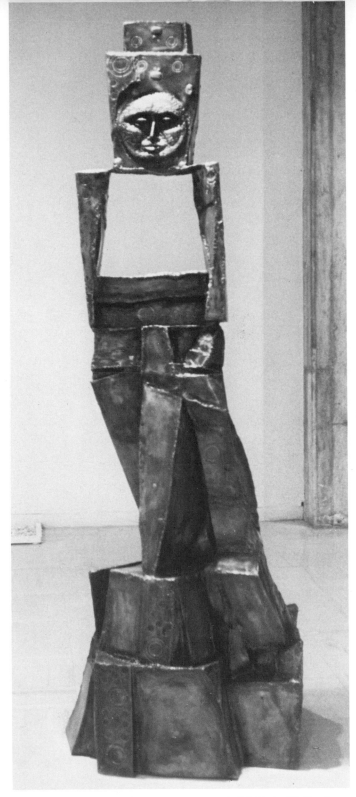

10-5. *Space Walker.* Copper-coated steel, 88″ high. (Collection of Caroline Whitbeck.)

135

THE ART PROCESS

There are many ways to create a work of art. I create my sculpture through a variable balance. Of intuition—moving with the possibilities as the work emerges—and order—thinking out the work beforehand and executing it according to predetermined decisions.

Making a decision about a piece of sculpture frequently entails a long and laborious physical process to bring it to completion. Welding seams, polishing, and finishing are mechanical activities which in themselves may not seem to require extraordinary intelligence. I have come to realize that constant concentration on the physical process helps the decision-making process. The machinery becomes part of your body, and grace and skill in the execution is invariably reflected in your work.

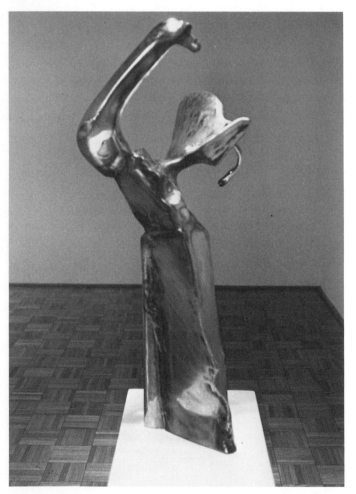

10-6. Richard Hunt. *Antique Study.* Welded steel, highly polished, 43" high, 1973.

THE FUNCTION OF SCULPTURE IN OUR SOCIETY

The structure of our environment vastly influences our behavior. A well-thought-out environment that reflected the totality of human activity and expression would provide an ideal human community. The problem with most ideals is a lack of imagination in allowing for new possibilities and for the fact that human life is ever-changing and not fixed. They usually assume that people have a limited number of needs and do not allow for the infinite variety of subtleties and unspoken needs. I want to approach sculpture in this world from a different point of view.

Monumental sculpture—sculpture as an adjunct of architecture—is concerned with specific function; on the rare occasions of its use in contemporary building, it is usually considered in relationship to the building and/or the landscape surrounding the building. Free-standing sculpture is sometimes found in the landscape, in front of the building, or in the entering lobby. The emphasis of architectural scupture has largely avoided a relationship to people who live in the building. Contemporary architecture compartmentalizes people and does not allow a variety of activities to be experienced. Work is isolated from love and relaxation: each of these has a separate environment. Needless to say, it is difficult for sculpture that speaks to the complete being to exist in this environment. In addition, sculpture that allies itself to architecture often concentrates on being larger than life and removed from human scale, which further exaggerates feelings of alienation and anonymity.

Welded sculpture has always been allied with functional objects; many sculptors started working with metal after they were exposed to commercial welding. There is now a small but growing area called *functional sculpture*. Its intent is to create art objects that can also serve a function, such as boxes, tables, chairs, lights, or chests of drawers.

The art world as it exists today, with the mechanics of gallery showings and commissions handed down by large corporations, is not really dealing with the vital function of art in culture. Art is to be lived with. It should be a part of the daily fabric of our lives, reminding us of our values and our inner feelings as we pass through the day. Because contemporary art has been so associated with elitist wealth and untouchability, the average person is reluctant to accept the fact that art should be accessible to all people. The life experience of every stratum of society is valid as part of the human continuum. The greatest art contains elements that speak to all people.

10-7. Anita Margill. *Circle in the Square.*

The need for art is intrinsic to human life. Given our vast population, we have a great need that is not being filled by our artists. We should encourage art that will reach large numbers of people. Sculpture in public places is an ideal vehicle for these aims. It is important that the artist address herself to the possibility of new uses of community space. We live in a time when the sense of community is in great jeopardy. Our transient society is in need of space that will facilitate the gathering of people into new communities.

In order for art to reach the vast public, new ways of communicating that do not reinforce elitist separation must be developed, such as the vest-pocket park, which is a haven of small space that offers comfortable seating and an environment that includes both nature and art. This concept deals intelligently with the serious problem of congestion in city living. At this point in time the artist can be the catalyst for bringing important uses of space into existence. Awakening political officials, finding community support, and encouraging donations of funds from the business community are related fields for an art career.

When the public in general begins to understand that it has the right and opportunity to create an environment according to its needs, these innovative uses of space will become a national concern.

The problems always seem to be money, priority, and productivity. Our society functions despite extraordinary waste, and I can envision what might be accomplished if it were understood that production and productivity are two entirely different concepts. Art is concerned with the development of the individual and of the environment.

10-8. Jean Woodham. Fountain sculpture in welded bronze. From right to left: *Morning Sun*, 5' in diameter; *Noonday Sun*, 13' high; *Evening Sun*, 16' wide. (Photo by Scott d'Arazien.)

Artists must concentrate a great deal of energy on this task and may well have to assume the role of shaman, bringing to light human values and creating a healing, life-giving environment.

Art leads to the total expansion of our imaginations. A logical result of this attitude is a new creation. Sculpture symbolizes the physical, the real.

Creation is disciplined action, and art is a shorthand for the vast body of human experience. It is a historical record.

It is a serious and worthy endeavor to choose to become an artist, a nonverbal historian. To transmit a complete statement on human existence into a three-dimensional object is only human. The artist's responsibility is to direct energy towards finding a vital place for art in our culture, towards helping everyone to understand what it is and what it can be to be human. To discover your life work, your creativity, is to discover yourself.

10-9. Anita Margrill. *Water and 2″ Painted Yellow Black Steel Pipe.* 8′ high, 1971. Permanent installation in Jackson Square Park, New York.

Appendix

WELDING SUPPLIERS
Airco Welding Products
P.O. Box 486
Union, N. J. 07083
Complete welding equipment, including small, portable tanks for traveling jobs. They produce Mapp gas and Ebrite, a nickel-free stainless steel.

Eutectic-Castolin Institute
40-40 172nd St.
Flushing, N. Y. 11358
Very good rods for welding exotic metals. Salesmen will come to your studio and demonstrate rods and equipment.

Hobart Brothers Company
Hobart Welding School
Troy, Ohio
An extensive line of welding equipment, a welding school, and an annual course in July for sculptors. They have a very helpful and positive attitude toward sculptors.

Linde Air Products
Union Carbide Corp.
270 Park Ave.
New York, N. Y. 10017
Purox torches. Local distributors can be found in the Yellow Pages of your telephone book.

Jackson Products
5523 East Nine Mile Road
Warren, Mich. 48091
Welding accessories, electrode holders, and safety equipment.

Lincoln Electric Company
22801 St. Clair Avenue
Cleveland, Ohio 44117

Westinghouse Electric Corporation
Industrial Equipment Division
Box 300
Sykesville, Md. 21784

Dockson Corporation
3839 Wabash Avenue
Detroit, Mich. 48208

Smith Welding Equipment Company
Division of Tescom Corporation
2600 Niagara Lane North
Minneapolis, Minn. 55441

Victor Equipment Company
Flame Welding and Cutting Division
Airport Road
Denton, Texas 76201

METAL SUPPLIERS
U. S. Steel
Public Relations Department
600 Grant St.
Pittsburgh, Pa. 15219

U.S. Steel Supply Service Centers are located in the following cities (see local Yellow Pages for street addresses): Atlanta, Baltimore, Birmingham, Boston, Buffalo, Chicago, Cincinnati, Cleveland, Dallas, Denver, Detroit, Hartford, Houston, Indianapolis, Kansas City, Los Angeles, Memphis, Moline, Newark, Philadelphia, Phoenix, Pittsburgh, St. Louis, St. Paul, San Francisco, and Seattle.

Monarch Brass Corp.
75 Beechwood Ave.
New Rochelle, N. Y. 10801

Edgecomb Metal Services
950 Bridgeport Ave.
Milford, Conn. 06460

T. E. Conklin
322 West 23rd St.
New York, N. Y. 10011

ARTISTS' ORGANIZATIONS

Artists' Equity Association of New York, Inc.
1780 Broadway
New York, N. Y. 10019
(212) 586-0554
Useful and practical information for the artist. You must be somewhat established to join, but anyone can obtain information.

Foundation for the Community of Artists
32 Union Square E.
New York, N. Y. 10003
(212) 533-0050
Publishes *Art Workers' News* and has a task force to promote grants for women.

International Organization of Women in Art
University of Wisconsin (extension)
610 Langdon St.
Madison, Wis. 53706
Conferences, projects such as the Women's International Art Festival 1975, Toronto.

National Organization of Women Task Force on Women and the Arts
Suzanne Benton, National Coordinator
5 South Wabash Ave.
Chicago, Ill. 60603
National committee of women artists in local NOW chapters. National newsletter. Encourages development and exposure of women in art, especially self-definition by women through the arts.

Sculptors' Guild
122 E. 42nd St.
New York, N. Y. 10017
(212) OX7-1690
Professional sculptors of outstanding ability and achievement.

WEB (Feminist Women in the Arts, National)
1962 North House
Chicago, Ill. 60614

WEB (Boston)
c/o Ellen Buckman
Mountain View
Swampscott, Mass. 01907

WEB, Inc.
c/o Institute of Contemporary Art
955 Boyleston St.
Boston, Mass. 02115
Newsletter.

Women in the Arts
237 Lafayette St.
New York, N. Y. 10012
Feminist-oriented newsletter.

Women's Interart Center
549 W. 52nd St.
New York, N. Y. 10019
Workshops, shows, and special events.

A. I. R. Gallery
97 Wooster St.
New York, N. Y. 10012
Co-op feminist gallery.

East-West Bag
55 Mercer St.
New York, N. Y. 10012

International Festival of Women in Art
Fine Arts Committee
c/o Maggi Tripp
870 U.N. Plaza
New York, N. Y. 10017

International Women in the Arts
c/o Linda Heddle, Art in Society
University of Wisconsin Extension
610 Langdon St.
Madison, Wis. 53706

WAIT
c/o Erika King
4060 Hardie Ave.
Coconut Grove, Fla. 33133

WASABAL
c/o Faith Ringnold
345 W. 145th St.
New York, N. Y. 10039
Black women artists.

Washington Women's Art Professionals
c/o Claire Sherman
4516 Que Lane, N. W.
Washington, D. C. 20007

Women's Ad Hoc Committee
c/o Agnes Denes
93 Crosby St.
New York, N. Y. 10012

Women and Art
89 E. Broadway
New York, N. Y. 10022
Newspaper containing etchings and self-portraits by women and news items describing organizations of women artists to redress grievances, sponsor conferences and exhibits, and demand resources.

Women's Art Registry
2325 Oak St.
Berkeley, Cal. 94708
International women's history archive with indexes of films, study courses, and black women.

Associated Council of the Arts
1564 Broadway
New York, N. Y. 10036
Publishes *The Visual Artist and the Law*, which deals with legal matters involving artists such as agents, copyrights, contracts, and tax problems.

Art Information Center
c/o Betty Chamberlain
189 Lexington Ave.
New York, N. Y. 10016
(212) 725-0335
Nonprofit organization, which supplies free information on galleries and has a slide registry that you can join.

GRANTS
PUBLICATIONS
Survey of United States and Foreign Government Support for Cultural Activities
(U. S. pamphlet no. 54-888)
U. S. Government Printing Office
Includes information on the State Councils for the Arts.

Washington and the Arts
Associated Councils of the Arts
1564 Broadway
New York, N. Y. 10036
Information on federal programs and a section on federal regulations affecting artists and the arts.

Grants and Aid to Individuals in the Arts
Washington International Newsletter
115 5th St., S. E.
Washington, D. C. 20003
Primarily study grants. Newsletter with ongoing information.

American Artist Business Letter
2160 Patterson St.
Cincinnati, Ohio 45212
Monthly brochure.

FULL GRANTS
Foundation Center
888 Seventh Ave.
New York, N. Y. 10019
(212) 489-8610
Other offices in Washington, D. C. and regional affiliate libraries. Files on thousands of American foundations.

John Simon Guggenheim Memorial Foundation
90 Park Ave.
New York, N. Y. 10016
Generous stipend of about $11,000. Most of their

grants, however, are to university persons—very few women. Deadline for application is October 1 of each year.

NOMINATION GRANTS
National Institute of Arts and Letters
633 W. 155th St.
New York, N. Y. 10032

Gardner Howard Foundation
Brown University
Providence, R. I. 02912

RESIDENCE FELLOWSHIPS
Prix de Rome Fellowship
American Academy in Rome
Executive Secretary
101 Park Ave.
New York, N. Y. 10017
Minimum stipend of $4620 and free residence and meals. Deadline for application is December 31 of each year.

Roswell Museum Art Center
Artist-in-Residence
11 Main St.
Roswell, N. M. 88201
Apply at least one year ahead. Grant includes residence, studio, supplies, and at least $250 per month.

NATIONAL AND STATE ARTS COUNCILS
National Endowment for the Arts
806 15th St., N. W.
Washington, D. C. 20506

Alabama State Council on the Arts and Humanities
Suite 224, 513 Madison Avenue,
Montgomery 36104

Alaska State Council on the Arts
338 Denali Street,
Anchorage 99501

Arizona Commission on the Arts and Humanities
6330 North Seventh Street,
Phoenix 85014

Arkansas State Council on the Arts and Humanities
Game and Fish Commission Building,
Capitol Mall,
Little Rock 72201

California Arts Commission
Room 205, 1108 Fourteenth Street,
Sacramento 95814

The Colorado Council on the Arts and Humanities
Room 205, 1550 Lincoln Street,
Denver 80203

Connecticut Commission on the Arts
340 Capitol Avenue
Hartford 06106

Delaware State Arts Council
601 Delaware Avenue,
Wilmington 19801

District of Columbia Commision on the Arts
Room 543, Munsey Building,
1329 E Street, N.W. 20004

Fine Arts Council of Florida
Department of State, the Capitol Building,
Tallahassee 32304

Georgia Commission on the Arts
706 Peachtree Center South Building,
225 Peachtree Street, N.E.,
Atlanta 30303

Hawaii—The State Foundation on Culture and the Arts
Room 310, 250 King Street,
Honolulu 96813

Idaho State Commission on the Arts and Humanities
P.O. Box 577,
Boise 83701

Illinois Arts Council
Room 1610, 111 North Wabash Avenue,
Chicago 60602

Indiana State Arts Commission
Room 815, Thomas Building,
15 East Washington Street,
Indianapolis 46204

Iowa State Arts Council
State Capitol Building,
Des Moines 50319

Kansas Cultural Arts Commission
Suite 204, 352 North Broadway,
Wichita 67202

Kentucky Arts Commission
400 Wapping Street,
Frankfort 40601

Louisiana Council for Music and Performing Arts
611 Gravier Street,
New Orleans 70130

Maine State Commission on the Arts and Humanities
146 State Street,
Augusta 04330

Maryland Arts Council
15 West Mulberry Street,
Baltimore 21201

Massachusetts Council on the Arts and Humanities
3 Joy Street,
Boston 02108

Michigan Council for the Arts
10125 East Jefferson,
Detroit 48214

Minnesota State Arts Council
100 East 22nd Street,
Minneapolis 55404

Mississippi Arts Commission
P.O. Box 1341,
Jackson 39205

Missouri State Council on the Arts
Suite 213, 7933 Clayton Road,
St. Louis 63117

Montana Arts Council
Room 310, Fine Arts Building
University of Montana,
Missoula 59801

Nebraska Arts Council
P.O. Box 1536,
Omaha 68101

Nevada State Council on the Arts
124 West Taylor Street, P.O. Box 208,
Reno 89504

New Hampshire Commission on the Arts
3 Capitol Street,
Concord 03301

New Jersey State Council on the Arts
The Douglass House, John Fitch Way,
Trenton 08608

New Mexico Arts Commission
Lew Wallace Building, State Capitol,
Santa Fe 87501

New York State Council on the Arts
250 West 57th Street,
New York 10019

North Carolina Arts Council
Room 245, 101 North Person Street,
Raleigh 27601

North Dakota Council on the Arts and Humanities
North Dakota State University,
Fargo 58102

Ohio Arts Council
Room 2840, 50 West Broad Street,
Columbus 43215

Oklahoma Arts and Humanities Council
1426 Northeast Expressway,
Oklahoma City 73111

Oregon Arts Commission
325 Public Service Building,
Salem 97310

Commonwealth of Pennsylvania Council on the Arts
503 North Front Street,
Harrisburg 17101

Rhode Island State Council on the Arts
4365 Post Road,
East Greenwich 02618

South Carolina Arts Commission
Room 202-A, 1001 Main Street,
Columbia 29201

South Dakota State Fine Arts Council
233 South Phillips Avenue,
Sioux Falls 57102

Tennessee Arts Commission
507 State Office Building,
Nashville 37219

Texas Fine Arts Commission
818 Brown Building,
Austin 78701

Utah State Institute of Fine Arts
609 East South Temple Street,
Salt Lake City 84102

Vermont Council on the Arts
136 State Street,
Montpelier 05602

Virginia Commission on the Arts and Humanities
Room 932, Ninth Street Office Building,
Richmond 23219

Washington State Arts Commission
4800 Capitol Boulevard,
Olympia 98501

West Virginia Arts and Humanities Council
State Office Building No. 6,
1900 Washington Street East,
Charleston 25305

Wisconsin Arts Foundation and Council
P.O. Box 3356,
Madison 53704

Wyoming Council on the Arts
P.O. Box 3033,
Casper 82601

ARTS MAGAZINES
Art News
121 Garden St.
Marion, Ohio 43302

The Art Gallery
Ivorytown, Conn. 06442

Arts Magazine
23 E. 26th St.
New York, N. Y. 10010

Art in America
150 E. 58th St.
New York, N. Y. 10022

American Artist
2160 Patterson St.
Cincinnati, Ohio 45214

Craft Horizons
44 W. 53rd St.
New York, N. Y. 10019

Art Workers' News
32 Union Square E.
New York, N. Y. 10003

The Feminist Art Journal
41 Montgomery Pl.
Brooklyn, N. Y. 11215

Art Forum
155 Allen Blvd.
Farmingdale, N. Y. 11735

Bibliography

INTRODUCTION
"How New is the Welding Process?" *Canadian Metals*, December 1956.

Welding and Metal Fabrication. October, 1955.

SAFETY
Precautions and Safe Practices in Welding and Cutting with Oxygen-Fuel Gas Equipment. Union Carbide Corporation, 1939.

Safe Practices in Welding and Cutting. Airco Welding Products.

WELDING MANUALS
Airco Electrode Pocket Guide. Airco Welding Products.

General Products Catalog. Airco Welding Products.

All State Instruction Manual and Catalog. All State Welding Alloys Company, Inc.

Eutectic-Castolin Welding Pocket Data Book. Eutectic-Castolin Institute.

Hobart Welding Guide. Hobart School of Welding Technology, 1969.

Oxyacetylene Welding and Cutting. Hobart School of Welding Technology, 1970.

Welding Journal. American Welding Society.

Welding Engineer. Jefferson Publications, Inc.

WELDED-SCULPTURE TECHNIQUES
Oxyacetylene Welding and Oxygen Cutting Instruction Course. Airco, 1966 (revised edition).

Baldwin, John. *Contemporary Sculpture Techniques*. Van Nostrand Reinhold Company, 1967.

Bealer, Alex W. *The Art of Blacksmithing*. Funk & Wagnalls, 1969.

Irving, Donald J. *Sculpture Material and Process*. Van Nostrand Reinhold Company, 1970.

Jefferson, T. B. *The Oxy-Acetylene Welder's Handbook*. Welding Engineer Publications, Inc., 1960.

Meilach, Dona and Seiden, Don. *Direct Metal Sculpture*. Crown Publishers, Inc., 1966.

Rich, Jack C. *The Materials and Methods of Sculpture*. Oxford University Press, 1973.

Rood, John. *Sculpture with a Torch*. University of Minnesota Press, 1964.

Smith, H. R. Bradley. *Blacksmiths' and Farriers' Tools at Shelburne Museum*. The Shelburne Museum, 1966.

The Oxy-Acetylene Handbook. Union Carbide Corporation, 1960.

Oxy-Acetylene Welding, Brazing and Cutting for the Beginner. Union Carbide Corporation, 1973.

Untracht, Oppi. *Metal Techniques for Craftsmen*. Doubleday and Company, 1968.

Application and Technical Handbook. Welco Alloys Corp.

Copper and Copper Alloy Welding. American Welding Society.

Training in Shielded Metal-Arc Welding, I and II. Hobart School of Welding Technology, 1972.

Semiautomatic Arc Welding, Hobart School of Welding Technology, 1970.

Lessons in Arc Welding. Lincoln Electric Company, 1941.

Welding Products Catalog. Union Carbide.

PROJECTS
D'Allemagne, Henry René. *Decorative Antique Ironwork.* Dover Publications, 1968.

Grayshone, Alfred B. *General Metal Work.* D. Van Nostrand Company, 1956.

Maryon, Herbert. *Metalwork and Enamelling.* Dover Publications, 1971.

John, F. *Metal Craft.* W. & G. Foyle Ltd., London, 1953.

Kronquist, Emil F. *Metalwork for Craftsmen.* Dover Publications, 1972.

Weygers, Alexander G. *The Making of Tools.* Van Nostrand Reinhold Company, 1973.

PRESENTING YOUR WORK
The Visual Artist and The Law. Associated Councils of the Arts, Association of the Bar of the City of New York, and Volunteer Lawyers for the Arts, 1971.

Berlye, Milton K. *Selling Your Art Work.* A. S. Barnes and Company, 1973.

Chamberlain, Betty. *The Artist's Guide to His Market.* Watson-Guptill Publications, 1970.

Goodman, Calvin J. *Marketing Art.* Gee Tee Bee, 1972.

Mates, Robert E. *Photographing Art.* American Photographic Book Publishing Company, Inc., 1966.

Morrison, Bradley G. and Fliehr, Kay. *In Search of an Audience.* Pitman Publishing Corp. 1968.

Reiss, Alvin H. *The Arts Management Handbook.* Law Arts Publications, Inc., 1974.

Washington and the Arts: A Guide and Directory to Federal Programs and Dollars for the Arts. Associated Councils of the Arts, 1971.

THE WOMAN ARTIST
Elizabeth Gould Davis. *The First Sex.* G.P. Putnam's Sons, 1971.

Harding, M. Esther. *Woman's Mysteries, Ancient and Modern.* G. P. Putnam's Sons, 1971.

Hess, Thomas B. and Baker, Elizabeth C. *Art and Sexual Politics.* Collier Books, 1973.

Sheehan, Valerie Harms. *Unmasking. Ten Women in Metamorphosis.* The Swallow Press, 1973.

SCULPTURE AND SOCIETY
Bazin, Germain. *The History of World Sculpture.* New York Graphic Society, Ltd. 1968.

Burnham, Jack. *Beyond Modern Sculpture.* George Braziller, 1969.

Laliberté, Norman and Mogelon, Alex. *Masks, Face Coverings, and Headgear.* Van Nostrand Reinhold Company, 1973.

Julio Gonzalez: Les Materiaux de son Expression. Catalog for exhibition, Saidenberg Gallery, 1969.

Read, Herbert. *A Concise History of Modern Sculpture.* Praeger Publishers, 1971.

Panero, Julius. *Anatomy for Interior Designers.* Whitney Library of Design, 1974.

Penrose, Roland. *The Sculpture of Picasso.* The Museum of Modern Art, 1967.

Seuphor, Michel. *The Sculpture of this Century.* George Braziller, 1960.

Smith, David. *David Smith.* Holt, Rinehart, and Winston, 1972.

Tefft, Elden C. *Proceedings of the Sixth National Sculpture Conference.* National Sculpture Center, The University of Kansas. 1971.

Tefft, Elden C. *Proceedings of the Seventh National Sculpture Conference.* National Sculpture Center, The University of Kansas, 1972.

Trier, Eduard. *Form and Space.* Frederick A. Praeger, 1962.

Index